Passage Europe

MUSEE D'ART MODERNE DE SAINT-ETIENNE METROPOLE

Catalogue

Curator
Lorand Hegyi

Traductions
James Gussen, Michael Hastik,
Gabrielle Lawrence,
Gudrun Meddeb,
Margret Millischer,
Polyglott Language Services,
Nita Tandon, Aude Tincelin,
Alexander Zigo, Suzanne Watzek

Art Director
Fayçal Zaouali

Editorial Coordinatior
Laura Maggioni

Editing
Andrew Ellis

Cover
Nebojsa Seric-Soba
Untitled
(Sarajevo 1994 – Monaco 1998),
1998-2000

For the illustrations:
© The artists and photographers
© ADAGP, Paris, 2000 (Opalka,
Kabakov, Knifer, Abramovic, Dakic,
Nadler, Hencze, Kelemen, Feher)

For the texts:
© Musée d'Art Moderne de Saint
Etienne Métropole and the authors

© Musée d'Art Moderne
de Saint-Etienne Métropole

© 5 Continents Editions srl, Milan, 2004
info@5continentseditions.com

ISBN: 88-7439-168-4

General Director
Lorand Hegyi

Secretary-General
Emmanuelle Thuong-Hime

Chief Curator
Jacques Beauffet

Public Relations
Stefano Arnaldi

P.R. Department
Lorraine Philibert

Personal Assistant of Direction
Blandine Gwizdala

Library
Christian Gay

Photography
Yves Bresson

Collection and Museology
Cécile Bourgin - Martine Dancer,
Régina Gonnet,
Sophie Lepine - Sébastien Terrat

Administration
Jacques Alu,
Gilles Bacher - Marc Bœuf,
Patrice Cote, Nathalie Darne,
Josette Delafosse, Pascal Devun,
Nelly Imbert, Dominique Jay,
Annie Joubert, Patricia Liodenot -
Pierre-Henri Perez,
Valérie Sigaut - Laure Sintes,
Joëlle Verdier, Yvette Viricel

Fundraising
Elisabeth Delaigue

Educational Department
Pierre Arnaud, Jean-Marc Cerino,
Frank Chalendard,
Eliane Chavagneux,
Patrick Condouret,
Esmeralda Emmons,
Bianca Falsetti, Dominique Marel,
Alexis Meilland, Nicole Pascal,
Emma Re, Philippe Roux,
Dominique Viou

Books are to be returned on or before
the last date below.

Exposition "Passage Europe"

Curator
Lorand Hegyi

Invited curator
Maïté Vissault

Adjunct Curators
Nada Beros, Dunja Blazevic,
Zoran Eric, Rainer Fuchs,
Anne Landréat, Jiri Sevcik,
Stevan Vukovic,
Hanna Wroblewska

Curatorial Assistant
Bernhard Fellner (Vienne)
Sonia Reynaud-Thien

Trainee
Jennifer Yamanaka

Museology
Corinne Cazorla
Evelyne Granger

Multimedia
Gilles Cheminal

Technical Team
Nasser Abdechakour,
Gérald Lima,
Carole Macary,
Yves Monmart,
Daniel Simonnet

Executive Production
Fondazione Culturale Edison
Parme – Italy
www.edisonline.org

General Coordination
Andrea Gambetta
Massimiliano Di Liberto
Stefano Caselli

Production Coordination
Francesca Tagliavini
Laura Borrini
Siglinde Alberti

Technical Coordination
Sergio Simonazzi

Acknowledgments
Michel Thiollière, Président de
Saint-Etienne Métropole,
François Jamond, Vice-Président
à la Culture et aux Grands
Equipements Culturels de
Saint-Etienne Métropole,
Richard Lagrange, Directeur
Régional des Affaires Culturelles
Rhône-Alpes

François Barré,
Christoph Brockhaus,
Bernard Ceysson, Tatiana Dumas,
Bernhard Fellner, Andrea Gambetta,
Ernst Hilger, Henry Meyric-Hughes,
Edelbert Köb, Gabor Kovacs,
Gabor Littasy, Catherine Millet,
Mihael Milunovic, Katalin Neray,
Emmerich Oross, Gaudens Pedit,
Wolfgang Roth, Toth Tamas,
Marta Tarabula, Enzo Unfer

Galerie Thaddaeus Ropac
Galleria Lia Rumma

Galerie J. Rabouan-Moussion
Galerie Jiri Svestka
Galeria Zacheta
Galerie Ernst Hilger
Galeria Zderzak
Baukunst Galerie

Museum Moderner Kunst Stiftung
Ludwig, Wien
Ecole régionale des Beaux-Arts de
Saint-Etienne
Faculté d'Arts Plastiques
de Saint-Etienne
Fondazione Culturale Edison, Parme
Stiftung Art in Motion, Wien
Studio 920, Budapest
Fondation KOGART, Budapest
Groupe CASINO
FOCAL
Banque européenne d'investissement
Saint-Etienne Métropole
Service Communication

Photography Credits
The artists
MUMOK, Museum Moderner Kunst
Stiftung Ludwig, Wien p. 22, 41, 50,
72, 83, 97, 99, 100, 108
Galerie Hilger p. 52, 130
Galerie Zacheta p. 54-55
Galerie Jiri Svestka p. 74
Galerie Rabouan Moussion p. 21
Edison p. 77
Galerie Thaddaeus Ropac p. 118,
122, 123, 125
Egbert Tragemann p. 16

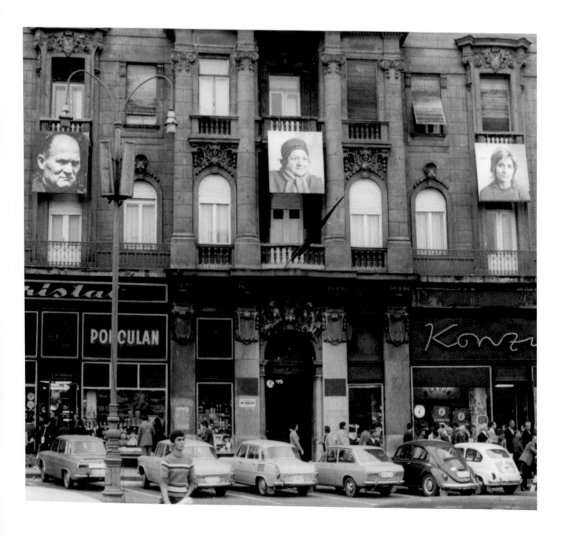

Passage Europe
Connecting Passages
Constructing the Present
Confronting the Past
Reconstructing Europe

Lorand Hegyi

Shortly before the inauguration of this exhibition, Europe celebrated the official accession of ten new members to the European Union. This rings in a new chapter in the history of the continent. Separation and mistrust, hostility and tension, will make way—or so we hope—to a new era of construction in a new European community. Clearly, the European Union is not the same as the European continent. Many regions, many large countries and their historical experiences and enormous cultural wealth, their significant economic and intellectual resources, still remain "outside" and will, alas, continue to be considered as "marginal" for some time to come. Nevertheless, the enlargement of the European Union opens up gigantic new vistas and serious hopes and expectations for all Europeans.

The formal accession of the ten new member states to the Union is the result of a long and complex process which was felt at economic, political, and strategic levels, but also (and considerably so) at an intellectual level in terms of European *Weltanschauung* and culture. The process of reorientation and change that value systems have undergone went from a *status quo* of separation to a new reality of co-existence and connection, including a new European sense of unity and solidarity.

At a cultural level, at the deeper level of collective thought, this process also involves addressing and reframing European culture, the European past, the political and ideological splits in Europe during the Cold War. It also involves a critical and analytical review of many suppositions and assumptions, clichés and visions, which often interpreted reality in an ahistoric, abstract, simplistic and one-sided manner, taking it out of context and divorcing it from determinant aspects. The division of Europe into two competing, hostile, ideologically and morally antagonistic entities kept alive, somewhat artificially and manipulatively, the image of the "alien", the image of the "enemy". In the process, many shared values, experiences, even the entire cultural heritage of Europe, were split asunder and misinterpreted in a wrongful, historically incorrect way.

Presenting differences as absolutes, mystifying the "otherness" of the respective "other" part of Europe, depicting antagonism as an insoluble problem, presenting the "other" as diabolical and manufacturing "enemies" create an absurd, irrational, tragicomic and, above all, mistaken division of Europe into a part that is "good", "progressive", "free", "humane", and a part that is "evil", "regressive", "repressive", and "inhumane". In the process, both sides always brought out the same clichés and moralistic arguments when viewing the "other side". This was perhaps the most painful aspect in the intellectual history of the Cold War: this common—and often unconscious—falsification of European cultural history, of the collective heritage and shared experience. Virtually everyone was involved in creating this dangerous and absurd schizophrenia: policy-makers, ideologists, the press, and even the intellectuals—if often unconsciously, and with the best of intentions. Dividing the continent between "good" and "evil" destroyed historical thought, since historical, philosophical and cultural processes

were falsified retrospectively.
An irrational teleology projected the strategic, political, ideological objectives of the present—that is, of the Cold War period—onto the processes of the past and elevated the contemporary separation or divergence to the level of the absolute. Under this teleology, connections that were perfectly obvious in logical and historical terms, natural bonds, were misinterpreted in a wrongful and manipulative manner in order to present the existing division as an eternal, timeless, immutable, irrevocable and irreversible status quo. This approach destroyed correct historical perspectives and created an almost demonic perception of the "other", which automatically became something completely "alien" and "the enemy".

This mechanism of permanent misinterpretation and the creation "enemy images" meant that cultural processes and artistic constellations were often perceived incorrectly or one-sidedly. The complex connections between cultural centres were forgotten or simply ignored. The schism between

the entire Soviet avant-garde and developments in the West started as early as the late 1920s, although a number of personal contacts and professional activities between the Soviet Union and the rest of Europe survived until the mid-1930s, especially in the field of contemporary literature and film. In architecture and the visual arts, there were also significant contacts, co-operation, competition and a lively exchange of ideas and concepts in specialist literature. The disappearance of mutual references illustrates how the cultural schism intensified between the regions of Europe and heralded the tragic collective amnesia of the 1950s and '60s.

After the Nazis came to power in Germany in 1933, they started their systematic ideological and cultural reorganisation of Germany, with the "cleansing" of "foreign" elements from the Germanic culture taking on a manic-obsessive, totalitarian form. Never before in European history had ideas and forms of art, aesthetic concepts and themes, images and texts been persecuted and eradicated as thoroughly as in the Third Reich. The ideological

changes and strategic considerations in the Stalinist Soviet Union during the 1930s, especially the radicalisation of internal battles against the different tendencies and groups of "dissenters", Trotskyites and Bucharinists, and the almost paranoid distrust of Western Communists, led to an escalation of repression and, above all, to a growing isolation of the Soviet Union from the Western world. After the *Anschluss* in 1938 and the outbreak of war in 1939, the active, intensive, reciprocal cultural ties between the European cultural centres, between East and West, which had survived under different regimes, were almost totally destroyed. Only resistance and emigration, the culture of illegality and emotional solidarity, kept the memory of certain contacts and, moreover, certain cultural references, alive.

Shortly after the defeat of fascism and of the Nazi regime, Europe had a brief period of respite—albeit diluted by great ambivalence, doubt and mistrust—feeling once more a sense of unity and solidarity, although the war wounds and the horrifying experiences under the various repressive regimes

in the totalitarian societies, in the repressive power systems, and in the cynical ideological manipulation mechanisms of the intellectuals would never again allow comparable optimism, any clinging to the fetish of development, or romantic euphoria about the future.
In the 1930s and 40s, European intellectuals lost the last shreds of their naïvety.
In the 1950s, state cultural policies and ideologies were clearly manipulated by the waves of "official optimism" and "mandatory euphoria". Scepticism and melancholy were banned in one part of Europe, while critical scepticism, nihilistic fatalism and the "lightness of freedom" led to the development of a certain (frequently unconscious) arrogance and hedonistic irresponsibility in another part of the continent.
Although philosophers and thinkers from Camus to Moravia probably understood and profoundly analysed the ethical dimensions of the political battles of 1956, collective amnesia and political sluggishness constantly exacerbated the split. Some eastern intellectuals sought refuge in diverse kinds of dangerous nostalgia, or masochistic yet arrogant and pseudo-heroic isolationism, while others actually left their home country. Adapting to the situation in their new countries, under time pressure and often fraught with problems, frequently resulted in profound identity crises.

The political turnaround in Central and Eastern Europe around 1989 improved the chances for rebuilding the historical, logical ties between the various European cultural centres and cultural constellations. Chances also improved for differentiated, rational and less ideologically or strategically motivated analyses. However, the paranoia of antagonism and the spectres of deeply entrenched "enemy images" continued to exist in primitive, diseased, poisonous and hideous forms in ideological and political spheres, and even in everyday life.

The connecting passages through Europe were opened up, and fresh air swept away the old dust, but the old clichés and the new forms of hatred, racism and nationalism, religious intolerance and fundamentalism, xenophobia and egotism still appeared—albeit now sometimes in new costumes

and supported by new, "modern" arguments—on the stages of the new Europe. The connecting passages of Europe need to be in constant use and to be analytically reassessed. This is the only way of ensuring their remaining 'in use'. They are metaphorical meeting places, where the specific messages and forms of communication of the diverse cultural and intellectual constellations can be shared and compared in the authentic, well founded statements of artists, writers, philosophers, architects, film and theatre experts, and musicians.

This exhibition is a modest attempt to contribute to the construction of a new vision of Europe, without claiming to provide a comprehensive, statistically encyclopaedic picture of art from Central and Eastern Europe. The works exhibited here do not represent countries or regions, they are not "ambassadors" or representatives of their home countries; they create their own new home within the arts. They create new spaces, new contexts, new constellations, where individual experiences and personal histories, specific cultural and intellectual determinants such as language,

philosophy, political, economic, social, and ecological situations construct a specific, personal, authentic structure of individually-interpreted values. The diversity of constellations illustrates the diversity of European culture, its diversity and creative heterogeneity, where old connections mingle and combine with new contacts. Old connections are subjected to critical review and analysis and are compared with new experiences. The artists want to make all of Europe, the whole world, their own. They want to transcend borders, take experiences out of their various intellectual, social, and cultural contexts. If the connecting passages of Europe are reopened, this will be due in no small part to artists, to the authenticity and subversive nature of creative work, which accepts neither borders nor frontiers, in any sense of the word.

Table of Contents

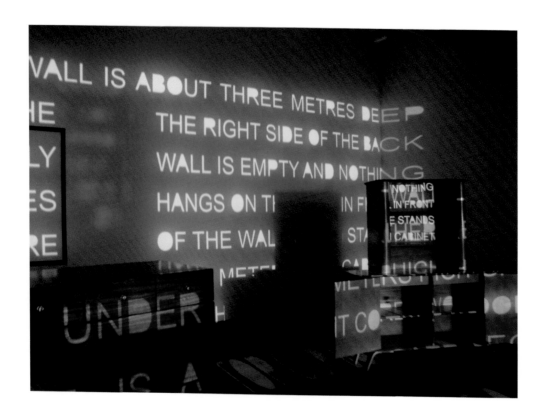

Jan Mancuska
Behind the Wall…
2004

HOMMAGE
Zdenek Sykora
Stano Filko
Roman Opalka
Ilya Kabakov
Jiri Kolar
Julije Knifer
Erik Boulatov

CARREFOUR
Braco Dimitrijevic
Marina Abramovic
Mihael Milunovic
Danica Dakic
Maja Bajevic
Olga Kisseleva

NOMADE
Nebojsa Seric-Soba
Jiri Georg Dokoupil
Marjetica Potrc
Dean Jokanovic Toumin
Antal Lakner

INSULA
Ivan Kozaric
Istvan Nadler
Karel Malich
Tamas Hencze
Miroslav Balka
Zeljko Kipke
Nedko Solakov
Karoly Kelemen
Jan Mancuska
Denisa Lehocka
Leon Tarasewicz
Andras Koncz
Tomas Hlavina
Jiri Cernicky
Laszlo Feher

DISCOURS
Sejla Kameric
Dan Perjovschi
IRWIN
Andreja Kulundzic
Piotr Jaros
Alma Suljevic
Ilona Nemeth
Renata Poljak
Jiri Suruvka
Uros Djuric
Oleg Kulik
Gordana Andjelic-Galic
Ivana Franke
Miodrag Krkobabic
Jelena Radic
Dejan Kaludjerovic
Michal Pechoucek
Alexander Ponomarev
Anastasia Khoroshilova
Azorro
Kuba Bakowski
Bergamot
Anna Niesterowicz
Julita Wojcik
Artur Zmijewski
Jan J. Kotik
Jesper Alvaer
Inta Ruka
Ene-Liis Semper
Laszlo L. Revesz
Erik Binder
Sandor Pinczehelyi

West-East Side Story

Dunja Blazevic

In Sarajevo in 1999, during a workshop on *Générations et représentation* (Generations and representation) organised by the periodical *Transeuropéene* (Transeuropean) and the Soros Centre for Contemporary Art, we sought to address the notions Global, International, and Universal, taking as our point of departure a reality dominated by the local, the national, and the particular. Below I paraphrase the foreword, which still seems to me appropriate today:

"New states are in the process of forming in the regions of the former Yugoslavia. As a result of the war, the fragile 'peace' that followed it, and the new political situation, the communities in each of them are re-establishing their bonds on new foundations (having previously lost all contact with one another). The familiar society has disintegrated, the social bond has broken, and a new social (dis)order is rising in its place. This reorganization is still under way and will continue for several decades to come. This situation is also the consequence of the Cold War (of its end) as well as of the process of globalization in general. The motor of this globalization, which transcends borders and makes the definition of nation-states increasingly obsolete in economic terms, is capital. While it is true that, in this part of Europe, the circulation of transnational capital is in the process of being liberalized, this is not the case with respect to the movement of individuals or populations. Forced migrations due to the war and economic chaos are a very important characteristic of the peripheral countries, while the countries at the centre are better protected against this type of movements. [...]

"In the Western world, multiculturalism clearly signifies the recognition of differences within the framework of neoliberalism. Although it is infinitely preferable to the absence of recognition, its ideological limits are obvious. The respect for differences is often no more than a false neutrality, or it only concerns the pseudo-universality of transnational capital. Multiculturalism does not seem to prevent racism, nationalism, or communitarianism. [...]"

International—Where to Locate the Centre?

On the international artistic scene we arrive at similar conclusions. The relationship of hierarchy, arbitration, and unilateral domination does not derive from the a priori evil character of the West, but from the fact that there still exist profound

Page 16
Danica Dakic
*The Group Portrait with the Dance Group of the
Bosnian Homeland
Association "Bosanski vidici",* 2003

Irwin
*Retroavantgarde,*1999

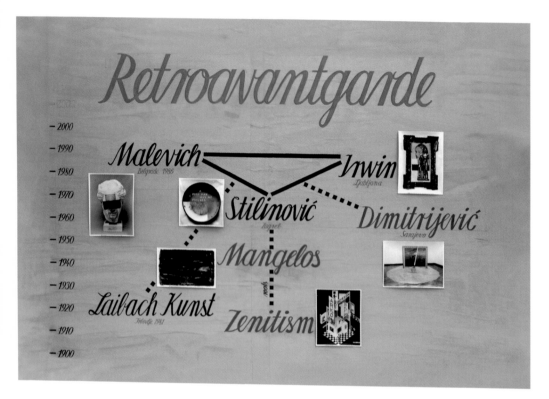

economic, systemic, and cultural causes on the other side that stand in the way of any relationship of reciprocity or partnership. Mladen Stilnovic (of Zagreb) expressed it perfectly in 1994 in a work entitled *An Artist Who Cannot Speak English Is No Artist.*

If we judge by the number of artists from the countries that were previously excluded from what was called the international artistic community, the situation has certainly improved since the fall of the Berlin Wall. In Europe at least, there has been a realisation of the fact that it was not "politically correct" to put a hundred artists—always the same ones—into circulation, and that from time to time one had to include certain artists of the former communist countries who were still living in those countries. It is not yet a question of reconsidering the idea we have of art, but rather of expanding the spectrum to include artists who will not disturb the prevailing order. Something that Miran Mohar, a member of the group IRWIN (Ljubljana), expresses like this: "The Western art world behaves in exactly the same way as strictly political entities like the European Community. The only artists or countries considered for admission are those who will not risk introducing instability into the system. The only difference being that the strategy of the European Community is consciously and openly political, while the art world is not" (*Transnacionala,* Ljubljana 1999).

Nevertheless, as problematic as this process of integration may seem, it must not be rejected or generalized. It is obvious that old structures like the Venice Biennale or *Documenta* in Kassel cannot effect radical changes, but can only take certain occasional or virtual initiatives, such as, for example, the discovery of Chinese or South African artists.

An example of the new type of international exhibition that is potentially capable of transforming the current hierarchical system is *Manifesta*. It was conceived as a Pan-European exhibition, one that is mobile and migrates to a new European centre every two years. New organizers are appointed each time, and care is taken to ensure that they come from different regions of Europe and are already present on the international scene. This exhibition offers a good snapshot of the state of affairs on the ground, since the organizers are required to move about to gather information. The artists selected represent only themselves and not their countries. Whatever its impact may turn out to be, the concept of *Manifesta* seems to me—and not from a symbolic perspective only—better adapted to the time and the new reality of Europe than the old models of international exhibitions.

I will also mention the exhibition *After the Wall* at the Moderna Museet of Stockholm in 1999. The director of the museum, David Elliot, made an important gesture by entrusting the exhibit's organisation to Bojana Pejic (originally from Belgrade and resident in Berlin since 1991), one of the most talented critics of her generation. This exhibition offered a global vision of the events of the last decade in some twenty ex-Communist countries. Even more important than this "gift" to the western colleagues—the opportunity to encounter in one place and at one time a valid image of something one knew only partially or peripherally—was the potential of this image itself. This exhibition demonstrated that in fact, this art, with all its variants, differs from art in the West. Its sources are different, it uses a different referential system, and it puts its own cultural and ideological traditions in question. Boris Groys (*Die Zeit*, 2 December 1999), writing of the artists of the East, declared that instead of complaining they would do better to attack the system and the code and to undertake a re-evaluation of their art. That is effectively what the most lucid among them do, and they are recognized for it.

West Side
How is the process of recognition and integration of the art that is being created in the East unfolding? What are the new agents that are encouraging this process? Between the 1990s and today, several governmental and non-governmental foundations were formed alongside those that already existed, and they are adapting their policies to the new needs of communication and exchange inside and outside Europe. The largest network was formed at the beginning of the 1990s thanks to the Open Society Institute of New York and the creation of Soros Centres for Contemporary Art in twenty countries of Central and Eastern Europe. They later evolved into a genuine source of logistical support for their partners in the West. This program, however, did not anticipate any form of support for East-West projects, apart from the partial financial support of the organization Arts Link, which is headquartered in New York. For years, Arts Link has organized visits to the United States by artists, writers, musicians, and film-makers from the countries of Eastern Europe. This organization has had to tackle the new situation created by the financial withdrawal of Georges Soros, and today it pursues its activities on a more modest scale.

Having recently visited the United States, where I had not been for fifteen

years, I was able to register the enormous changes that have taken place there. I discovered new galleries and non-commercial centres (in the parts of New York where the commercial galleries are located) supported by foundations like the Trust for Mutual Understanding, which subsidizes the programs and projects of artists from Eastern Europe (Apex Gallery, Location 1). These institutions, like Artist's Space, which are open to collaboration with the artists of the "other world," are financed in whole or in part by public funds, a phenomenon that did not exist in America twenty years ago. There are also interesting examples of collaboration in Washington DC as well as in other less attractive artistic centres. By contrast with the obvious interest shown by these alternative cultural centres that have discovered new sources of funding, the museums—especially the new ones, which resemble the headquarters of large international corporations (and behave like them as well)—do not show any curiosity. Quite the contrary. This simply means that the art of "the other side" still does not represent a form of capital, does not return any profit, is not "priced".

In Europe the situation varies. Among the museums, I will give first mention to the Museum Moderner Kunst Stiftung Ludwig in Vienna, not only because of the various exhibitions in which Eastern European artists have participated during the last ten years, but also because of its purchasing policy. Its collection reveals a balance between works that come from the East and those of the West. For Lorand Hegyi, who has been directing this museum for ten years, this was not a risk insofar as the future will certainly validate the correctness of his decision. But nonetheless, it represented a risk when he had to justify the purchase of works by "anonymous" artists to the authorities charged with financing the museum as well as to the Austrian public, that is, the

Oleg Kulik
Big Milk, 1999

taxpayers. Recent events in Austria have confirmed this, and not only with respect to the museums and their new mode of funding (their privatization). The politics of the governmental agency KulturKontakt, which is especially active in this region, is thus called into question.

Another example of sustained and competent action in support of the affirmation of the artists of the region is that of Silvia Elblmayr, today the director of the Galerie im Taxispalais in Innsbruck. The periodical *Springerin* is also particularly active in this domain. The Austrian example is interesting, because Austria's interest in cultural integration raises the question: is the goal to enable Austria to assert itself as the new and primary centre of the region, as during the period of its imperial splendour, or to form new relationships in this region? What motivates the countries concerned with these initiatives is their concrete interest in developing a partnership with a country that, geopolitically speaking, is located on the outskirts of the European Community, and is hence a border country that tends and aspires to redefine the relationship of centre and periphery in terms of its own strategic interests. For us, co-operation with the neighbouring Western countries is one of the avenues that will allow us to accede more easily to a large European context. The example of another neighbouring Western country, Italy, is also interesting, as is the behaviour of its cultural agents vis-à-vis the south-western Balkans. One of the most eminent is *Flash Art* and the galleries that cluster around the periodical. Giancarlo Politi devotes special attention to Albania and in part to Montenegro. But despite all the advan-

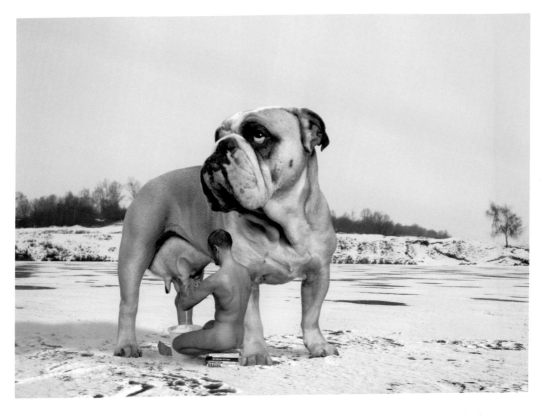

tages associated with the promotion of Albanian artists in Italy or elsewhere, just as with Austria we cannot fail to pose a question that has nothing do with art, that of political aspirations. The historical reminiscences are inescapable.[1] Of course, given the situation in which these artists find themselves in their country, this kind of initiative (including the future Biennale organised by *Flash Art* in Tirana) represents a veritable lifeline, but unfortunately no other alternative is appearing on the horizon. Let us recall once again that without a minimal degree of logistical support—without mediators present to take over locally—this kind of "patronage" can remain useless.

In Western Europe, the museums and galleries that propagate the new values, especially in Paris, are little inclined to promote what is unknown. And this is difficult to understand, given the substantial engagement of French intellectuals during

the wars in former Yugoslavia. Aside from the translation of a few books focused on the war, or the sociopolitical analyses of famous French authors who come from the Balkans, this human and moral tragedy—the direct or indirect source of important reflections on art—provokes no interest. Only *art press* covers this region from different perspectives and on the basis of different sources in a "non-imperialist" manner. It is true that for almost thirty years *art press* has been the first periodical in France to open up to the West and the East of the "rest of the world," and it continues to find that quite normal. It is not typical of the French cultural scene.

Traumatized by its own past, the experience of division, immigration, and the problems of its cultural reunification, Germany demonstrates a genuine interest in the similar experiences of others. It is interesting to note that on the whole the initiatives come from the eastern part of

Marina Abramovic
White Dragon Standing, 1990
Red Dragon Sitting, 1989

which is encouraging. We are witnessing the appearance of new networks based on reciprocity, on the organization of visits for the artists, often stimulated by the ability to utilize the special funds allocated for this purpose by the Council of Europe.

East Side

The example of the former Yugoslavia offers a radical window on the differences that characterize the processes of transition in the former socialist countries. The gulf between a democratic and economically independent Slovenia and Bosnia and Herzegovina seems difficult to bridge. It must be remembered that ten years ago these countries lived in identical conditions and that in relative terms they had achieved an identical level of development. It needs to be stressed that what is at issue in Bosnia and Herzegovina is not simply a transition—the evolution from one system to another—but also the reconstruction of a country devastated by the war, the creation of the basic conditions that would allow for the return of the refugees and displaced persons, who number in the hundreds of thousands. The country was placed under the protectorate of the international community, and it does not live by means of its own economy (which is ruined and shows no signs of reviving) but thanks to donations, which now—six years after the conclusion of the war—are steadily decreasing. The governmental institutions of this Frankensteinian system, which was created by the constitution drawn up at Dayton, simply do not work. The international community is financing the reconstitution of the infrastructure (the restoration of dwellings, electricity, water mains, drainage) so that the refugees are able to return, but without ensuring the conditions necessary for their survival, that is, employment. Moreover, culture and art do not have a place in the donors' reconstruction programs. The material destruction is accompanied by the

Germany and Berlin (Dr. Barbara Barsch, IFA – Institut für Auslandbeziehungen [Institute for foreign relations]). Among the museums that practice a different politics, the example of the ZKM in Karlsruhe should also be mentioned.

In recent years a new North-South axis has begun to emerge. The northern countries too, rich and well-organized, feel they are on the periphery of the dominant European cultural centres. Their desire to communicate with the countries that border them on the south-east has made it possible to establish new avenues of exchange, and the periodical *Nu,* directed by John Peter Nilsson, plays a special role. Recently, certain new little centres in France and other European countries have shown a real will to cooperate with the new structures of the countries of the East,

Braco Dimitrijevic
Memories of Childhood, 1983

constant departure of the young and the intellectuals, above all for destinations overseas, since Europe refuses to receive them. The rate of emigration has not stopped rising since hostilities ended. If one adds to this the fact that during the siege of Sarajevo and the war, a large portion of the active population and intellectuals left the country, then the picture becomes truly catastrophic. (In recent days, the main television channel announced on its daily news show that a piano tuner was finally available in Sarajevo.) Given the absence of any cultural policy, all that remains is a few vestiges of the old system. The museums, galleries, and cultural centres, which used to be extremely dynamic, have disappeared or subsist on minimal financial resources. This year the budget of

the Federal Ministry of Education, the Sciences, Culture, and Sports stands at six million DM or 0.2% of the national budget.

But what is most alarming is that the local authorities and public opinion seem to find this abnormal situation normal. There is not the slightest project for dealing with this crisis situation. In view of the absence of funds, ingenuity remains the only means of survival. For example, the museums and the galleries rent their halls to those who can pay to organize exhibitions there. Thus, the Academy of Fine Arts rents certain spaces to the Sarajevo Centre for Contemporary Art or other parties so that it can cover its heating costs. If one were to be really cynical, one might say that these are the first signs of a market economy. The paradoxical fact, or perhaps it is simply a normal one, is that art—that hardy plant—still flourishes here despite the absence of all of the elements it requires to live.

The old institutions are not in a position to fulfil their function. We are witnessing

the emergence, as substitutes, of non-governmental or non-profit organizations with more flexible structures, which encourage initiatives in the various domains of artistic production. These projects were supported by the Art and Culture program of the Open Society Foundation until 2000, the year in which that program ceased to exist in Bosnia and Herzegovina; by the Swiss foundation Pro Helvetia, which in 1999 inaugurated a program to support the development and promotion of new cultural projects and alternative structures; and by the Austrian foundation KulturKontakt. However, these foundations only fund specific projects and not the administrative costs of the local organizations. Similar new structures are emerging throughout the region, which by and large are supported by these same foundations, including the European Cultural Foundation (Amsterdam), which does not have an office in Bosnia and Herzegovina.

The Soros Centre for Contemporary Art in Sarajevo (SCCA) has played a crucial role since the conclusion of the war (1996). The Soros Centres operated as a network in twenty former socialist countries, with a small but effective professional team and flexible programs (financial aid to professional projects, data collection and processing, communication and liaison with foreign institutions and experts and exhibitions). These centres developed an intensive co-operation, and thanks to collective—or coordinated—activities, they made it possible to present Eastern European art to the West. In 2000 (when Georges Soros withdrew his financial aid) they changed their name and created a new network, the International Contemporary Art Network, which is headquartered in Amsterdam. The reason cited by Georges Soros to justify his withdrawal of financial support is that local agents should shoulder responsibility for their own artistic life after a transitional period of ten years (this argument, however, did not take the specific case of Bosnia into account). It cannot be maintained that the SCCA, which has now become the Sarajevo Centre for Contemporary Art, plays a more important role in Bosnia-Herzegovina than it does in other countries (for the reasons cited here). It is nonetheless the case that it brought about the creation of a new artistic milieu, a collaboration with the artists living in the country or in the diaspora, and numerous exchanges at an international level. Without the concrete contributions of the Centre, the artists of Bosnia-Herzegovina would not have been able to participate in various international exhibitions, from *Manifesta* to the first Valence Biennale in 2001. However, in view of the current situation in the country, the continuation of the SCCA's activities is seriously in doubt, and this despite its aptitude for adapting to conditions of any and every kind.

A large project that is currently under way, once again in Bosnia-Herzegovina, is the formation of an international collection—the seed of the future contemporary art museum ARS AEVI—whose initiator and director is Enver Hadziomerspahic. The first pieces of this collection were gathered during the war, thanks to the solidarity of European museums and centres of contemporary art with the martyred city of Sarajevo. According to this innovative formula, the museums themselves will select the works (since the author of the project is not a specialist in contemporary art) and solicit the artists to donate them to the collection. Numerous professionals have become involved, including the architect Renzo Piano, who has offered to create the design study for the future museum. A more-or-less coherent collection has already been created. It embraces some one hundred works, which offer a good overview of the contemporary art of the last thirty years. Hadziomerspahic's

intention is to turn this museum into a multicultural centre, and he is counting on the geopolitical position of Sarajevo to make this possible. Let us leave aside for the moment the aspiration to international status and look at this project's advantages and disadvantages from the inside. The answer to the question, Do we need an international museum of contemporary art?, is certainly yes. But the analysis of the situation, of the real possibilities and needs, above all the question of the professional and material basis of the entirety of this enterprise, has still not been openly addressed. To this day no true museological study has yet been undertaken. The general consensus around the fact that this museum is a necessity for us prevents us from posing more expert questions concerning the concept itself, the content, or the profile of the professionals who will work on it. We can only partially accept the argument that for the moment we must be content to do what we can. This project has assumed such grand proportions that we can no longer close our eyes to the problem of professional standards. As to the financing for the infrastructure and all that it entails, that is to be the contribution of the international community. Certain governments and European institutions might be interested. The European bureaucrats will understand and reward the idea of promoting multiculturalism beyond their borders, especially in Bosnia and Herzegovina, where it seems to be the magic formula for avoiding new ethnic wars (in Bosnia and Herzegovina, however, the notion of multiculturalism is older than that which the modern liberal, capitalist discourse ascribes to it).

The position of Miran Mohar (IRWIN) is interesting in this regard: "Multiculturalism has become an official ideology that uses art to control the neighbourhood. Multicultural art has become a means for re-establishing peace in zones of conflict. That is an official need, and it is important to ask who it is that is supposed to benefit from it. Artists are neither policemen nor social workers, yet I find interesting similarities here. As soon as art is instrumentalized, it becomes what socialist realism was during the first phases of communism. In a liberal system, multiculturalism may very easily be transformed into a sort of social liberal realism" (as quoted in *Transnacionala*, Ljubljana 1999).

By making it possible to intensify international relations, this museum might eventually acquire strategic importance, but if it does not permit the on-site development of an artistic production that is both local and international, it will only represent an expensive decoration.

The characteristic local (provincial) syndrome that I will call "Sarajevo, centre of the world, confluence of the entire planet" expresses itself in the organization of various pseudo-artistic international manifestations whose effects can be measured by the thousands who participate, as well as in the launching of Sarajevo's candidacy for the Olympic Games of 2010. I mention these "planetary" undertakings in order to emphasise this disturbing symptom of a malady one might diagnose like this: a normal reaction to an abnormal situation, in which there exists neither politics nor system nor the will or opportunity to create the basic elements indispensable to any cultural and artistic life. Despite the fact that the athletic life depends entirely on the enthusiasm of a few individuals and that the SCCA remains the only organization that encourages new artistic production, experience has shown that only "mega" projects succeed in finding sponsors (another sign—let's remain cynical!— that globalization is not passing us by). This "normal" behaviour under abnormal conditions places wholly in question the less spectacular but everyday efforts to ensure a minimum of activity and to allow this country to entertain normal relations with the international artistic community.

Happy End or No End

The contribution of artists from Central and Eastern Europe to "global culture" depends on at least two factors today. The first is the personal engagement of the artist, his ability to ensure his own promotion, his talent. The new technologies of transmission—email, the Internet—have facilitated the establishment of different systems of communication. The second factor has to do with the new local artistic structures. Two characteristic commentaries describe the new situation of artists as a positive consequence of globalization. The first citation is from the critic Viktor Misiano of Moscow, the second from Dusan Mandic (IRWIN):

"My cosy global

1. The positive side of globalization is that you no longer have to leave home in your search for the Centre. You no longer need to go "to Paris" or "to New York" as you did before. Thanks to the new technologies, you can "globalize" at home, in Moscow or in Ljubljana.

2. At the same time, the fact that the "global" or "central" is accessible online—in Moscow or Ljubljana—allows you to avoid being submerged (to express myself archaically) by the local and provincial narrowness of spirit, the dogmatism, the personal rivalries, and the intrigues. Your membership in the Global protects you; the Global allows you to maintain your distance, and your independence.

3. The more you approach the Global, the more you discover that in fact its structure is local. It is composed of closed groups in which you rediscover the very same narrowness of spirit, dogmatism, personal rivalries, and intrigues. And the fact that you belong to the Local—in Moscow or Ljubljana—will protect you, will allow you to maintain your distance and your independence.

4. This balance between Global and Local will be your opportunity to come to terms with yourself, to follow your own path. Still more important, it will be your opportunity to establish a system of confidential transnational connection, which is the reference point and final purpose of your activity. That is to say that in fact you have your own localized Global, or globalized Local." (Viktor Misiano, excerpt from the catalogue of the Pavilion of the Republic of Slovenia, Venice Biennale, 2001)

"The artists of the East are represented in three ways in the artistic world of the west. First of all, you have the dissidents (the artists who fled the East to escape repression). The dissidents have a very specific political and ideological significance in the West. The idea that they are victims in fact reinforces western democracy.

Then there are the artists who, like Marina Abramovic and Braco Dimitrijevic, emigrated for practical reasons. They left countries that were less developed economically and culturally, to join the centre. They work in the West, where they are integrated into Western society, leaving behind them the social and economic conditions of their country.

We (IRWIN) have adopted a third approach. We live in our home countries while at the same time we form part of the Western artistic world. It is not a question of an ideological decision, but a decision of a practical order, one that would not have been possible under socialism. This situation dates from the 1990s, and I wish to make it quite clear that our position differs from that of Russia, of the former Yugoslavia, or of the other Eastern European artists who live abroad. This is important for our debate, because there are presently more and more artists who live in the East but circulate in the world." (Dusan Mandic, IRWIN, *Transnacionala*, Ljubljana 1999).

This third approach, together with Misiano's, best defines the new situation, the beginnings of a fundamental change in the East-West division and the relationship between periphery and centre. But

what does Mandic actually have in mind when he declares that the decision to remain at home was not an ideological but a practical one, one that would not have been possible under socialism? As far as the art of the former Yugoslavia is concerned, it is a known fact that there was never a political obstacle to communication with the West, that such communication was free and particularly well developed. The obstacle to integration was the incompatibility of the political, economic, and artistic systems. One of the principal elements—the market with all its components—did not exist in our country. For Raymonde Moulin (*Le Marché de l'art*, Flammarion 2001), there is a close correlation between artistic value and the market. Thus, we were missing certain essential agents of the system as it functions in the West. However positive an "artistic impression" the artists of the former Yugoslavia may have made, because they were not "priced", as it were, they could not form part of the other artistic system. The only way to integrate oneself into "the international" was to physically travel to the West. When Mandic notes that there are presently more and more artists who live in the East and circulate in the West, that simply means that there are more and more systems in the East that are compatible with those of the West. That also means that Mandic's decision is based on the real situation in Ljubljana itself, on the fact that a logistical infrastructure has been established there that permits him to stay at home. Is that also the case in Sarajevo? Even if we did not take into account the situation described above, today there is a new and very serious concrete problem that did not exist under the old system. For the artist to be able to "circulate", he must go through a veritable nightmare in order to obtain the visas required to enter virtually any country in the world, including Slovenia.

But let us not overestimate the positive tendencies of globalization. Sanja Ivekovic of Zagreb, a famous artist, is still not "priced" after nearly thirty years of artistic creation and participation in international exhibitions. This is a reflection of the milieu in which she lives, which does not yet allow her (or others) to exist here and there at the same time. Her most recent large-scale creation, *Lady Rosa de Luxembourg* (Luxembourg, 31 March–3 June 2001)—a replica of Gëlle Fra's monument to the Luxembourgians killed in the World War I, identical in size and built of the same materials—was erected in the centre of the city. The only difference is that Sanja's Rosa is pregnant. If a prominent artist of the West had constructed a work of this stature, with its different levels of interpretation, it would have been the object of a true international promotion. In this case, it will have been no more than a local affair, which also provoked an uncharacteristic and passionate debate, but only within Luxembourgian public opinion, and this although the questions it raised largely transcended the local level. It was possible to complete this project successfully thanks to the courage and the efforts of Enrico Lunghi, the artistic director of the Centre Casino Luxembourg, Forum d'art contemporain.

The case of Sanja Ivekovic, which is far from unique, demonstrates that the geopolitical environment is still the determiner of destiny.

(Translated by James Gussen from the French translation by Nicole Dizdarevic published in "Ecosystèmes du monde de l'art", *Art Press*, Special no. 22, 2001)

1. Remember, among other things, that Austria and Italy seized control of Albania in 1914, and that having becoming independent again, the country was newly invaded by fascist Italy in 1939. Remember also that Austria invaded Montenegro in 1916, while Italy tried to turn it into a protectorate after the World War II (Ed.).

Ostkunst, State Art, Official Art
and the Status of Abstract Art in the Former Eastern Bloc Countries

Lorand Hegyi

Ostkunst—State Art—Official Art

In recent years, there has been increasing talk about *Ostkunst,* or the art of the so-called "Eastern Bloc" countries, and then the art of the former "Communist bloc" countries. Yet the term *Ostkunst,* which intellectuals in the countries of the former eastern bloc never employed, was never appropriately defined by science and history. On a rather superficial, journalistic level, *Ostkunst* is used in a wide range of definitions: *Ostkunst* includes the nostalgic-provincial new "icon imagery" with their pseudo-religious motifs, the kitschy pseudo-folklore phenomena manifesting a false and painfully embarrassing identification with the so-called "true tradition", but also "state art"—seen in a negative light of course—which is not a clearly defined, sociologically specified term in Western Europe. This confusion about the term *Ostkunst* reflects the inability of Western media to distinguish between the phenomenon of "ART IN EASTERN EUROPE" and the problematic of *Ostkunst* and "state art"

This bewilderment is surely due to the ignorance in matters concerning the history of the said eastern bloc countries, which, historically, do not coincide with the *political* Eastern Europe (witness

Czechoslovakia, which was integrated with the western world in all cultural fields, a country with a democratic, pluralist, and progressive culture in the years between the world wars). In 1945, the cultural-political changes in these countries were not as radical as one would think. If one can speak of radical change at all, then much rather when referring to the end of fascism and the occupation by national-socialist Germany and the ultra-conservative, Christian-nationalist, racist, and authoritarian power philosophy of the regimes of the Central European counter-revolution ruling since 1919/1920.

In 1945, the intellectuals in Hungary, Poland, and Czechoslovakia still held high hopes and also practised a certain genre of (non-Stalinist) "self-criticism". In particular, this implied they pondered on the problematic of the class position of intellectuals. The fall of the fascist, authoritarian regimes kindled a certain sentiment of solidarity with the great masses of the peasant proletariat and the metropolitan working class. No wonder that the social democrats, but also the Communist Party, were never as popular among the intellectuals as in the years after World War II. Even the Communist Party then

began a popular front policy to replace the dogmatic ideology of class dictatorship. The military dictatorship, which had regained power in 1919 through the counterrevolution and was supported by the fascist movements, had oppressed the peasantry from its post-feudalist positions both economically and politically and disqualified the metropolitan working class from their capitalist positions—at least in political terms. The authoritarian regimes with their steady drift to the right, and their growing willingness to compromise with National Socialism and Italian fascism, ultimately carried the imperialist policy of the Third Reich and had become unacceptable for the intellectuals. (The fall of Poland is an exception here, as the ultraconservative Pilsudski regime itself became a victim of the Third Reich). After 1945, the metropolitan intellectuals discovered the peasants and considered them a partner in the build-up of a pluralist democracy. The Social Democrats always enjoyed support among intellectuals, but in the peasant policy, this party has for old ideological reasons always been inflexible and "rigid". For this reason, major groups of writers and scholars, for instance, became active in the left wing of the Democratic Peasant's Party in Hungary. The democratic coalition between anti-fascist parties (in Hungary the Communist Party, Social Democratic Party, Democratic Peasant's Party and the Independent Smallholder's Party) governed the central European countries for some three and a half years.

The radical about-face in political structures and the associated cultural policy occurred in 1947/48, when the Stalinist Communist parties—supported by the military presence of the Red Army and the Soviet military and secret police—undemocratically seized control and introduced the dictatorial one-party systems of the Soviet type. For cultural policy this undemocratic system meant direct dependency of cultural issues on the respective party policy of the cynical absolutised class struggle. The Stalinist Communist parties attempted to legitimise the one-party system and the unbridled party dictatorship with the ideology of the class struggle. Even the intellectuals were considered an enemy of the working class. Paradoxically, the left-wing intellectuals (the so-called "Spanish" communists who fought against Franco as young activists in the Spanish Civil War; the social-democratic intellectuals, who, given their "revisionist" ideology, had allied with the liberal bourgeoisie, but also the left-wing intellectuals of the Democratic Peasant's Party, who advocated the petit-bourgeois philosophy—to use Stalinist diction—the right to ownership and the emancipation of peasants) were discriminated and fell victim to the Stalinist conceptual trials.

One can actually speak of "state art" starting 1948, when the various Communist parties formulated the first clearly defined directives for artists. Strict formal and content-related rules were set out to stipulate the tradition of realism and naturalism, on the one hand, and—particularly in architecture—the formal language of neoclassicism as ideal models, on the other. Art was interpreted to be a means of waging the class struggle; the topical political themes and the ethical, pedagogical moments characterised the imagery of "socialist realism". A communist iconography was conceived as catalogue of patterns, never resolving the theoretical contradictions between the prescribed realism—as the representation of truth—and idealisation—as ethical education. New socialist art was meant to be *realist*, meaning "true", and was also to suggest an optimistic perspective of the future of this new society by means of convincing power and dynamics, meaning with agitational monumentality.

No scientific study has yet ventured to understand how the aesthetics of "socialist realism" discriminated the left-ori-

Page 28
Istvan Nadler
Tension, 1970

Zdenek Sykora
Linie Nr. 220, 2002

ented, agitational, revolutionary avant-garde of the 1920s and 1930s for ideological reasons. Constructivism, which had been denounced as Bolshevist, cosmopolitan art by ultra-conservative, Christian-nationalist cultural politicians and criticised as being synonymous with the communist revolution, was now discredited as decadent, bourgeois *l'art pour l'art* bare of any social relevance in the 1950s by Stalinist cultural policy. Paradoxically, it was the deliberately international, constructivist avant-garde with a firm belief in the revolution this was criticised by Stalinist aesthetics for representing bourgeois, cosmopolitan and thus "rootless" culture.

The official cultural policy of the 1950s was seeking new ideals: the agitational, neo-classicist church art of the

1930s—which was directly imported from Rome, from fascist Italy—is found in the facades of the party buildings, the power stations and steel factories. Only the attributes have changed: in lieu of Christian allegories, there are symbols of the classical worker's movement and allegories of the Communist build-up. The false idealisation, the pseudo-idyll of day-to-day life and optimistic visions of the future create a similar imagery—with similar stylistic means—as Roman Catholic art under the protection of the pre-fascist, authoritarian dictatorship.

Although the new cultural policy created a rather strongly controlled system of institutions governed top-down, where only the loyal artists working by the rules were able to reach out to the public, the avant-garde, but also bourgeois liberal culture, continued to exist in the 1950s. Artists went into a sort of inner exile (*innere Emigration*), and created quasi-institutions in private studios and private apartments entirely independent from official cultural life. Musicians, men of letters, and artists met up regularly and lead a hermetic life geared entirely toward internal communication.

When speaking of the art of the former "Eastern Bloc" countries, one needs to analyse the various concepts in different periods. The period between 1948 and 1956 was the time of the "iron" (as against "velvet") dictatorship. In these years, official art can be clearly distinguished through formal and motivic premises from the alternative art of the existing avant-garde, but also from prevailing conservative realist-naturalist art. After the Hungarian revolution of 1956 and the fall of the Stalinist regimes in Poland and Czechoslovakia, the gradual, inconsistent liberalisation process began in several Eastern Bloc countries. Many marginal phenomena between "official" and "non-official" art emerged in this phase of transition, which lead to the Prague Spring in Czechoslovakia and was brutally terminated by invading Warsaw Pact troops, yet which continued with cautious reform attempts in Hungary and Poland, at least in economy and culture. On the one hand, the historical avant-garde (constructivism, Bauhaus, left-wing Russian futurism, dadaism, surrealism) was aesthetically rehabilitated and finally also collected by state museums and at least mentioned and tolerated in schools and universities, while, on the other hand, the young representatives of the new avant-garde (action painting, pop art, hard-edge, conceptual art) had a better social starting position: by easing travel restrictions in Poland and Hungary, they were allowed to travel to the West to establish contacts and directly get in touch with museums, galleries, collectors, and art magazines. This gave artists not only a chance of improving their financial lot, but also a possibility of realising their aesthetic programme. They were able to rent out studios, create large-format artwork, organize self-financed exhibitions, and publish special-interest papers in small quantities.

While several private galleries and exhibition halls organized by artist initiatives promoted alternative art as early as the 1970s in Poland, the authority in charge of cultural policy in Hungary also permitted exhibitions of avant-garde artists, now and then, in state-owned galleries. The forum for avant-garde artists, however, included university galleries, youth clubs, cinemas, district cultural centres and—paradoxically—cultural associations of large-scale industrial enterprises. One would think that precisely these "strongholds of the working class" would dismiss the avant-garde—tagged as bourgeois and decadent, formalistic, vacuous culture. The situations was rather different in reality: young cultural activists discovered the authenticity, the powerful quest for truth, but also the

Julije Knifer
Diptych JK F HC 91 I, 1991

unconventional process of becoming aware of this new art for themselves, and hence facilitated committed artists to get in direct touch with workers, particularly with younger workers. This cultural-historical phenomenon should be examined more closely in order to explain the cultural-sociological impact of the "enlightening mission" of alternative art in the former eastern bloc countries during the "velvet" dictatorships.

Even the different avant-garde movements have developed varying relationships to "official" art. The "activist" avant-garde theatre attempted to find acknowledgement for their experimental aesthetics also inside the established state-owned theatre, while experimental film and video art sought legitimisation in state-owned (and commercial) film production. This endeavour becomes all the

more apparent in architecture, where the various new movements were in fact only able to develop within state-owned architectural firms.

In all these areas and art genres, we find major examples of highly interesting, experimental, avant-garde productions of art-historical significance which were carried out in spite of all administrative hurdles during the "velvet" dictatorship (i.e. in the 1960s, 1970s and 1980s). The reasons for this phenomenon are rather complex. On the one hand, the heroic, activist, utopian, avant-garde notion of revolutionary art persisted among the intellectual groups of avant-garde culture. The belief in the social and aesthetic effectiveness of the expansionist avant-garde was still strong and fostered by the movements of the Western European "new left". The rediscovery of the avant-

garde of the 1920s (particularly of constructivism, dadaism, surrealism, experimental theatre of the Russian revolution, the architecture of Bauhaus, and the literature and theory of literature of the Russian formalists) gave rise to the illusion that experimental art and the progressive reforms of the liberal Communist regime (in Hungary and Poland) went hand in hand. Although the brutal invasion of Warsaw Pact troops in Czechoslovakia, which was just undergoing liberalization, was a shock for the intellectuals, the illusions regarding the possibilities of an avant-garde unfolding in the country more or less persisted. On the other hand, the reform Communist regime wanted to show its liberal and tolerant side, and allowed many cultural phenomena to continue in a *laisser-passer* spirit.

Economic factors in the Eastern Bloc countries gradually opening up also helped intensify the export of progressive, avant-garde cultural assets, as this cultural export brought both political and purely economical benefits: The Communist bloc countries were able to prove to the West that alternative art was also able to exist with the new stream of tolerance; from an economic standpoint, cultural exports generated more income, since the proceeds from sold cultural assets were channelled into the state banks. But it was also more than desirable for the artists themselves, as it was easier to travel with the Western currency earned and thus were able to intensify their contacts to the West. Socio-politically, it incited the state divest itself of the obligation to care for the freelancing artists and intellectuals, and out of this "independent" social status rose the illusion of true freedom.

Until now, we have spoken of so-called "official" and so-called "unofficial" art as two homogeneous phenomena—this homogeneity is of course only conditionally true in historical terms—interpolated by so-called "transitional phenomena"

and "hybrid forms" appear. These "hybrid forms" were moulded by the individual historical and cultural-political realities in all former Communist bloc countries. The various Communist regimes had to manipulate their own rules of the game and own traditions—for real-political, strategic reasons. In Czechoslovakia, where progressive political tendencies and the dynamically developed avant-garde movement coexisted in harmony in the 1920s and 1930s, we find many props from this heroic, avant-garde period in the official "socialist-realist" art of the 1950s. This pseudo-avant-garde and pseudo-modernist traits in the fine arts and architecture altered the "socialist realism" of Czechoslovakia in spite of the generally applicable strict formal provisos imported from the Soviet Union. In contrast to this, Hungarian "socialist realism" of the 1950s exhibited completely different characteristics, which had been inherited from Hungary's art history, meaning from the period marked by the pre-Fascist cultural policy of the 1930s. While, as we all know, a conservative-democratic, pluralist system could have unfolded in Czechoslovakia, an authoritarian, downright anti-liberal system of government would have ruled in Hungary, which would have endorsed an agitational, Catholic Church art as a propaganda tool in the struggle against bourgeois liberalism—cosmopolitan, Jewish, homeless and bare of tradition (to use the jargon of official ideology), against social democracy and against Bolshevism.

Socialist-realist art of the 1950s took on many formal elements of the Church's propaganda art. In the history of style, it is considered a blend of Novecento neo-classicism, naturalist landscape painting, realism of the late nineteenth century, and Soviet socialist realism. After 1956, these formal traits were revised and radically altered. Official cultural policy ventured a gradual opening and liberal-

Dan Perjovschi
White Chalk-Dark Issues, 2003
Installation Kokerei Zollverein für
zeitgenossische Kunst und Kritik,
Essen

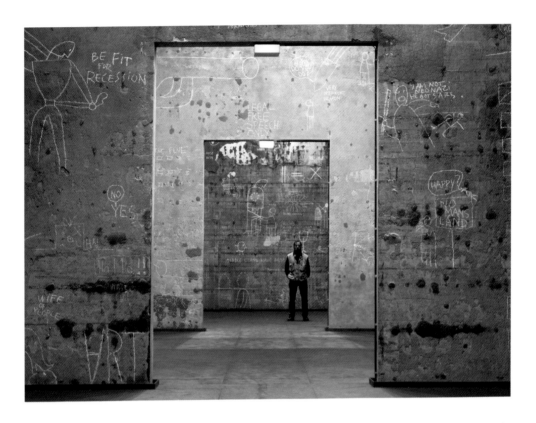

ization. In the context of political efforts of the Kadar government—supported by the anti-Stalinist Khrushchev regime—a certain "popular front policy" was developed, which was expected to ensure a consolidation of the regime. "Popular front policy" meant more understanding for the problems of the peasants and a greater acceptance of the intellectuals' interests. Landscape painting, a newly acknowledged progressive form of art alongside "socialist realism", is a typical phenomenon of the late 1950s in Hungary. This school of painting underscored the problematic of the so-called native tradition as against socialist-realist art imported from the Soviet Union. For many intellectuals among the rural population, this art represented something authentic, something national and agrarian at the same time. The national connotation was considered to be independent of Soviet cultural policy and a rediscovery of one's national identity. For urban intellectuals another option offered itself: the rediscovery of the metropolitan-bourgeois culture with its brilliant poets and writers of naturalism, impressionism, symbolism all the way to the radical avant-garde. Official cultural policy thus attempted to substitute the "class struggle policy" with a "popular front policy" after the unsuccessful revolution which had been brutally

struck down and thus, in a way, set the ever broader scope of "official" culture.

The acceptance of various non-socialist-realist art phenomena markedly increased, and the different cultural-historical traditions gradually began to play a role in official cultural policy, too. Playing upon the notion of "socialist realism", one could say: apart from the desired "socialist realism", official cultural policy from now on also tolerated a "realism" without the qualifier "socialist", but also "socialist" art, which could not longer be attributed to "realism". In the former case, we speak of the frequently idealised, nostalgic landscape painting associated with concealed nationalist sentiments, which in terms of art history traces back to the middle of the nineteenth century, meaning to the landscape painting of the Biedermeier age and bucolic idyll, but also in the realism imported from Germany and France and Hungary. In the latter case, we speak of a social-critical, individualistic, anti-authoritarian, contemplative literature and art concerned with ethical issues rooting in impressionism, symbolism and the radical avant-garde of the turn-of-the century up to the 1930s. In this urban art, various "non-realist" phenomena can be observed, which are rather difficult to associate with the doctrines of "socialist realism" The basic tenor of all these different phenomena was social commitment, defence of the individual's sovereignty, concern with ethical and philosophical issues, but also an unconventional stance on formal experimentation.

When analysing the "official art" of "velvet" dictatorships, one needs to keep in mind the heterogeneity and multiplicity of these phenomena. "Official art" is no crisp concept, but rather a complex system undergoing constant change and formulated according to strategic considerations. The more the Communist regimes sought consolidation and the greater their bid for a class compromise in social matters, the more flexible and broader the remit of official cultural policy became, the more cultural phenomena and motivic moments (religion, historical awareness, minority issues), which had been unacceptable before, were tolerated.

In Hungary and Poland, this development gave rise to a situation in the mid-70s, where official cultural policy gradually lost its ideological-political nature and forsook its formal, aesthetic expectations. The self-organising, alternative culture was not only tolerated, but also fostered by means of various grants and promotion projects. The state museums and exhibition halls actually showcased and collected anything that was not directly opposed to the political system. In other words: the official cultural policy of the last one-and-a-half decades of the "velvet" dictatorships actually no longer served as cultural policy per se. Culture was in fact freely organised—solely in cases of directly expressed political views or political activities, decisions remained firmly in the hands of the party apparatus. As the politics of the Communist parties targeted a general social reconciliation, all artistic developments suggesting this conciliation were directly or indirectly fostered. Thus, paradoxically, the Communist parties of Hungary and Poland supported a new ecclesiastic art and a nostalgic, conservative, popular, rural art and architecture which had no relation to Communist ideology. The kitschy and nostalgic pseudo-folklore was sold everywhere, the artists of pseudo-folklore landed large contracts, and wherever frescoes and monuments of the proletariat had stood before—in the houses of the political parties, factory halls, hospitals, and administrative buildings of the ministries—stylised trees of life in the badly replicated style of Hungarian folklore embellished the scene. The general economic and social developments facilitated

the independent existence of the so-called "avant-garde" and "alternative culture" also financially. The state acquisitions, which no longer went by aesthetic and political rules, and the increasingly active selling activities in the West, secured a relatively stable standard of living for artists, musicians and writers. When the governments stopped tendering large-scale contracts (monuments, interior decoration of public buildings and party offices) for economic (but also political) reasons, no terrain was left for so-called "official" art. In lieu of firmly organised "official" art, a heterogeneous art production of pseudo-folkloristic kitsch, from nostalgic, conservative realism and naturalism all the way to pseudo-modernistic forms of art, thrived, simply adapting the formal elements of the long-tolerated old avant-garde without any motivic-conceptual implications.

The great fallacy of the Western media, shared also by the experts, lies in the fact that they believe in the differentiation between an "official" art, and an "alternative" art completely distinguishable from the former on account of clearly definable formal, content-related and aesthetic moments. In reality, the situation was such that all art and cultural phenomena were treated as "art" in an official system, thus also indirectly promoting many pseudo-art phenomena of nostalgic, conservative, popular art, pseudo-folklore and also empty, vacuous realisms and naturalism without any content, while the experimental, progressive art movements were merely tolerated and existed on the fringe of the system. Their legitimacy was not challenged, their productions were also acquired for state cultural institutions, but they were always combined with other, pseudo-artistic phenomena.

In the late 1980s, all artistic and pseudo-artistic phenomena in the then "Eastern Bloc" countries had, in fact, more or less found their place in the system. After the downfall of the Communist regimes, which transpired in different ways in the various countries, a vacuum was left: the system of state institutions no longer functioned, while a new, private-economy system was not able to work yet. The regimes following suit after the Communists and reform Communists, ventured to manifest their identity using art in the public once again. While the "velvet" dictatorships had abandoned the Stalinist doctrines of state art as a means of representation of the political rulers step by step during the last one and a half decades, the new rulers, paradoxically, used art to represent the new order. Only the pre-existing models already in place were used for this reinterpretation of art, for this ideological shift in the approach to art. Thus pseudo-art of the last fifteen or so years was also quickly harnessed by the new system, while progressive art continued to remain on the fringe of the system.

For further discussion of the art-historical and cultural-sociological situation, it is vital at this point to establish a concrete-historical definition of the terms "state art" and "official art" in the various former Eastern Bloc countries and various political periods, which were determined by different domestic-political, economic, and geopolitical-strategic moments. The term "state art" describes state representational art characterised by strictly formulated formal and content-related rules, and was used as a weapon in the historical class struggle by Stalinist ideology. The notion of "official art", however, describes an official, cultural-political system comprising the various art phenomena, of which many did not meet the strict criteria of "state art", neither formally nor in terms of content, but precisely as such "foreign", non-socialist-realist forms of art they fulfilled a cultural-political and social function, i.e. the representation of tolerance and understanding for the broad spectrum of non-Communist cultural production, including nostalgic, conservative, nation-

Tamas Hencze
Space Resonance I, 1975

alistic contents. This apparent diversity of cultural life was at once both false and true. False, since pluralism was only permitted for the sake of purely political considerations and aims and was made dependent on the respective bandwidth of prevailing political-strategic ideas of the Communist parties. True, since, in spite of all Machiavellian, cynical and strategic considerations, the real colourfulness and authentic pluralism of cultural production, meaning the historically actually existing values of different aesthetic standpoints, were reflected and appeared in social public.

The clear differentiation between the concepts "state art" and *Ostkunst* or "art of Eastern Europe" is just as important. Eastern European art is just as colourful and pluralist as so-called "Western" art and, in the art-historical context, inseparable from the latter. If *Ostkunst* is taken as "state art", the wide field of central and eastern European avant-garde is neglected, but also the even larger area of non-socialist-realist art, from the popular tendencies and realist-naturalist phenomena to metropolitan-bourgeois, contemplative and social-critical phenomena. Non-socialist-realist art and literature gained ground after the dismantling of Stalinist structures in 1956/60, constituting a growing part of overall cultural production, and was therefore able to influence the social public beyond the strict categories of "socialist-realist state art".

In other words, one could say that art from central and eastern Europe exhibits a pluralist overall picture, in which so-called "state art" (of Stalinist socialist-realism) only represented one phenomenon among many—which, historically, was becoming increasingly significant.

It is thus vital to be clear about the precise definitions of the concepts "state art", "official art" and the notion of *Ostkunst*, which, historically, has never been defined and is rather questionable as

such. I myself would say neither *Ostkunst* nor *Westkunst*: the art of the countries constituting the political eastern Europe is rightly part and parcel of the West's cultural community, just as much as the art of the countries historically ranked among the Western regions. The phenomenon of "state art" is also not typical of Eastern Europe, just as little as the "official art system". Everything that developed as "state art" in Eastern Europe during Stalinism can also be found in Western Europe: Novecento art in fascist Italy, in the national socialist cultural policy of Hitler's Germany, and in all other centralised, etatist cultural phenomena root—no matter whether we would prefer to conceal this or must accept it - in the culture and philosophy of the occident, from Kant's utopian state ideals to Spengler's irrational cultural philosophy. It is the West's naive self-deception to consider "state art" in political Eastern Europe a specific phenomenon of Eastern Europe that would never have been possible in the Western Europe. By placing the notion of "state art" in its historical context of radical, centralised, and authoritarian political models, it becomes clear that Stalinist "state art" is in principle nothing more than a power-representing type of art stemming from the Italian fascist model, determined by ideological and real political objectives and representative of the Fascist drive to merge all the various social strata. This model emerged from the collapse of bourgeois liberalism and the pluralist social order after World War I. Fascism and national socialism were political answers to this crisis, the solutions they propose (centralisation, cooperative pseudo-reconciliation between the classes, national or racial pseudo-unity, the leadership principle, the dogma of the dominant nation, the ideology of the eternal struggle in terms of social Darwinism) hails from the political visions and irrational cultural philosophies of the West.

Tamas Hencze
Space Resonance II, 1975

Not only the models actually implemented, but also the basic ideological motifs, exhibit a strong resemblance to Stalinism and its "official culture". This is why the historically fallacious differentiation of centralism—etatism and authoritarian state principle in Western Europe, on the one hand, and in Eastern Europe, on the other hand—cannot be maintained. The complex, circuitous art production of eastern Europe must not be reduced to the concept of "state art" on account of a fallacious historical starting point. It cannot be said often enough: there should be no confusion between "state art" and "official art", the latter being something organised as a practical cultural system for real-political reasons.

The Status of Abstract Art

Within official art or the official system of culture, the most varied forms of abstraction, characterised by different art theories in the former Eastern Bloc countries, developed in the very different ways. The various political periods as well as the widely differing party-political aims and their impact on culture, need to be clearly defined. Following World War II, approximately up until 1947/48, Communist parties in Central and Eastern Europe attempted to build a broad base among the masses, and this in the spirit of a supposed (but actually manipulated) popular front. They were in a position to reckon with the sympathy of intellectuals, particularly in Hungary, which had no organised and internationally acknowledged exile group or exile government, and no strong resistance against the German Nazis and their national alliances. The intellectuals embraced the anti-fascist parties, supported their reconstruction policy, and set great hopes in the democratisation process directed against post-feudalist and reactionary structures. Czechoslovakia and Poland, where the resistance movements were determined by different ideologies

and visions of the future, also had major intellectual groups that did not support the communist political ideas. In general, one could still say that the political periods between 1945 and 1948 presented a popular-front policy marked by a tolerant and open policy toward all artistic trends. The Communist parties believed it was more important to win over the intellectuals than to create some genre of "state art". The Communist parties governed in coalition with the social democrats, with conservative democratic liberal parties, in Hungary also with the Democratic Peasants' Party; one can therefore not speak of a strictly defined "state art" determined by an ideology in this period.

The most varied groups of modern movements, among them also abstract art, attempted to organise a venue for a public appearance themselves. The isolated galleries actually functioning in the postwar period were not open to abstract art, although there was no "official line" in cultural policy at all, no centralised art public controlled by administrative means. Typical exhibition forms of this period were large-scale exhibitions organised by a town or artists' union, jointly presenting all directions and artists whose activities had not been "compromised" during the Nazi period. Mayors often organised exhibitions where artists presented their artwork as a gift for the town's reconstruction process, or demonstrated their solidarity and willingness to help out. Exhibition forms of particular interest were those staged by the Communists or the Social Democratic Party, which clearly showed that the Communists gave no preference to any "direction" and cultivated no programmatic style in this period. In many cases, the same artists were exhibited by both parties, although they adhered to neither.

Between 1946 and 1948, there was a group of artists in Budapest by the name of "Group of Abstract Artists" which regu-

Karel Malich
The Landscape Freed from Its Chaines II, 1973-1974

larly staged group and individual exhibitions in the city gallery *The Four Points of the Compass* for their members. Major art critics, as Ernst Kallai—who had returned to Hungary from Germany to flee the national socialists—Katalin Kemeny and Bela Hamvas, lectured and organised debates with the artists. The members of the group also included established artists, as Ferenc Martyn who, strongly influenced by French abstract painting, had been working in Paris as a member of the group "Abstraction Création", or younger painters who had developed their abstract painting from the Ernst Kallais' art theory of "organised abstraction", such as Tamas Lossonczy, Gyula Marosan or Tihamer Gyarmathy. Characteristic of this new beginning was that this gathering of artists representing the most significant group of abstract art in Hungary, stood very close to the Communist Party. Ferenc Martyn and the theoreticians Kallai, Hamvas, and Kemeny were considerably more sceptical. But the younger artists became members of the Communist Party

and remained staunch Communists until the mid-1950s. The diary of Tamas Lossonczy clearly traces the growing tension between political conviction and aesthetic programme. While the artist was very optimistic about the political and artistic developments in the mid-1940s and believed in the development of a democratic, classless, collectivist society where abstract art would become the collective cultural heritage of an entire population, he began to look into the problematic of agitational state art and socialist-realist art serving as the "weapon in the class struggle" after 1948. For a long time, Lossonczy was unable to resolve this incongruity. He still considered the political and social aims of Communism to be the only possibility—in spite of all the implications—of building a democratic society in Hungary, yet he was unable to identify with the dogmatic, conservative and authoritarian cultural policy and its concept of realism, which he denounced as pseudo-realism, as aesthetic lie, as superficiality. This ethical and aesthetic crisis prevented him from further developing his abstract painting. In the early 1950s he ceased painting and did not resume until after 1956.

One cannot speak of an art policy strictly determined by the day-to-day political aims and Stalinist ideology with a focus on the concept of realism and governed by canonised formal rules until after the political changes in 1948. In parallel to the take-over of power by the Stalinist line—which played more or less by the same scenario—the party leadership in all Communist states took the Soviet model as a yardstick for art and for official cultural life. Zdanov's theory of socialist realism placed the notion of "mimesis"—that is the representation of social and historical reality—at the centre of artistic activity. The artists were to depict the true class conditions, the true social processes, the true historical developments, in a manner comprehensible to all members of society. Realism, on the one hand, intended the representation, the true imitation of reality, while, on the other hand, the general comprehensibility of art. In Zdanov's theory of socialist realism, however, there was also a different side to truth, namely, true representation. True depiction of historical and social reality was not to be superficially naturalist; socialist realism was to reveal and depict the covert relationships and the deeper true conditions of appearance and truth using the methods of dialectic and historical materialism. In this way, socialist realism—in the diction of its apologists—was not only the "passive" depiction of truth, but the only "scientific" revelation and unveiling of historical truth.

This "scientific" unveiling of the true correlations between the appearance and essence of things also involved an "active" moment of revealing the true, historical structures. The differentiation between "truth" and "appearance" also reflected an ethical, or better said, moralising stance, which, in "actually existing" socialist realism gave birth to idealisation. In the practice of art, Truthful realism and idealisation built on ethical conviction went hand in hand. Idealisation was embodied in the central aesthetic moment of socialist realism, that is, "typing". According to Zdanov's theory, typing allowed the artist to make absolutely typical moments out of true moments. Typing reformulated the "static" true facts as "exemplary" truths. In his *Aesthetics of Socialist Realism*, Georg Lukacs wrote that the type lies between the particular and the general, meaning it has individual traits, on the one hand, to become realistic, credible, concrete, tangible, while on the other hand it also features general traits that evolved through history, but were never visible in everyday reality on account of their abstractness and clarity. This is why the artist recognises the abstract, historical truth, which

he attempts to make concrete in a human way, in everyday life. The artist reveals the general historical truth in the seemingly coincidental occurrences and seemingly particular phenomena making them—by means of "typing"—graspable, concrete, and tangible, he gives abstract truth a real, concrete and credible form. "Typing", according to Lukacs, builds a bridge between the abstract and the particular.

In this system of aesthetics there was no room left for abstract art. Art without a function of representation could not be interpreted using the categories and concepts of realist art. In this way, abstract art was generally rejected as barren, empty decoration, as a play with forms, as formalism with nothing to convey. Geometric abstraction was considered the expression of the unconcretised "general"—according to the " theory of typing"—while lyrical-organic-expressive abstraction was interpreted to be the expression of the particular and the merely subjective. "Sterile" abstraction appeared to be alien to life, as it did not reflect true life, but only the "private sphere" of the alienated intellectual.

This criticism served as the ideological grounds for the official rejection and elimination of abstract art, which was no longer presented in the state exhibition halls, museums, or galleries after the political changes of 1948. Abstraction did not want to, or was not able to, serve the heroic mandate of socialist cultural work of the new communist society. According to Stalinist ideology and aesthetics, it was a phenomenon of decadent bourgeoisie culture, and as such not only unsuitable for the new collective-optimistic culture, but also blatantly antagonistic, directly harmful and thus to be combated in the social public on all levels and in all forums.

This fight took on different forms and was of varying intensities in each of the socialist countries. Poland was always the most liberal country in terms of cultural policy. Between 1948 and 1956, the Communist Party pursued a relatively brutal line which, as one would expect, also harshly criticised abstract art and banned its presentation in state art institutions. In spite of this discrimination, abstract art was from time also bought (but not exhibited) by state collections. In particular, the Sztuki Muzeum in Lodz, which had been operating independently since 1932, regularly bought significant artwork of abstract artists and considerably developed its collection of abstract art.

In Hungary there was also a bitter cultural struggle against all forms of alienated bourgeoisie culture: among those damned were abstraction, "subjectivism", and "pessimism", which were accused of conveying only scepticism and doubt instead of assertive optimism. Abstraction was eliminated from all state museums and exhibition halls, with art critics denouncing it as empty formalism and reactionary irrationalism. In a polemical article in the year 1948, speaking from the perspective of socialist realism, Georg Lukacs—who was severely criticised later on by ultra-dogmatic literature theoreticians (such as Jozsef Revai) for his liberalism and "softness"—condemned all forms and styles of the avant-garde as manifestations of late-capitalist irrationalism. Lukacs repeated his arguments in an article that he had laid out once before in the famous "expressionism debate". The ensuing dispute between Lukacs and Bertolt Brecht was the most important debate between realism and the avant-garde within the left-wing movement.

Georg Lukacs had already formulated his anti-avant-garde notion in the "first Brecht-Lukacs dispute", in the Marxist magazine *Linkskurve* in 1932, in which he criticised the notion of art proposed by Brecht, who argued against realism. According to Brecht's theory, there are two methods in literature he denounces: the first method he criticises is realism

based on the principle of "empathy", the other expressionism and avant-garde based respectively on the principle of "alienation" and "activation".

Bertolt Brecht had taken these two categories from Wilhelm Worringer. In his famous book *Abstraction and Empathy*, Worringer had explained the development of art in the West with two "types of behaviour", namely "empathy" (classical art, realism) and "abstraction" (gothic, ornamental forms of art, all forms of abstraction, all forms of the inorganic, of the crystal-like). Brecht reinterpreted these categories such that "empathy" was the "type of behaviour" that accepts social conditions and political structures, while considering "abstraction" to be the base of "activation" and "alienation". Worringer's categories "empathy" and "abstraction" were interpreted as antagonisms in the struggle between realism ("empathy") and avant-garde ("abstraction", i.e., "activation" and "alienation"). Realism, according to Brecht, tends to depict reality, without fighting and changing this reality, that is, the capitalist society of private ownership and exploitation. By contrast, the avant-garde aims to change reality radically; it no longer wishes merely to depict reality, but to alienate the beholder, the viewer, from reality and point out the intangible, invisible, abstract laws of everyday life. The avant-garde would not allow the beholder to empathise with existing reality. Rather, it essays to activate the beholder and explain the true relationships of things. Brecht fought against realist-naturalist theatre and against all forms of realism. He wanted to alienate his public and, in this way, unveil and analyse the true social and political structures. This "activist" approach of the artist contradicted the realism concept of Georg Lukacs (or of Michael Lifschitz), since it preferred the "activation" and "alienation principle" to the principle of representation.

In Hungary in the 1950s Georg Lukacs reiterated his earlier criticism of Bertolt Brecht against abstract art. According to Lukacs' theory of realism, abstract art has no possibility of depicting reality as a whole, it merely attempts to allow a vision, a subjective idea of truth, without being able to draw the true overall picture. Abstract art can only "alienate" the beholder, without drawing a picture of the whole, the true historical and social structures determining historical development. Abstraction, according to him, is merely an expression of "subjectivist-voluntarist-irrationalist" "alienation" and "activation". Instead of overall reality, with its historically contingent contradictions, abstract art ventures to present a subjective idea, a voluntarist vision of barren, "pure", "irrationalist-timeless" form to replace reality.

The general perception of abstract art in the 1950s prevented state museums from pursuing any regular collection activities. The main representatives of abstract art were not able to exhibit at all between 1948 and 1956 and could not sell their artwork in state-controlled art market. They were not accepted as artists, their membership in the centrally-controlled artists' associations organised around 1950 was rejected. Many of them did not work as artists in this period, yet total abandonment of artistic activities was rare. Abstract art was not allowed to appear in social public between 1950 and 1956, but it continued to develop in the studios and artists' workshops.

A typical phenomenon of cultural life in the former Eastern Bloc countries was the so-called "inner exile" (*innere Emigration*) of different-minded intellectuals, artists and regime opponents. Furthermore, in Poland, Czechoslovakia, and Hungary private societies existed in this period, serving as discussion forums, possibly even as exhibition venues or for literary evenings. The studio exhibitions were very common in these years; artists

of the avant-garde who were not able to exhibit their work in official exhibition halls showed their work in these events. Cooperation among intellectuals was much more intensive in this period than later on: everyone felt alone and oppressed, and attempts were made to develop a "counter-strategy". The scope of these activities was very narrow, of course; the fear of an administrative crackdown or political retaliation restricted these events to small circles without any direct or explicit political coinage.

In 1956, the state's cultural policy underwent crucial changes. The insurrection in Poland and Hungary had decided the fate of Stalinist dictatorship in central and eastern European countries in spite of the victory of post-Stalinist forces and the brutal retaliation (particularly in Hungary). The newly installed regimes attempted to democratise communism, to enlarge their base in the masses and to distinguish the original ideas of Marxism-Leninism from the Stalinist "mistakes" and "transgressions of power". The Kadar government in Hungary criticised the "voluntarist-Stalinist" leadership of Matyas Rakosi just as the politics of the insurgent Imre Nagy government which ventured to introduce a multi-party system and democratic socialism. In Poland and Hungary one speaks of the struggle against Stalinist dogmatism and Western imperialism. The old ideas of the popular front policy were rediscovered: in lieu of the "proletarian class dictatorship", the new regime sermonised the vision of a socialist democracy, which was to be founded on the alliance between the worker class and the "cooperative peasantry". The democratically-minded, meaning the "loyal-minded", intellectuals were also to play their role in this alliance, making general cultural policy in Czechoslovakia, Poland and in Hungary relatively liberal and intellectual-friendly in the 1960s. As early as 1957, the grand spring exhibition was organised in Budapest, in all halls of the Budapest Art Gallery, where, after an interruption of eight years, the works of the abstract artists were shown again. The young public of the time was completely unfamiliar with these artists, since no abstract paintings had been shown in the state's exhibition halls since 1948. This large spring exhibition was a revelation for many intellectuals. An understanding of abstract art markedly increased.

There were numerous transitional phenomena that emerged between the clear, uncompromising forms of abstraction and realism which—in an art scene not free for a long time still and in a yet inhibited cultural infrastructure—was often used to replace radical abstraction. Official cultural policy was not only very opportunist when manipulating this type of "pseudo abstraction", but the public also found easy access to this superficial, decorative "pseudo abstraction" without a consistent programme and theoretical considerations, which spread quickly particularly in the field of applied arts. Official cultural policy continued to represent the aesthetics of socialist realism, but in a "modernised" and "liberalised" form. The limits of realism were drawn much broader now. Many phenomena of the early avant-garde, such as expressionism, futurism, cubism, the social-critical Neue Sachlichkeit and the various forms of agitational resistance art of the 1930s were accepted. Instead of the strictly defined formal criteria of realism, official cultural policy attempted to centre on politically committed content, "rehabilitating" numerous artists, actually even accepting and appropriating them as "pioneers" of socialist art. The formalism of the avant-garde, the "alienation" and "aesthetic arbitrariness" of abstraction continued to be seen in a negative light, yet "formalist errors" met with growing acceptance and tolerance. The aim was to draw the limits of realism as broadly as possible in order to embrace more artists

in the range of socialist art. Especially in Hungary and Poland, there was more and more talks of "humanist" art, while the category of "socialist realism" was gradually replaced by the category of "socialist humanism".

In spite of the liberalization in official cultural policy, the difference between the regard for "classical" abstraction and intolerance toward new forms of abstract art ("Hard Edge", monochromism, minimal art, and so forth) remained manifest also in the 1960s and 1970s. The approach to abstract art in the 1920s and 1930s related more strongly to the various historical moments, which modified and relativised the aesthetic-ideological approach. Classical abstraction was already part of art history in the 1960s and 1970s; constructivism, abstract "pictorial architecture", Bauhaus, and it successor were no longer of actual cultural-political significance.

A typical phenomenon of official cultural policy in the former Eastern Bloc countries of the 1960s and 1970s was "playing off" two different perspectives and motivations of abstract art and "neutralising" it so to say. On the one hand, "classical", historical pioneers (as Malevich, El Lissitzky, Kandinsky, or Lajos Kassak, Frantisek Kupka, Wladyslaw Strzeminski, Katarzyna Kobro) were played off against the "new abstraction" of the younger generation of the 1960s and 1970s. Here, official cultural policy—forgetting its leading critics—charged the new forms of abstraction of being "bare of content" and merely "formalist", while old, "classical" abstraction was considered an ideational, philosophical art. The left-wing political activities of numerous abstract artists during the 1920s and 1930s also served as an argument against the "young abstract artists", who were spurned on grounds of their "nihilism", the "alienation" and the "lack of a world view".

The other strategy of "neutralising" abstract art consisted in using amorphous, non-representational forms of art as decoration, as "art on the building". Many artists lived off this opportunity: it warranted a secure financial income, a status among official artists, and even a form of publicity. By taking abstract art as applied art, the representatives of the official cultural policy were also in a position to present themselves as "liberal", "tolerant", "modern", "open", and "open-minded" party politicians who accepted anything that served the establishment of a democratic socialism and its free, open, humanist culture, and supported it with contracts. Abstract art appeared in various forms in the "art on the building" programme: the new hotels, the new office buildings of an economy gradually opening up, the community buildings, recreational homes, hospitals, and airports—often funded by western monies—were decorated with abstract concrete reliefs, non-representational graffiti and purely ornamental patterns on mosaic walls starting in the mid-1960s, particularly in Poland, but also in Hungary and Czechoslovakia.

The phenomenon of applied abstraction makes apparent how the Communist regimes wished to demonstrate their candour, modernity, tolerance and their cultural liberalism. As of the mid-1960s, a careful reform movement began within the Communist Party in Poland, Czechoslovakia and Hungary. The efforts toward a "controlled market economy" on the basis of state ownership and agriculture organised in collaboration with the agricultural cooperatives went hand in hand with a cautious liberalisation of culture. In the publishing industry and in book-selling, a surprising openness to embrace western literature was to be observed, in the cinemas of Warsaw, Prague, and Budapest, films of Godard, Antonioni, Fellini, or Bertolucci were shown; in architectural functionalism and rationalisms—which had been totally discredited in the early 1950s—were completely rehabilitated

and the first high-rise buildings with aluminium facades and rigid geometrical structures were built as early as the 1960s. Communist society attempted to implement several reforms, which harboured only a very small "political risk" especially in the field of art and culture and had no direct impact on existing structures.

The radical groups of abstract artists in Poland, Hungary and Czechoslovakia rejected this kind of assimilation. Nevertheless, many believed in a real opening, which was also meant to give abstract art a possibility of assuming its role in culture as a whole. The museums began to collect their artwork, abstract paintings were shown more often in national exhibitions, art critics published in art magazines more often—although only rarely with positive critiques—about the non-representational painting and sculpture, and the first reproductions of cubist and constructivist works appeared in school books. Also the first sizeable monographs on key artists of "classical" abstraction of the 1920s and 1930s appeared in the mid-1960s.

This general upbeat mood, which created a new situation particularly in art and culture, was also supported by the most diverse forms of the gradually emerging, very narrow art market. Especially in Poland, in the 1960s artists had opened small sales galleries in Warsaw and Krakow. Gradually a group of collectors emerged that regularly acquired abstract art. In Budapest, a gallery for self-financed exhibitions opened its doors in the city centre: in the "Fenyes Adolf Terem", "modernists" (among them also abstract artists)—who had no prospects of receiving support from the artists' association and the art fund, and who at the time were not able to stage any major individual exhibitions at the Art Gallery or in other state-owned galleries and museums— were suddenly able to present self-financed individual exhibitions. These events were well frequented, and the "official" art critics also became involved. Many young artists came into contact with the social public for the first time in these exhibition halls.

The era of hope and of cultural and economic opening in Poland, Hungary and Czechoslovakia culminated in the political renewal movement of the "Prague Spring", which intended to radically change the "really existing" socialist society and culture as a whole. The new leadership of the Communist Party under Alexander Dubcek discarded all taboos and restrictions checking the autonomous development of art, literature, theatre, and film. The avant-garde once again nourished the "real hope" of playing a central role in the historically given political and social situation characterised and overshadowed by the structures of the Stalinist Soviet Union after World War II in spite of the rejection and discredit suffered in the past. Progressive Czech artists and writers actively helped organise the general reform processes.

In Budapest, the young progressive artists organised their first large-scale exhibition as a group in the festive hall of a Budapest architectural studio (IPARTERV) in 1968. The political reform efforts, culminating in the formation of the new government under the leadership of Jenö Fock, went hand in hand with artistic development. The large avant-garde exhibition had a great impact on the development of Hungarian art over the next ten years: all the key positions were represented here, from social-critical neo-realism and pop art to the Hungarian Fluxus movement and, of course, representatives of reductive, abstract art (Istvan Nadler, Tamas Hencze, Imre Bak, Sandor Molnar, Krisztian Frey). The IPARTERV exhibition in Budapest in 1968 was of similar art-historical importance to the large spring exhibition in the Budapest Art Gallery in 1957.

After the invasion by troops of the Warsaw Pact in Czechoslovakia on 20 August 1968, the progressive intellectuals once again had to abandon their hopes of reform. Brezhnev's post-Stalinist policy—demonstrating its strength and military power one last time—attempted once again to make the critical, revolting, "different-minded" intellectuals responsible for the "tragic events". After August 1968, but even more so after the middle of 1969, a restoration policy in all area of society of "truly exiting" socialism began. The economic and political reform ideas of Ota Sik or Jenö Fock were denounced as "revisionism", as "anti-socialist reformism". Economic liberalisation was halted, just as the process of cultural opening. In Hungary, there was a second wave of intellectual emigration: philosophers and sociologists, economists, and artists, theatre people as well as writers left the country between 1970 and 1976 to different parts of the world. Of the artists exhibiting at the legendary IPARTERV show of 1968, Laszlo Lakner, Laszlo Mehes, Endre Tot, Krisztian Frey, Tamas Szentjobi, Gyula Konkoly left for the West. Only once had Hungarian cultural life experienced such a tragic loss of creative personalities, and that was in the winter of winter of 1956/57.

The retraction of economic reforms, the restoration of the centralised bureaucratic-administrative system of economy, the curtailment of cultural freedom and autonomy triggered a general depression and lethargy among intellectuals. One could describe the first half of the 1970s as an era of stagnation and political disillusionment. Poland and Hungary remained liberal, at least with regard to culture, all the same: travelling was restricted no more than prior to 1968, contacts to the West—at least in the cultural sphere—were kept more or less alive. Czechoslovakia, however, was completely bereft of its sovereignty, its dynamism and cultural diversity for two decades.

In the 1970s, new forms of institutionalising alternative art emerged outside of the "official framework". Groups of artists, workshops, alternative—and only short-lived—studio galleries were reactivated. In Hungary, the major groups of the 1970s included the "Pécser Workshop", active between 1970 and 1980 (the only avant-garde group of significance outside Budapest), the Studio gallery in Balatongboglar (between 1872 and 1975, organised by Konzept and mail-art artist Georg Galantai) and the "Budapest Workshop" (Imre Bak, Janos Fajo, Tamas Hencze, Ilona Keserü, Andras Mengyan, Istvan Nadler), which was founded in 1975 and lasted until 1980. These self-financed artist galleries and workshops did not only provide a forum for joint work, they also served as a venue for exhibitions and discussions, and as publishers of numerous publications, catalogues and documentaries. The "half-official" exhibition halls and artist clubs also merit mention, as the university club for instance (Bercseny-Klub in Budapest, JATE-Klub in Szeged), district cultural centres in the larger towns, and evening schools where committed employees staged key exhibitions and discussions for progressive artists, writers and theatre people (for instance the Budapest Kossuth Club of the Scientific Organisation TIT).

All in all, the situation in Hungary and Poland was much brighter in the second half of the 1970s; the prospects of exhibiting progressive art were much better than before. The activities of the museums and state-owned exhibition halls were much more open in the second half of the decade, the programme repertoire was much more varied, art criticism, book-selling, and the daily press were much more into progressive art without prejudice, particularly geometric abstraction—considered the successor to constructivism. At the end of the 1970s, that is, at the end of the described period,

abstract art in Hungary and Poland already held a scientifically accepted, historically and differentiated, cultural-politically "legitimate" position which opened the gates of museums and collections of the state-owned institutions. The state acquisition campaigns in the two countries also involved abstract art; numerous artists of abstraction were now able to live exclusively from their artwork. In 1979, the first monographs on the proponents of "new abstraction" were published (Istvan Nadler, Imre Bak, Tamas Hencze, Janos Fajo). In Poland, the major museums, particularly the Sztuki Museum in Lodz, served as hubs of art-historical research and as publishers of art-historical studies on abstract art.

In the second half of the 1970s, there were no longer any debates on the legitimacy of abstraction. Serious scientific work to come to terms with abstract art commenced, and the various state-owned museums became increasingly active in organising exhibitions on abstract art, particularly abroad in the West (Netherlands, Federal Republic of Germany, France). Even the representatives of the various movements of radical abstraction no longer considered themselves aggressive, "missionary" representatives of objectlessness, but attempted much rather to underscore the differences and peculiarities of individual positions. The heroic, aggressive, "educating" avant-garde of uncompromising abstraction as an aesthetic approach was no longer valid: the young generation of artists of the 1980s positioned itself no longer in relation to the earlier avant-garde and no longer had to reckon with attacks from "official" cultural policy. The crisis of the economic system in Poland and Hungary, but also the growing reform efforts within the party, and the ever more active oppositional activities outside of the Communist power structures have put the issue of culture into a proper perspective. The system's struggle for survival began in the 1970s already, simply sidelining and rendering insignificant "official" cultural policy.

Since the early 1980s, one can no longer speak of a political, philosophical, and aesthetically uniform, coherent cultural political direction determined by a clearly defined ideology. The era of ideology had come to a definite end. There were no longer any ideologies, no party philosophers: economy-oriented pragmatists attempted to prevent the fall of the Communist system, and in this bitter, historical struggle, culture has entirely forfeited its "political" significance. In the vacuum that thus resulted, a completely new, own position emerged—as opposed to the avant-garde tradition and the ruined, faceless, ever more anxious official former ideology hiding behind old, conservative, frequently nationalist-popular forms—a strong and sovereign culture and a new awareness of art among the young generation of the 1980s.

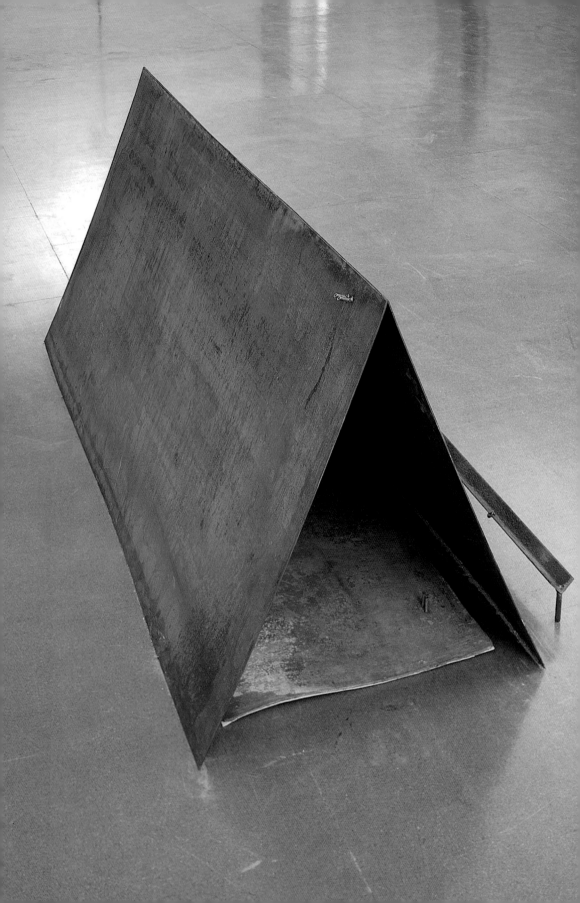

What Do We Have in Common?

Dunja Blazevic

What is the common denominator for the successor states of the Socialistic Federative Republic of Yugoslavia? The creation of nation-states (a process still under way) based on national or nationalistic ideologies and policies, which continue to dominate the Balkan political space.

The result of such policies is not (only) liberation from domination by the bigger and stronger, nor the struggle against the aggressor and for safeguarding one's "own territory" and national integrity, but also the ethnic division and homogenization of a people, accomplished through the perpetuation of a feeling of endangerment and fear of each other. Or, assuming that the cause of the dissolution and wars was the hegemonic and aggressive national policy of the Serbian leadership (which declared itself Yugoslav), then the consequence is not only the legitimate defence and formation of independent states, but also of "ethnically clean" states. The *raison d'etre* of these new states is ethnic homogeneity—unity. In this process of transition, one collective ideology—"the rule of the working class"—was exchanged for another, namely, "the rule of the (ethnic) nation". This pre-political state still exists, despite the fundamental changes in the political system that were carried out more than a decade ago—the introduction of a multiparty system and a parliamentary democracy. The majority of the influential political parties, regardless of their names, go no further than "defending the interest of their people" in their programmes and corresponding populist discourse in all spheres of social and economic life.

This historical dynamic is also the answer to the question of why Bosnia-Herzegovina (BH), as a multinational country, paid the bloodiest price for its survival. The reason for the war and aggression in this country was its "cleansing" and its breaking apart both from the outside and from the inside. The goal of the neighbouring countries' aggression was annexation—the merger of the "other" cleansed parts of BH with the ethnic mainsprings in these neighbouring countries. The Dayton Agreement stopped the war and prevented the redrawing of external borders, but it accepted the internal *fait accompli,* and incorporated these ethnic divisions into the "Dayton Constitution". With this, the bearers of political legitimacy are representatives of the "constituent nations", not the citizens

Page 50
Miroslav Balka
Untitled, 1992

Sejla Kameric
Basic 1-3, 2002

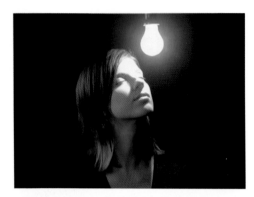

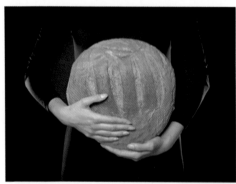

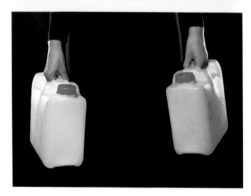

of BH (who should serve as the foundation of a normal, democratic state). Such a system perpetuates the dominance of national (or nationalistic) parties—the protectors of special national interests. The economy, material goods, infrastructure and state institutions were destroyed by war; the ethnic image of the country was changed, redistributed along ethnic lines. Civilian victims of the war are still being counted, as are displaced persons and refugees. A large part of the able-bodied and educated population left the country. The consequences are: unbridgeable generation gaps, discontinuity and a lack of people working in certain professions. The young continue to leave the impoverished country. There is neither strength nor political will for setting the economy in motion, creating jobs, returning the displaced. Young, educated and talented people, who remain in the country despite all these things, possess a dispersed but potentially positive energy. As a rule, they abstain—they don't vote in elections ("we have no one to vote for"), they don't participate in public political life.

Instead of establishing a new system, with economic and social programmes and reforms, there reigns controlled chaos, the absence of a system, a lack of political transparency and of public opinion in all spheres—from the economy to culture and art. This has to do not (only) with the inability and incompetence of the political players to solve urgent and accumulated problems, but with the intentional creation of chaos. Because only in the conditions created by an absence of a system, a clear policy and a programme and set of values upon which good and responsible decisions can be made, can one voluntarily rule the people and institutions.

The country is maintained with the assistance, supervision, and donations of the International Community; from humanitarian aid during the war to the great financial resources (often inefficiently) invested in

Alma Suljevic
Holy Warrioress, 2002-2003, video

infrastructure and material reconstruction. The large amounts of money invested in the development of a civil society, democratisation, and human rights were spent on the formation of an NGO elite and its promotional activities, but without real effect, while support was lacking for those initiatives and programmes whose goal was to change the cultural model, the value systems, and people's behaviour. This is proven by the fact that the same political structures that ruled at the beginning of the war are still in power now, seven years after the war has ended.

"In no country in Europe is cultural policy more important than in Bosnia-Herzegovina. Culture is both the cause and the solution to its problems. Cultural arguments were used to divide the country, yet culture might be able to bring the people back together again through initiating cultural programmes that increase mutual understanding and respect."[1]

This diagnosis of the symptoms of the disease, as well as its cure, can be applied to all parts of former Yugoslavia. The disease is called: the manipulation of culture, art, religion, and media by the nationalist elite. The cure is called: the decontamination of culture.

The reigning national policies have their equivalents in culture. Those are occurrences of pseudo-national culture generated from the folkloristic-religious matrix in a retrograde, obsolete form. The reproduction and recycling of "our inherent" and "God-given" models should be proof of "our eternity, uniqueness and authenticity". This has nothing to do with the creative use or reinterpretation of traditional patterns, nor with expert and competent efforts to protect the historical values and

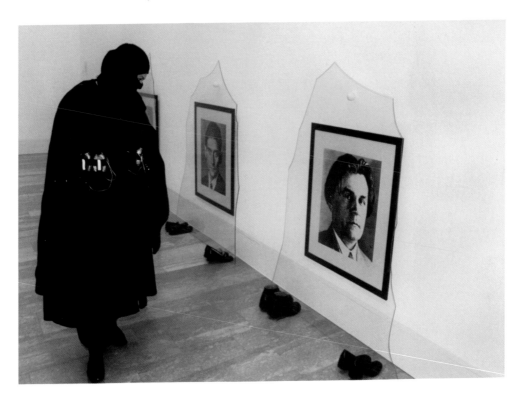

Leon Tarasewicz
Untitled, 1993

heritage of different origins and national backgrounds; our historical inheritance is watched over by a very small group of experts, without any kind of support from the "nation savers", aside from the daily political use of historical material.

The ruling national elite produces corresponding forms of its own representation that can be recognised in mythic images and symbols of "the glorious and tragic past" of the nation. Implanting the new cultural matrix is accomplished through the rewriting of history and the erasing of memory. Overnight, our bygone heroes become terrorists and enemies, and vice versa; old symbols are erased and new ones are drawn—"more beautiful and older" than their predecessors; new anthems are taught, new old languages; dead writers, and poets are thrown out of the books; dictionaries are corrected and rewritten; new place-names are introduced… all in keeping with the new patriotism. Erasing the traces of the recent and distant past results in the physical destruction of the material evidence of those things that do not fit in with the new presentation of reality: alien religious objects, books written by alien writers, anti-Fascist monuments, monuments of victims and heroes of World War II, symbols of the Communist era. The methods, however, are not new. In the last 100 years—or even less, in the Yugoslav (South Slav) territory— a fundamental purging of the past has been carried out at least three times.

The silent cultural majority supports and reproduces traditional culture and artistic templates.

That is the type of culture that sees itself as the decoration of society; it is that harmless, un-conflicting, self-satisfied, pleasing art—generated from itself and existing for itself. It builds its protective mechanisms—to shield it from outside influence or challenge (artistic, social)—by establishing local value systems and creating local celebrities.

Also on the scene is a contemporary art that thinks about and reflects on the time in which it lives, open to communication with the outside world, with others. This is art that uses and explores new media and art forms, that poses questions, that deals with social traumas, that demystifies traditional notions of art as well as collective ideological patterns and truths. This artistic practice is, on the one hand, unaccepted (the majority of local cultural arbiters neither recognizes nor admits these appearances as art), and on the other hand, unacceptable (entering the public space, the domain of the political arbiters).

This "other art", with its practice—its method of organization, its working strategies and spheres of interest—has the potential to change the dominant cultural models and thought matrices. To make this potential visible and efficacious is the task and the goal of the new and emerging cultural subjects in the region.

1. Cultural Policy in Bosnia Herzegovina: Experts Report, *Togetherness in Difference: Culture at the Crossroads in Bosnia Herzegovina*, by Charles Landry; European Program of National Cultural Policy Reviews; Steering Committee for Culture, COUNCIL OF EUROPE. This report was presented and accepted at the 1st Plenary Session, Strasbourg, 9 October 2002.

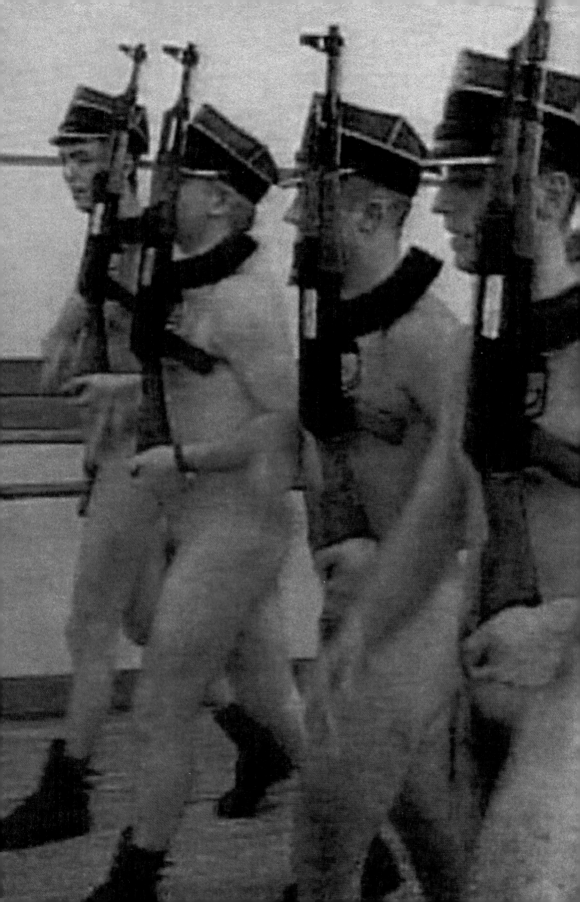

Public Rituals
Body Politics—Media Reality—Art World

Rainer Fuchs

It is precisely in ritualistic processes that societies and their institutions try to shield themselves from transformation and firmly cement existing structures. For this reason, public rituals that stabilize the system constitute those areas vulnerable to attack, where both social self-affirmation and the contradiction between democratic demands and praxis in real politics are revealed: "Ritual behaviour is characterised by its tendency to repeat actions, lending them aesthetic form, a formula-like appearance, and precision. The inherent logic of a ritualistic action lies in being self-focused and thus becoming an end in itself, a mere protocol-like behavioural pattern removed from original intentions and free of all content."[1] Originating from the Protestants, this critique of religious behaviour, that is, of religious rituals, can also be applied to today's secular world and its rituals, although the critique only describes the restorative aspect of ritual.

Since ritual has an ambiguous spectrum of meanings—as does myth (among whose connotations ritual can be found)—it cannot simply be seen as analogous to reactionary and restorative forms of behaviour. What Bernhard Hüppauf says about the potential of myth—to relativise

Pierre Bourdieu's definition of myth as merely an instrument for maintaining authority—can also be applied to ritual: "Thinking in mythical terms [...] is inseparably connected to historical emancipation movements. [...] The power of obscurant mythical thinking has remained unbroken in crises and revolutionary movements, and even regenerated itself when these movements failed. This vicious cycle of crisis development and mythical obscuring cannot be broken by a critique of mythical thought since the suggestion comes less from myths than from the conditions of their reception."[2] The power of myth as well as that of ritual is therefore not something a priori, but can only be deduced from concrete historical contexts of function and use.

Were we to see ritual as not merely a standardized initiation rite and symbolic, conservative communal act, but rather, emphasising its potential for overcoming perilous situations, to also see it as "all formalised and dramatised symbolic actions by individuals or even groups with a transitory character",[3] then behavioural patterns and representatives from, for example, youth cultures or even artists and artist groups who provide resistance

to customary rituals and their proponents, would all fall under the same term. The attitude towards rituals can also flow into counter rituals, which for their part can be subjected to institutionalization and standardization. In the same way as the "ritual" proves to be a complex behavioural form and linguistic figure, the "public" represents a differentiated, alterable phenomenon that is conditioned by various interest groups, social classes, and political and ideological orientations. Whenever the "ritual" or the "public" is referred to in this essay, the use of this collective singular form always implies its differentiated and heterogeneous range of meanings.

In the videos shown in this exhibition, young Polish artists and foreign artists living in Poland deal in a playfully ironic and critical manner with the rituals of society, media, and the art world. Even though the artists act within the context of post-communist Poland and the specific dynamics of its history, their work is not up for discussion here as a national phenomenon, but rather as part of an international debate to which they make a substantial contribution. Emerging from their experiences with the free market economy and the subsequent collision with traditional post-communist and neo-liberal structures, socio-political and social questions play a central role in the work of these young artists. The public rituals, which have at the same time become virulent, are examined in the exhibition through three interrelated themes: *body politics, media reality,* and the *reality of the art world.* From a critical distance, the artists interpret and comment on the rituals carried out in these domains, wrenching the rituals away from an interiorised view and confronting them with outlines, that is, measures which in turn re-negotiate the definitions and reality of the public and the ritual. The definition and the execution of "public rituals" form the framework of this action-related, performative art, which usually employs video technology for documenting and communicating its interpretative actions. While here video art stands for the recording and presentation of cross-media and also trans-media projects, it also means the creative and reflexive use and interpretation, as well as the expansion of video as a medium. These ideas do not simply stand diametrically opposed to one other, but are linked in various ways in the individual works.

Body Politics

Long before post-structuralist discourses on power and their relevance in defining the body emerged, anthropologists in the field of ritual research had examined the effect of social conditions on the biological body. In his essay *Les techniques du corps* (1934), Marcel Mauss depicts bodily expression and cultural environment as a hierarchical relationship in which the individual uses his body language to express his subordination to cultural and social norms: "Every one in every society knows, and everyone must know and learn what to do under all circumstances, the body techniques, prescribed by social authority and acquired for it."[4] The fundamental definition of the real body as a political body inherent in this is characteristic of the traditional constructivist, post structuralist, and feminist conceptions of the body. These conceptions juxtapose the "real body", the "body without history", the "actual body", the "biological body"; and "the instinctual body", with different models of argumentation that never regard the body as divorced from history, politics, or culture. However, it is through the very history of the body, its various definitions and classifications, that the body reveals its true nature. According to Michel Feher, "The history of the human body is less a history of bodily representation than the history of its construction."[5]

Page 56
Artur Zmijewski
KR WP, 2000, video

Bergamot
Organic Life, 1999, video

In their work for this exhibition, Artur Zmijewski and the artist team Bergamot establish relations between social structures and bodily rituals which should be placed in the discursive tradition roughly outlined here about the body as a biological, social, and political entity.

In his video *An Eye For An Eye* (1998), Artur Zmijewski mounts disabled and intact human bodies into hybrid body images making it shockingly clear that so-called normality is a fractured, vulnerable, and hybrid category created by the human imagination. With choreographic finesse, he positions and overlays the able and disabled bodies of the protagonists in such a way that on first glance the missing body parts of the disabled seem to be replaced and extended by those of the able-bodied performers. Veiled in this way, the mutilations suggest a seeming normality: they show that normality is simply a questionable category that may be created or exposed through lies and deception.

Zmijewski counters this model of confronting contrasting images with their ostensibly secure realms of good and bad, healthy and sick, beautiful and ugly, normal and abnormal, by linking the opposites. By coupling the intact body with the impaired one, he suggests a whole where in reality fragmentation and loss rule. The arrangement of the figures in his tableaux also alludes to antique sculptures and reliefs, whose classical and flawless forms have suffered with the passage of time and history and have ultimately been destroyed, drawing them into the discourse about the art historical attempts at standardisation and their transitory character. Zmijewski's ruthless method of presentation counteracts the motif of dis-

interested pleasure as the maxim of reception of "timeless", classicist work. Works such as these aim at a viewer's consternation over their sense of disgust upon looking at such disfiguration; they produce in viewers an awareness of their own shameful suppression of disgust. Through his "radical psychologism", (Zmijewski), the artist is aiming at the viewers' awareness, which will open their eyes to the fact that their own psyche is a mixture of intact and disfigured or integral and spurious elements.

Zmijewski himself describes, as follows, the synchronicity within that which is commonly seen as contradictory: "I have the impression that as morals, dishonesty, xenophobia, and club law are seen as equally valid qualities of human personality as are honesty, kindness, and trust."[6] With this open rejection of such moral affectation, the artist consciously refrains from a superficially enlightening rhetoric that to him seems to detract from the true problems of human existence. In another context, by referring to the fact that war criminals who were responsible for the most horrible mass murders were also just simple, average, seemingly normal people, he drew attention to the fact "that every one is capable of everything" and that "we [must] accept the beast within us. We must put it on a leash and display it publicly."[7] Zmijewski's relentless rhetoric makes the humanistic and enlightened image of humanity and society, with its belief that education and upbringing as insurance for continual improvement will ultimately lead to the victory of good over evil, seem like starry-eyed idealism. But precisely because the artist, by referring to the deficits inherent in liberal, progressive thinking admits to a radical position, rejecting every insincere gesture, he himself resumes the tradition of critical, humanistic discourse.

Zmijewski's video KR WP (2000), made with former soldiers of the Polish guard of honour, whom Zmijewski made exercise naked for him in a fitness centre, also depicts standardised behavioural patterns in a form that is in stark contrast to these norms. Adaptation and deviation, their movements seemingly guided by leading strings, and anarchistic derision unite into a deconstruction of prevalent ideas of morality and values. As viewer, one has no option but to join in with the scorn and still be amazed at the inappropriateness of the occasion. Here, "displaying the inner beast" means freeing the soldiers of the leash of national political obedience; it means mobilising the soldiers against their own orders. In this work, Zmijewski's strategy of undressing and of baring internalised rituals and his insistence on naked facts find both literal as well as symbolic expression.

The artistic duo Bergamot (Volga Maslouskaya and Raman Tratsiuk) use some of their performances for body focused actions that extend through to physically violent exchanges to attack each other, thereby acting out the mechanisms of power and control that latently pervade our day-to-day lives. Their particular works are conceived as aspects of a larger complex of works and share with it the title *Organic Life*. The term "organic life" can therefore be applied to both the organic connection between ostensibly disparate aspects of real life, such as the private sphere and public sphere, as well as to the thus emergent meaning and role of the physical body.

Bergamot's aggressively provocative behaviour usually addresses subtle and subliminal mechanisms. Being against apologists for an impassive "we", who disguise their hunger for power with a feigned need for harmony in order to be more effective, Bergamot resort to blatant public displays of conflict to make the efficiency of this veiled power visible and attackable. This is exemplified in a performance in which the artists slapped each other publicly while eating in a well-

Kuba Bakowski
Flag, 2002, video

known, state-subsidised milk bar. The performance that was staged as an interpersonal conflict in public—not recognizable for the others as an art performance—through the inclusion and provocation of a real public, aimed at showing the interpenetration of individual and collective, private and public power, and violence. When displayed to the eyes of the public, violence which usually takes place in seclusion and in private, normally tolerated as inevitable—as long as it remains concealed and suppressed—provoked immense indignation on being openly displayed. Involuntarily, the protesting restaurant clientele and the threatening waiter became the constabulary of a power that felt observed and put on the spot by this eruption of visible aggression. The attempt to use all means to make this visible violence vanish from sight also became recognizable as a rescue operation for suppression, and thus as the actual threat.

The fact and the extent to which the private is also political and the fact that power is not exerted by the state apparatus and institutions alone but also by micro levels of society, was already postulated by Foucault in his analysis of power: "Power relations run between every point of a social body, between a man and a woman, in a family […] and they are not just simple projections of a great and supreme power over individuals; they are, rather, the movable and concrete ground

in which power has taken root, they are the conditions of its prospect of functioning. [...] So that the state can function and for the way it functions there must be very specific power relations between man and woman, between adult and child, that have their own configuration and follow their relative autonomies."[8]

Although this questions the linear causality of power from top downward as a simplification, the relations of the different milieus of power remain unquestioned. The very display of private conflict also refers to its links to institutional and state power. Foucault found that in making the effects of this power unbearable in the everyday, lay the means for obstructing the state's apparatus of control.

Bergamot's *mise en scène* conflict between man and woman and their visual depictions of the interconnection between private and public affairs allows for extensive interpretations within the Foucauldian analysis of power: through the violence done to each other and in the alternating exchange of blows, each of the two adversaries proves to be both victim and culprit. Each reflex of power is therefore also one of resistance. This, too, shows a turn away from extremely contradictory and schematised images of power and powerlessness or those of culprit and victim. Instead, an insight into the dialectics of power enters that also includes the productive aspects and effects of power: "One must cease from describing the effects of power negatively. [...] In reality, power is productive; and it produces genuine things. It produces realms of objects and rituals of truth: the individual and his knowledge are the result of this production."[9]

In yet another performance, this time for an art audience in Minsk in 2000, Maslouskaya and Tratsiuk hindered each other from entering and leaving a room. In the doorway, at the threshold between indoor and outdoor space, they carried out a struggle for territory in a kind of deadlock. They acted out a gender-struggle in which each attacks the other but at the same time robs him or herself of all agency. But this struggle could also be seen as an endless duel or as a call for constant resistance against violence and the attempt to appropriate. In this case, doing violent harm to each other also means resisting the violence from the other and risking continuous conflict rather than resigning passively. In this work, Bergamot make it explicitly clear how much the establishment of power also has to do with drawing limits and that these are therefore precisely the limits that it is necessary to exceed again and again.

Media Reality

As an omnipresent tool used for representing and communicating reality in public ritual scenarios, mass media technologies provide artistic research and strategy their basic motive for deconstructing and critically analysing ritual and media strategies for obscuring and distorting reality. Anna Niesterowicz and Kuba Bakowski use the recording and transmission techniques of television and other media in their work to expose the functions and construction methods of the media, which are usually suppressed by its producers and internalised by its consumers.

Anna Niesterowicz based her video *Calling 07 Series* on a crime series broadcast by Polish television in the 1970s and the 1980s. Inspector Borowicz, the Polish offshoot and counterpart of super agent James Bond, had become a synonym for an incorrigible womaniser and police officer in whose person immorality and the claim to law and order merged effortlessly. In those days in communist Poland, like James Bond in the free West, Borowicz, too, used adventure and action to distract his viewers from their mostly bleak and monotonous lives. The Polish policeman, however, did have one advantage over the British secret agent: he did

not always have the mission to present and protect his own socio-political system as the only good and true one against the evil intentions of a foreign superpower. Without any politically motivated tasks to fulfil, he could operate in the ostensibly politics-free genre of entertainment, and nonetheless undertake a truly political mission within the social system.

As one of the earliest viewers of the series, Niesterowicz does not speculate with nostalgic idealisation in her method of recollection, but rather traces the mechanisms behind the idealisation and the sublimation of real conflicts that had led to the cool inspector's media success. She uses the original film material and filters out sequences for a new montage with which she lures the television serial away from the distance of its past into an interpretational trap in which the socio-political implications, such as the construction of clichéd gender role models, become evident in the ostensibly apolitical entertainment spectacle. With the help of editing and collage techniques, Niesterowicz interrupts the narrative flow and deliberately distracts the viewer from the concrete, individual stories to make clear that the series itself is a concretion of history. From the new montage of the scenes, new films about the old ones emerge so that the newly composed fragments are a comment on the structure of the entire series. What was previously so easily overlooked in the flow of episodes is highlighted in the new *mise en scène* of the old material so that we see it in a totally different light. For example, the artist has selected scenes and dialogues between the inspector and the women in which the ready wit of the female protagonists makes the male hero seem quite ridiculous. By accentuating and focusing on hackneyed statements, the artist filters away the reflexive moments in them thus reversing their polarity and turning them into the main issue. When one gangster in a hold-up orders the other to massacre the female victim as in films (*Do It To Her Like In The Movies!*), the TV film's desire to be as authentic as the reality outside the film or even be taken for it becomes apparent. But it also becomes clear that the film in which this scene is taking place is referring to a constructed filmic reality, the continual reference to the *James Bond 007* soundtrack being its most blatant sign. In its disunity, this loop of reality and media reality shown by Niesterowicz finds its correspondence in a purely opposing consumer-producer relationship. According to Vilèm Flusser, "Images are becoming more and more the way recipients want them to be, so that the recipients can be more like the images they desire. This is simply the interaction between image and human being."[10]

Kuba Bakowski's interpretation of media reality not only deals with the mechanisms for standardising and literally "flattening" complex realities into clichéd images, but also with the possibility of penetrating into the interstices of this media reality, occupying them and leaving behind creatively anarchistic footnotes. The artist contrasts the mere consumption of prefabricated images and stories with his own production of images and meanings by using well-known media images and symbols as a potential field of operation. In *TV Zero Zones* (2002), he used the transmission pause of the TV station to break the flow and conventionality of media images. While he declares the TV test image to be a logo for media stagnation, he also sees in it a free space for criticism. Using the blue box technique, he sneaks into the image and transforms it into a sort of real pictorial space. The form of an "electronic aquarium" (Bakowski) with its tiny fading figure of the artist as an encapsulated "swimmer"; is reminiscent of the limits set to the individual's freedom by media-produced desires and the satisfaction delivered along with them.

Bakowski acts in the zero zone of television within a display that, as a geometric colour map or virtual abstract painting, appears like a palette for all TV images, whose artificial abstractness refers to the fact that all media images are genuinely artificial. Rather than setting his test image to entertaining background music, he uses a martial sine tone that aggressively drills its way into our consciousness. *TV Zero Zones* sees the TV test image as a contrast to the sequence of programmes, as one lacking action, and turns it into the actual program. This reanimation of programme gaps proves the regular programme to be the actual gap; one of its messages being that television is at its best when it does not take place at all and its misappropriation shows how depressing it is when it does function normally. This concern about everyday television culture and the digressive use of the medium brings to mind Pierre Bourdieu's critique "On television" in a lecture held on television about television. Bourdieu confronted his listeners with the fact that he had negotiated exceptional terms for a TV appearance, such as unlimited talk time, no censorship, and his own choice of subject and this is what he said: "A very unusual situation I command here, to put it in an old-fashioned way, a very 'unusual power over the means of production.' In underscoring the reason why my conditions are

Anna Niesterowicz
I Have Absolutly No Driving Licence, 2001, video

so uncommon, I am also saying some-thing about the common conditions under which one has to speak on television."[11]

In the same way as the test image, Bakowski uses images of the Polish flag as both background and frame of a video performance. With the human figure at its centre, the flag's emblem becomes legible as an endless space with a horizon in which the artist stages himself as an emblematic figure, that is, as a substitute for the Polish eagle. Bakowski's move-ments play on both profane as well as sacrosanct rituals and blend together new body and beauty trends with the old cults of the state. He confronts the real situation of Polish society and contrasts it with an outdated national pride and, instead of hollow metaphors, ironically places the human individual in the centre.

The Art World
With its institutions, its representatives, as well as its opponents, the art world is the ultimate vanguard in the hierarchical machinery of rituals with public rele-vance. Critical self-representation and the questioning and crushing of the functional logic of institutions characterize those strategies in art that are critical and reflec-tive of the system and question art as art, that see in the detection of the art world's framework a form of artistic praxis, and are in radical opposition to every form of

traditionalism in art, even to art itself. If one sees art as a linguistic system then art that questions institutional art or anti-art is a form of language analysis, since it turns the very conditions of speech, the reason for transferring meaning, or shifts in meaning into the subject of debate. This is why art is primarily interested in interpreting those tasks and procedures that guarantee and establish the functionality of institutions. Art about or against making art is therefore always about and against rituals. But because it seeks to scrutinize power hierarchies and to deconstruct them, it also becomes vulnerable to the use of power and ritualization. Avoiding institutions from the very start is no guarantee against becoming institutionalised, just as criticising the system from within is not in itself a form of self-contradiction or betrayal of oneself. However, the effectiveness and meaning of interventions in art that reflect on institutions and are critical of them, cannot be reduced to just a question of location. All the talk about institutions and their unswerving power and authority simply excludes their specific and different art ideological and political positions and aims. In the discussion about the power and powerlessness of institutions, the disunited art world confirms its own basic political structure and thus provides art the motives for questioning and thematising it. The works of Julita Wojcik and the Azorro Group represent such interpretations of the system within the context of public rituals.

Julita Wojcik's work is based on the observation of everyday activities and processes and their inclusion in the context of art. In past years, the artist has used household activities that are regarded as inferior and feminine—such as knitting, cooking, serving, or gardening—for an artistic *mise en scène*. She not only thematises and problematises the borders between art and life and their references, but also absolves the viewers of their own customary role as spectators and consumers and incorporates them in her performative projects. In a place where viewers would expect something uniquely elite and extraordinary, Wojcik exercises and analyses the mundane. Her art therefore resembles a game with clichés and habits but in the context of art, it points out that neither the rules of the art world, nor of everyday life, can be taken as self-evident, unbending, or innocuous.

Wojcik's analysis of life in the art context is also a reflection on making and exhibiting art. When the artist peels potatoes or chops onions in an exhibition, she is also interpreting the norms and expectations in the art world through this very non-artistic and banal act. Because this is also a covert reference to Van Gogh's *Potato Peelers* and its critique of academicism in art, an added reference to art (historical) reflection enters Wojcik's work.

The Azorro Group also deals with the art world's framing conditions and examines the artist's position and function within art and society. They go about as a research group in exhibition spaces and urban environments asking passers-by or art insiders which gallery in the respective city would be best suited for their own exhibitional purposes. In addition to preparatory measures for exhibitions such as inquiries about spaces, also questions about the quality of the artwork asked subsequently as a supplementary project shift to the centre of Azorro's work. All the relevant rituals in the realms of art and society that more or less take place behind the scenes and in secret become the material that Azorro presents publicly. Since even the search for an appropriate gallery for their art becomes a work of art, it also reverses the role of the unaware curators and art dealers who try to shoo away artists, from that of art judge to mere supernumerary. In their work *Portrait With A Curator*, this involuntary role as extra becomes assigned to curators and art

judges so that the artists posing as foreground figures become a kind of "frame" for the curators who—though in the background and obviously without their knowledge—end up right in the centre of the picture.

The Azorro Group develops its ironic potential through a conscious overabundance of clichés about art and artists. Their disdain of the art world and their provocative play on vanity and superficiality always points at the gravity of the situation as well as the true power games and intrigues that establish art as part of society to the same degree as they influence society itself. In one of their works, Azorro takes the cliché of the artist as social outcast who has the so-called license to do everything literally, and translates this "freedom" into actions in urban space, breaking the relevant rules but, at the same time, also exaggerating their ostensible freedom to a point of absurdity.

1.Translated from: Florian Uhl, *Rituale – ein Charakteristikum lebendiger Religion (Zur Bedeutung und Funktion von Ritualen in Kultur und christlicher Religion)*, CPB/No. 1, pp. 4–8, p. 4.

2. Translated from: Bernd Hüppauf: *Mythisches Denken und Krisen der deutschen Literatur und Gesellschaft*, in: *Mythos und Moderne – Begriff und Bild einer Rekonstruktion*, Karl Heinz Bohrer (ed.) (Frankfurt/Main: Edition Suhrkamp, 1983), pp. 508–27, p. 522.

3. Translated from: Uhl, ibid., p. 5.

4. Translated from: Marcel Mauss, "Die Techniken des Körpers" (1934) in: M. Mauss, *Soziologie und Anthropologie II*, (Munich: Hanser Verlag, 1975), p. 206.

5. Michel Feher "Introduction"; in: *Fragments for a history of the Human Body, Part One* (New York 1989), p. 11.

6. Translated from: A quotation from Joanna Mytkowska, "Artur Zmijewski – Der Mensch, das unbekannte Wesen"; in: *na wolnosci / w koncú - in freiheit / endlich, Polnische Kunst nach 1989*, exhibition catalogue, Staatliche Kunsthalle Baden-Baden; Muzeum Narodowe w Warszawie, Polenmuseum Rapperswil, 2000/2001, pp. 82–84, p. 82.

7. Translated from: Ibid., p.83.

8. Translated from: Michel Foucault, *Dispositive der Macht. Über Sexualität, Wissen und Wahrheit* (Berlin 1979), p. 110.

9. Translated from: Michel Foucault. *Überwachen und Strafen. Die Geburt des Gefängnisses* (Frankfurt/Main 1977), p. 250.

10. Translated from: Vilém Flusser, *Ins Universum der technischen Bilder* (Göttingen 1989), p. 47.

11. Translated from: Pierre Bourdieu, *Über das Fernsehen*, Frankfurt/Main 1998, pp. 15–16.

Transition(s)?
Art and Culture in Bosnia and Herzegovina

Dunja Blazevic

The difference in the tempo and character of the transitional change the former Communist countries are going through is most drastically seen in the example of the former Yugoslavia. The gap between Slovenia, democratically ordered and policy-wise focused on economic self-sufficiency, and Bosnia-Herzegovina, a victim of the imperial aspirations of its neighbouring countries, looks to be unbridgeable. We recall that until twelve years ago these two countries lived in a single state under the same conditions, and there were no essential difference in the terms of level of development. It is important to emphasise that the issue in Bosnia and Herzegovina is not only about transition— the process of moving from one system to another—but also about the reconstruction of a country destroyed by war, and the creation of elementary conditions for the return of one hundred thousand refugees and displaced persons. The country is under the protectorate of the international community; it does not live from its own economy (still in ruins, with no sign of recovery as yet), but from donations, which are dwindling seven years after the end of the war. The state institutions of this Frankensteinian system, designed under the constitution patched together at Dayton, do not function. The international community, present here in the form of a great number of organisations (UN, EU, OSCE, UNHCR, *et al.*), finances the reconstruction of the infrastructure (destroyed houses, electrical and water supply) in order to give refugees a place to return to, but not to give them something to live from. In other words, there are no new jobs; the economy is stagnant. Culture and art do not feature in the donors' reconstruction programmes. This destroyed material condition is accompanied by the continuous departure of the young and educated, mostly to countries across the ocean, because Europe will not accept them. Since the end of the war, this percentage has grown. If we add to this the knowledge that during the war a large percentage of the active, educated population left the country, and that today entire professions are lacking, then it becomes clear that the situation is catastrophic.

Neither a cultural policy nor a system for the arts exists; instead there exists the remains of the old system. This year's budget of the Federal Ministry of Culture and Sport totals three million Convertible Marks (about 1.5 million euros), or 0.5%

Page 68
Ivana Franke
Center (12), 2003

Dean Jokanovic Toumin
If You Are Looking, 2003-2004

not merely involve individuals deciding how to distribute the tax-payers' money, but creating a legal, economic and social environment for cultural and artistic life. In order to define the needs it is necessary to open a debate and reach an agreement between the participants/subjects in cultural life and the authorities/Government.

The consequence of this situation is artistic production reduced to the heroic efforts of the individual, the marginalisation of alternative movements and organizations, and the flourishing of popular mass culture to the exclusion of all other kinds.

Cultural initiatives not geared for mass-consumption are disappearing because the main goal has become profit, which is impossible to realise even with many activities of doubtful quality. New and more capable institutions direct their energies to festival-like one-off events. It is the easiest way to attract sponsors and the public. In such a situation it is impossible to keep professional standards and provide programme continuity.

In this material and systematic vacuum, making do is the basic mode of survival. The former programme activities of museums, galleries, and cultural centres have either failed or are barely scraping by on minimal budgetary resources. Institutions that have their own building rent out museum-exhibition space to those who can pay. Here, therefore, programming policy does not even come into question. The Academy of Fine Arts, for example, in order to pay its heating bills, rents space to the Sarajevo Centre for Contemporary Art and other tenants. To put it cynically, we can conclude that these are the first signs of market behaviour. However, whether paradoxical or normal, that hardy, enduring plant—art—still grows here, despite the absence of the essential conditions for a normal life (a cultural policy, an art market, sponsors, collectors, or the other sources of financing, including public and private funds).

of the national budget. However, what is most frightening is that the domestic government and public consider this situation normal. There are no crisis plans, no plans for intervention.

Federal and cantonal ministers are deciding on their own how to spend the funds, a procedure that inevitably leads to the privatization of the public office. That does not mean that those persons are bad or corrupt by default, but that there are no objective criteria or mechanisms for spending public funds. There is still no awareness that having cultural policy does

Institutions of the old system are not capable of adapting to the new way of life; they are not in the position to carry out their functions, and contemporary art has no benefit from them. A substitute or parallel system of non-governmental, non-profit organisations is now emerging—a new model, flexible in structure, which has taken over the role of supporting new initiatives in contemporary art production in various fields. In this way projects have been supported by the Arts and Culture Programme of the Open Society Fund (until 2000, when that programme in Bosnia-Herzegovina was phased out), the Swiss foundation Pro Helvetia, which in 1999 started a programme of donations for the development and improvement of precisely these new structures and projects, and the Austrian KulturKontakt Foundation. These foundations, however, finance individual programmes only; they do not finance the operating costs of the cultural organisations themselves.

Similar new structures are appearing in the entire region and are supported for the most part by the same foundations. For the existence of that which we call contemporary art, an important role from the end of the war in 1996 until today has been played by the Soros Centre for Contemporary Art (SCCA). The fundamental model of the chain of centres that operated in twenty former Communist countries was conceived for work under conditions of transition—a small, effective and professional team and a flexible programme whose primary goal was to keep contemporary art alive: financial support for new projects, assembling and editing documentation, communicating and making connections with professional institutions and individuals abroad, organizing exhibitions—all actions that affirm contemporary tendencies in art that are complementary or alternative to the predominantly traditional and anachronistic local scene. Connected via a network,

Andreja Kuluncic
Homewards (Hazafele), 2003, video

they developed intense reciprocal communication and, by means of joint or co-ordinated initiatives, they helped the presentation of Eastern European art in the West. In 2000 (when the Open Society Fund started to reduce financial support, which ended in 2003) the centres legally changed their status and names and established a new network—the International Contemporary Art Network. The argument of Mr. Soros for terminating the budget line of the SCCA network was that if the local actors cared about culture, then they should ultimately assume the responsibility for the vitality of contemporary art. His logical assumption was that from the 1990s up until that moment, there had been enough time for all the countries in transition to establish new structures capable of assuming the care and responsibility for social economic development. Bosnia-Herzegovina, as a special case (where transition had not even started), was not considered.

Aside from generating new production, which changed the image of art in this

Marjetica Potrc
After the Flood, a House, 1999

country, SCCA (today the Sarajevo Centre for Contemporary Art) also appears as a mediator and promoter abroad for the works created in B-H. and co-operates (professionally and logistically) with foreign professionals and institutions in organising exhibitions in the region and wider area. It is difficult to say that the existence of SCCA in Bosnia-Herzegovina is more significant than in other countries (for the aforementioned reasons), however the fact remains that it was the nucleus for the creation of a new art scene, focusing on the development of multimedia and public art, working with artists in the country and in the diaspora, and creating two-way co-operation at an international level. In short, the concrete output is as follows: without this Centre, artists from Bosnia-Herzegovina would not be represented in international exhibitions since 1997, from Manifesta(s) to the International Biennales in Valencia, Istanbul, etc. In this moment the continuation of the work of SCCA is insecure, even considering its flexibility and ability to adapt to all sorts of conditions.

To describe the real context in which the minimum of professionalism struggles to survive, two more examples, typical for the situation in this country, are worth mentioning.

One of the mega-projects in regional terms is an international collection—the core of the future museum of contemporary art ARS AEVI, initiated and managed by Enver Hadziomerspahic. The drive to gather the collection—already started during the war—draws on the solidarity demonstrated by museums and centres of contemporary art all across Europe, for the martyred city Sarajevo. This formula has two clear advantages: first it capitalizes in on the tragedy of the city, and arouses the consciences of people who feel a moral and professional obligation to participate in this project. Given the fact that the museums make the choice and give their stamp of approval to the chosen works—which the artists then donate to the collection—the curator of the ARS AEVI project is freed of the responsibility of making the selection. Until now a more-or-less consistent collection of 100 works has been formed, a collection which gives a good overview of the last 30 years of contemporary art. The intention of Mr Hadziomerspahic is that the future museum be a global multicultural centre, deriving the argument for this concept from the geopolitical position of Sarajevo. Setting aside international aspirations and projections, let us look from the inside at the advantages and disadvantages of the project. To the first question of whether we need an international museum of contemporary art, the answer is affirmative. However, deep misunderstandings and confusion, still not adequately stated out in the open, exist regarding the order of steps to be taken, the analysis of the situation, the real needs and possibilities, and in the first place the question of professional and material premises for the entire enterprise. Up to now, no competent museological study has been proposed. The general consensus that we need a museum tends to waive the serious professional issue of "con-

cept and contents", as well as the requisite professional qualifications of the staff who will work in the museum. To put it quaintly, this is rather like selling a model of a cake with all its outer festive decorations, without knowing the cost, the ingredients, or even the recipe for baking it. As far as financing goes, from infrastructure onwards, the project is counting on the international community. Here one can theoretically rely on the cultural-political interest of European institutions and the governments of individual countries, but again, not in the long term. European bureaucracy will understand and reward the idea of spreading multiculturalism beyond its borders, especially in Bosnia-Herzegovina, in which this looks like a beneficial formula for preventing further ethnic wars. With this in mind, the opinion of Miran Mohar (IRWIN, Ljubljana) is very pertinent:

"Multiculturalism came to be an official ideology using art to control the neighbourhood. Multicultural art became a way to make peace in conflict hotspots. This is an official need, and it's important to ask whose needs this serves. Artists are not police or social workers, but I find interesting similarities here. As soon as art gets functionalised, it becomes what social realism was in the early stages of Communism. In a liberal system, multiculturalism can very easily become a kind of liberal social realism." (*Transnacionala*, Ljubljana 1999).

(The concept of multiculturalism here in Bosnia-Herzegovina is nevertheless a bit older, and has a slightly different meaning from that of contemporary liberal-capitalistic discourse.)

In short, this project needs to be carefully considered and to be professionally set on its feet. Potentially, for the intensification of international communication, this museum is strategically important, but without the fundamental conditions here for the development of domestic and international art production, the project could be destined to become merely an expensive ornament.

Renata Poljak
Jump, 2000, video

A characteristic local (provincial) syndrome, which could be expressed, "Sarajevo is the navel of the world into which the entire planet flows," describes various international quasi art festivals and biennials (whose effect is measured in thousands of participants), as well as the failed initiative for the Winter Olympic games in 2010. I mention this kind of "planetary" endeavour in order to point out the serious symptom of illness, which is called—a normal answer to the non-normal situation of the lack of policy, system, will and competency for the creation of the basic conditions for the life of culture and art. Despite the fact that the life of sport's organisations depends only on the enthusiasm of individuals, that new artistic production continues to be supported almost exclusively by SCCA, practice shows that only these kinds of "mega" projects find financing and sponsors, which is also a sign that globalization has not passed us by (to be cynical again). This kind of "normal" behaviour in non-normal circumstances completely brings into question those unspectacular and everyday efforts to guarantee a minimum of professional performance, which would allow this country normal communication with the international art community.

So much for local conditions and domestic actors in the international scheme of things.

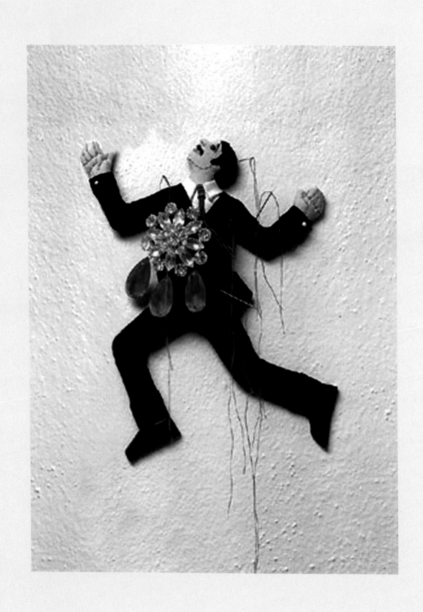

Strategies for Change

Jiri Sevcik

We speak without hesitation and almost automatically about the phenomenon referred to somewhat loosely as "Central Europe", but when a more precise definition is called for, things becomes considerably more difficult. Today a dead multicultural Europe is often spoken of with nostalgia; the requiem of a dead socialistic experiment undertaken in post-war "people's democracies" has begun to be written. And the newest consideration will be how to return this nostalgic complex to a broadly unified Europe. For many central Europeans, a unified Europe is too much of a modern bureaucratic project, disrupting the multi-significance and complexity of the traditional system. This "ecotype" of modernism brings an unbearably simple solution for more and more complicated problems, and members of smaller regions worry that in the end they will lose Europe in the name of higher principles and by a forced exportation of a certain kind of social-political system.

The present-day importance of these discussion lies mainly in the fact that a substantial post-socialist part of central Europe is entering a period of great uncertainty after the fall of the bipolar system, and is adapting itself to the new system with difficulty. In fact, not all generations, social groups, and certain cultural currents will probably be able to adapt. They are entering a new period with not only a historical heritage, but also with a different experience from the long-term participation in the socialistic experiment, which is probably the greatest burden. Integration is extremely fast without allowing time for a redefinition of its identity in a new context. Some historians have thus begun to realise that in new Europe the paradigms created in Eastern-Bloc [former "Communist-bloc"] times are no longer sufficient. We should redefine our own variant of "European-ness" and "think it out at the threshold of Europe." The central European question does not consist in thinking of invariants [invariables?], of fundamental similarities, or in the defence of transcendental values. Nor is it about inventing alibis for the long years of isolation, or defending the values we managed to conserve. In the present situation, culture is influenced by several long-term "residual" problems, lingering traumas and unsolved relationships with the avant-garde projects, with Social Realism, with the function of art and the

Page 74
Jiri Cernicky
Pin-Cushions (Daily Woodoo), 2003

Denisa Lehocka
Untitled, 2000

artist in society, with the traditionalisms, historicisms, and historical myths. A brief outline of some key situations since World War II should help the understanding of number of "re-armaments" and changes of art strategies in ex-socialist countries.

At the time, when the Communist apparatus started to inflate itself with a stolen avant-garde utopia, (especially that of the total transformation of mankind through its own and definitely not avant-garde means—as Boris Groys excellently formulated it), the ideas of the total freedom of art by the Czechoslovak avant-garde between the wars lost its sense. Unofficial art had to be de-politicised under the pressure of overly ideologically formed culture politics and thus the notion of art and its freedom obtained another interpretation. .

In 1950s and 1960s, the Existentialist movement gave a comprehensible form to the feeling of the tragically experienced Nazi occupation, but also to the feeling of frustration with the totalitarian socialist regime. Indeed Existentialism was in considerable tension with revolutionary surrealism, but it corresponded to the new situation. A "realism of human concreteness" couldn't have been ideologised and made pragmatic. Poetry and the revolutionary changes of society did not ensure freedom. Freedom relied on a conscious choice of a difficult existential situation and on the strength to stand behind it without the establishment's participation, or any official participation whatsoever. The ethic of the unofficial art movement emerged from this position. A large part of the culture perceived the communist take-over and life in the bipolar world of the Cold War as an extension of the Nazi occupation and a new threat to national existence. All of this influenced ideas on the role of the artist and art in society and established certain

Ilona Nemeth
Capsules, 2003

norms of behaviour and communication which have endured to the present as "residual problems", perhaps typical of the Central European area. This resulted in a critical attitude toward Western Art and present overly positive interpretation of the authenticity of art, which could not accept western self-reference in the socialist conditions.

The polarity of official and unofficial culture is understood by most of the cultural society as a problem of universal socialist culture and individualistic art of a liberal capitalist society. To all intellectuals sympathizing with socialism, and for some time even to members of the Communist Party, it involved an attempt to resolve the contradiction in such a way, which would reconcile Western culture with Western socialism. They were convinced that they were created from the same source, despite being absurdly disconnected. Under what conditions could they be synthesized? Prominent Czech art critic Jindrich Chalupecky in his essay *End of the Modern Time* declared that modern art lacked a live stimulus, which could return it to its "original place". It looked like socialism could solve the problem even it restricted the freedom of art. The squaring of a circle, socialism and Western art were finally solved by this critic through a special speculative method. The artist had to position himself in solitude, not outside, but within society, in some secret place, which would ensure his exclusiveness, but at the same time accessibility. Pseudo-dialectical attempt at reconciliation was an expression of post-war illusions and war experiences. In the 1980s, this critic gave him a different, more logical form, with socialism and Western culture operating as systems of similar bureaucratic and authoritative manipulation and art goes underground.

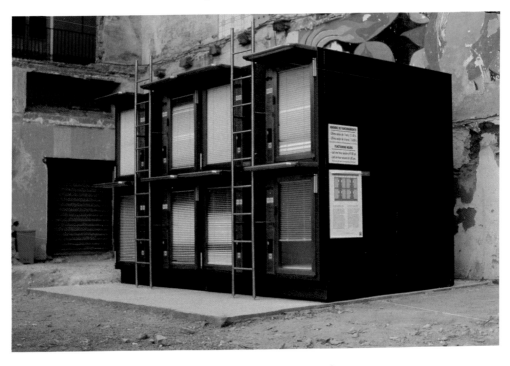

In the 1950s a polarization of the Czech scene began to occur between those who wanted to maintain the modernist methods and if need be adapt them to the reforming of social realism, and those who essentially remained with an existentially surrealistic outlook, and were already following the anti-avant-garde programme. This side insisted on building lasting values and rejected outright any pact with contemporary society. They considered the external structure to be blocked since social reality was occupied by totalitarian authority. The authenticity of inner experience, unaltered and uncensored from the outside became the key idea and yardstick of values. The moral position of non-participation in the life of the regime was the result of a decision to live with the tragedy of one's own existential situation. The Czech-specific form of Art Informel, known in the local milieu as "structural abstraction", developed a poetics of destruction and considered the picture as "material, emotionally urgent, a brutally deformed object". It was appreciated as the most pure symbolical expression of the wounded existence in totalitarian regime. At the same time, a few theoreticians tried to draft Breton's surrealistic model under the title of "imaginative art" and together with non-figurative informel painting, they declared it to be a constant of Czech art and its national school.

A large part of the cultural scene, identifying with the non avant-garde, albeit an authentic variant, was convinced that this art communicates more deeply than pop art and Western abstraction. The non-presence of contemporary art and the forgetting of modern tradition seemed to some to be a positive value.

A real polarity of the strong post-surrealistic school wasn't conservative modernism and other revisions of realism, but a programme of "objective tendencies." Art, once again integrated to society, was to become committed through the strength of the civilization process and whole "other nature". In Czech lands it is represented especially by the group Krizovatka (Crossroads), established in 1963, which began a new orientation (Malich, Sykora, Kolar and others). The "apocalyptic language" of the narrative figure and "symbolic scaffolding of the old world" were foreign to Malich. He spoke of form as construction, a flow of energy, and energetic events in space. About ten years later in the social isolation that took place after the 1960s, however, he discovered different esoteric sources, which we now see were just as strong and legitimate as the intellectual sources, as was the case with the avant-garde. Sykora established his structures on the basis of calculus with which chance is expressed in strictly mathematical terms and enters into a space of differently defined freedom. In his case, this special reviving contradiction is an unbelievably laborious, classically painted transfer of the mathematical text to the picture. This is similar to Malich's handmade construction of energy networks in his wire sculptures and probably belongs as well to the typical strategies of Central European space. Jiri Kolar is also a representative and influential figure, who with some other poets introduced a concrete poetry and enlarged it in some other alternatives—evident poetry, subjective poetry and de-static poetry. His instructions for using and comparing poetry were similar to the instructions of the young action artists of the 1960s.

In Slovakia there were parallel group manifestations with futurological orientation such as of Stano Filko, Alex Mlynarcik, Julius Koller, Miroslav Laky, Rudolf Sikora, Jan Zavarsky and others, whose iconoclasm resulted from different reasons than in the Czech lands. "Objective tendencies" were based on conceptualisation, a reduction of the language and follow a cooling of the medium.

Michal Pechoucek
The Collector, 2003, video

This type of thinking did not possess a strong enough tradition in the Czech and Slovak art and was forced to struggle with romantic aesthetics.

Under the pressure of the plurality of opinions penetrating from the outside, there were attempts to confront both contrasting currents of Czech art and present them as dual possibilities of choice between the appeal of existence and the order of values. The second half of the 1960s was a time for fusion. Art defined its more complicated and ambiguous identity in relation to Europe. The more open tension also gave the domestic scene a greater plasticity and

became more interesting for international audiences (exhibition for AICA Congress in Prague and Brno, visits of Western critics in Slovakia, for example. Pierre Restany, which brought comments and analysis from abroad). The avant-garde was introduced in the 1960s once again to the polemic in cultural magazines, but it was extremely problematic to speculate on a different role of the artist than what was defined during the totalitarian 1950s. It recalled and brought into a contemporary context the abdicating and masochistic attitude from the 1930s ("If the artist remains loyal to himself, his place is on the pillory"— J. Styrsky). In such an atmosphere, it worked to catalyse artists from the Krizovatka group, futurological conceptual projects, anti-happenings and the "super-subjective transcendence" of Slovak artists.

Jiri Suruvka
Tank Picasso (1), 2003

In addition to the constructive current, action art made its way to the domestic scene. Knizak's group Aktual had a destructive impulse of a Dadaist nature and an anonymous social and pedagogical function. At the same time in Slovakia, the permanent manifestations of Mlynarcik, Filko and Kostrova presented social reality as ready-made: their peaceful involvement is a complex experience of a naked, appropriated reality. Koller's "anti-happenings" created a cultural situation of a so-called cosmo-humanistic culture. The model of identification of art with a social practice changed in 1970s. Provocative actions became more internal and they were transformed into purely mental actions. Space is iconoclastically abandoned for an infinite void, a "timelessness" as, for instance, in the Slovak manifesto "White Space in the White Space"(S. Filko, M. Laky, J. Zavarsky) and also in the Knizak's mind actions or Malich's energies in space. Even the younger generation of Performance Art follows a similar strategy from 1970s. The actions of some artists, for example Jiri Kovanda, consisted of minimised acting, which is a protocol of the quotidian. Its social function was a neutralisation of the

oppressive existential situation and work with a "poverty of experience". This art is a restrained, consciously weak, a hardly identified project almost merging with reality. In the late 1970s the situation of the country's occupation during World War II, and after the 1948 Communist coup repeated itself, connected closely by similar failings of the cultural elite. Solving the dilemma between sense and conscience thus became one of the main and constantly displaced traumas of the time. The underground developed into its real meaning when it became an attitude of the artist renouncing advantages, but not clarifying positions under the pressure of the establishment. In the *Samizdat*-distributed "news" about the alternative music culture, the underground defined its aims: its aim was not to destroy the establishment, but to create a second culture which freed people from the scepticism that nothing is possible. The Chiliastic spirit of the underground bridged the contradiction of a formal and popular culture and maintained a lively culture in the most depressive situation of the hardening regime.

Besides the underground programme of 1970s, Jindrich Chalupecky's programme obtained a definite form responding to the atmosphere in the broad unofficial society of artists, which actually belonged to the first culture. In it, Chalupecky developed a criticism of socialism and capitalism in which state bureaucrats and businessmen both degrade art in a similar way and manipulate it commercially and ideologically. This variant of Modern Art arose through introversion, by turning to the solitude and individuality, through liberation from all obligations. Chalupecky borrows André Breton's expression "l'écart absolu", the absolute distance, for this approach. He was once again convinced, as in 1946, that art had lost its social function and there was no place to put it. Art surpassed the function of religion and

its goal was a renewal of the transcendence experience. Yet this is always connected with an experience of failure. Chalupecky needed to construct a model and discover an example for local artists. Marcel Duchamp and the famous conclusion of Duchamp's lecture "Where We Are Heading", which he gave at the Philadelphia College of Art in 1961, served to mythicise the artist, which was what the "Czech variant" needed. Chalupecky received the typewritten version of this lecture straight from the author. It spoke of an "ascetic revolution, which the audience would not even realise and which would only be elaborated on by a few enlightened ones on the edge of the world, dazed by the economic fireworks". In the spirit of Czech post-war experience, it is understood as a resignation of public activity and a descent to the anonymity.

Total distance has its parallel in Vaclav Havel's non-political policy and power of the powerless as well. The sources are similar: Western democracies did not offer a way out; they were only a milder way of manipulation. The way out is not an alternative to a political model but a return to the hidden sphere of the pre-political: existential revolution, moral reconstruction of society, a post-democratic system of parallel polis—outside a real antagonisms of society, was the perspective.

The 1980s brought a radical change of situation. The individual conviction of truth was replaced by *indeterminacy*, by an acceptance of the same neutral distance from everything. A new construction of truth and responsibility forbade total judgement. In 1984, a young generation began to exhibit, unofficially for the long time. They painted taboo and fragmentary stories with problematic truths and were more a virtual expression of possible projections to which the synthetic picture did not correspond. If to many artists it seemed as if normalisation seclusion meant the return to the basis of creation, the 1980s generation pursued the non-authentic and non-traditional and were not even interested in the conflict of art and power. New art amused itself with mythological situations, national symbols, the grotesque, but took them with the same distance as the most serious themes. Their relativisation of values was a shock to society. Jiri David's manifesto "Total Distance in the Time of Social Pallor" accurately represented the turning point. By coincidence its title "Total Distance" is almost identical with Chalupecky's "absolute distance," but has an opposite meaning. Contact with the "situation" took place namely on the language basis, language constructions and models. At the same time the excessively contrasted poles of immanence-transcendence, abstract-concrete are eliminated and authenticity is replaces by pallor. Not nihilism and alienation, but social enervation. The goal was to project art without programmes, without hierarchy and without "psychologising". Faded national symbols (meaning a situation of weakened ideology) could have been understood as a renewal of traditions in the time around 1989. However, in reality they demonstrated that contact with them was not straight and took place on a linguistic basis. The truth about the nation is more like of the story of language, which can't even be understood as a whole. The Postmodern project disrupted the moral base of the resistant attitude in the eyes of society and was criticised because the artist ceased to be the guard of morals and responsibilities, a specialist of transcendence and ceased to convey the anxiety of the victims.

Several of the artists' strategies, which were mentioned, can be easily extracted from post-war Czechoslovak history. However, after the regime change in 1989, artists lost their support in the situ-

ation that was restricting them as well as the source of their resistant energy. There has not been sufficient investigation into the fact that one of the consequences of political emancipation was the peaceful division of Czechoslovakia and ensuing "post-colonial situation". In radical terms, the Czech (dominant) culture and Slovak (minor) culture got rid of their disturbing parallels. We have not delved seriously enough into the question of whether or not this was a type of exclusion or, perhaps, displacement of an important part of our own modern art history (lasting from the inception of Czechoslovakia in 1918 to 1993, interrupted by World War II). Main problems of overcoming the traumas of change and reconstructing our own identity were, nevertheless, simplified. The revolutionary change in 1989 was followed by a conservative solution in the sense that a more difficult but more comprehensive whole wasn't upheld and particular interests were given priority. The anxiety following 1989 was without a doubt one reason for this. It was necessary to calm and temper it, and one of the ways to deal with the situation was to simply remove problematic differences and

substitute the sources. Productive tension was concealed by it and it the way for using the past and myth of pre-modern age was freed.

When the necessary consolidating space is created, Czech and Slovak art will probably from a distance be revealed in their close parallels and different variations of Modernism, as well as in their absolutely original allusive and subversive strategies. During the normalisation period of the 1970s, both sides of the lost Czechoslovak cultural space were looking for shelter from political reality, had problems with "non-tradition" and had their Byzantinisms and iconoclastic rebellion and transcendental escapes.

The next generational wave arriving in the early 1990s already knew how to count the rhythm of the new international style and were enchanted by its attraction. Some of the young artists redefined the idea of "distance" and put it into a different context. They understand it as an admitted poverty in the world where Benjamin's "poverty of experience" is an important phenomenon. A sense for reductive reality is connected with the revival of secondary elements on the most common basis, which cannot be ideologised, like, for instance, the installations of Jan Mancuska and Denisa Lehocka· and the videos of Jesper Alvaer. The central element of videos of Michal Pechoucek are ordinary, but at the same time fascinating objects of everyday reality. They are the focus of attention since they have never been part of social symbolism. Depoliticisation, the narrowing of the context, escape to the intimacy of everydayness, feeling of freedom without the obligations and traumas of the former political situation are a universal appearance. The renewal of art, active in the political context as in the work of Jiri Suruvka and Jan Kotik, was still a rarity at this point. One of them gained his sense for involvement from the reality of the periphery, the other

Tomas Hlavina
An Attempt to Define Two Ways, 1996

from the experience of Western society. Milena Dopitova analysed identity as a social problem, as an intimacy made public and an open situation of choice, where one can decide between abidance and change. The contradictory names of her works: "I Don't Count on My Changing." - "Don't Be Afraid To Take that Big Step," sounded merely symbolic during the period of transition.

Yet central Europe has wider problems concerning pan-European integration, and the identity crises of post-Communist states have to be discussed outside the narrow context of a post-totalitarian regime. The problem of how to reconstruct self-defences arose for their culture; how to reconcile its old resistance and new enticing strategies of adaptation; how to fill ourselves like cannibals with the otherness of large culture centre models—how to digest them. The renewal of Central Europe should not be similar to the activity of the "stone ladies" in Marguerite Duras's "Tangible Life." They "arose from the ruins of the war and have spoken of Central Europe for the past forty years…" and "always, again and again, Europe is renewed on the basis of their friendly terms, acquaintances, social and diplomatic connections, Viennese and Parisian balls, the dead from Auschwitz, dead exiles". We would rather believe Czech historian Dusan Trestik when he writes that renewal will have to proceed by "thinking out" of a new political and cultural identity of nations on the threshold of Europe.

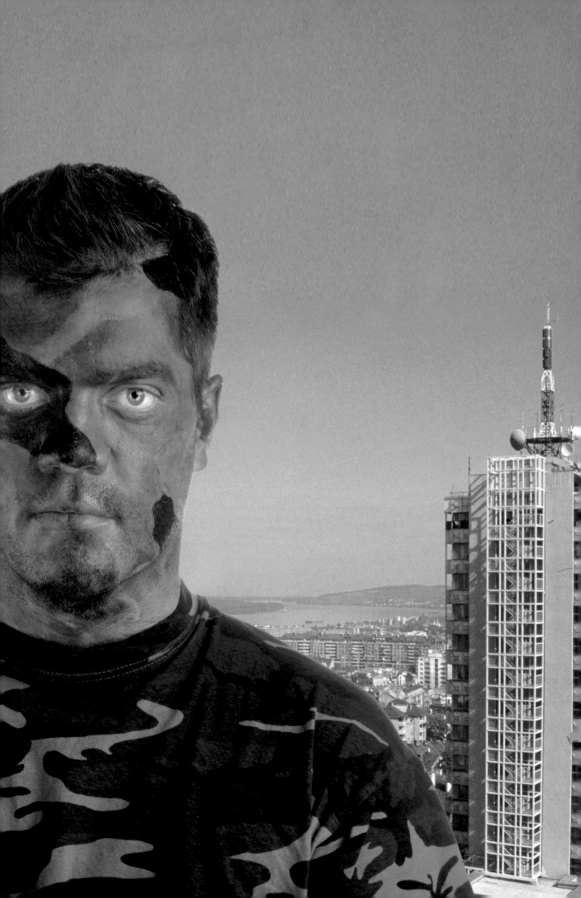

The End of Yugoslavia
On Social Utopias and Artistic Realities

Zoran Eric

The Loss of Collective Identity in Socialist Federal Republic of Yugoslavia

The question of identity and identification has been one of the most frequently raised in the European post-socialist countries since the fall of the Berlin Wall in 1989. The shift in ideology and the dominant social paradigm were critical factors that started reshaping the social space of these countries, and resulted in serious inner confrontations among the citizens. The period needed to accept the process of transition was very long, and had its ups and downs in most of the countries of the region that subsequently became members, or still are on the waiting list for joining the European Union.

The case of the former Socialist Federal Republic of Yugoslavia was the most specific, because the transition did not occur in a peaceful way. The brutal civil wars and ethnic conflicts, first in Croatia in 1991, and then in Bosnia in 1992, shaped up each one's social space in a radical way, and strongly affected the development of the newly formed states. One of the most specific cases was that of the Federal Republic of Yugoslavia that passed the period of complete isolation from 1992 till 1995 due to the sanctions imposed by the UN, and finally in 1999 was bombed by NATO countries, which devastated its already weak economy and infrastructure.

When the old Communist systems of values and the ideology of "brotherhood and unity" collapsed, the changes in collective identity were inevitable. The newly formed oligarchies that came to power abused the fact that citizens needed to acquire new identity, and to identify either with political, national or other programmes and goals. In this situation, when the question of collective identity became blurred and confusing for most of the citizens, it was very easy to turn to the over emphasised national identity and "rediscovery" of national, and ethnic identity as being "older" than the ones of other neighbouring nations. The proof for this claim was found in rich national histories, so the process of recirculation of national myths, started to strongly shape the public opinion through all the media. History was therefore "understood as the active force that determines the roots of nations, nurtures the constitutive myths of ethnic communities and strengthens the national identities."[1]

In the almost half-century-long history of the socialist (Communist) doctrine in

Yugoslavia, the ethno-national factor had to be suppressed by the idea of self-management of the working class, and solidarity of all comrades, regardless of their ethnic origin. From the beginning of the fifties the concept of national unity was cherished, and even a *new* national identity—namely the Yugoslavs—was created and introduced in 1961 in the demographic poles, and in the declaration of citizens in official documents. A growing percentage of citizens, and especially those coming from mixed ethnic marriages, tended to adopt a new identity and claim that they are just Yugoslavs. The chance of pacification of ethnic differences that this identity offered was constantly endangered with ethnic outbursts of nationalist that could not see Yugoslavia

as a fulfilment of their national goals and opted for independent nation states. The cases of nationalistic movement in Croatia in the early 1970s, and demonstrations in Kosovo in the beginning of eighties, are just some of the examples.

The ultimate efforts in creation of a civil society were the reforms of the last prime minister of SFR Yugoslavia, Ante Markovic. They were focusing on four fundamental principles: the free market economy; the opening up of the country to world; the establishment of a legal state, and development of civil rights; and the democratisation of political life with introduction of the pluralistic parliamentary democracy. This programme faced strong resistance from the Communist oligarchy in the republics, because it was compromising

all previous pillars of the doctrinaire rule, and all the monopoly that public companies possessed. The Serbian leaders immediately launched a media campaign against the reforms and, finally, with the break into the monetary system and the illegal emission of dinars, fully undermined the policy of reforms and devastated the state budget with a loss to the value of US$1.5 billion.[2]

Thus the last chance for choosing a civil society, instead of a purely ethnic one, was lost due to the prevailing "national awareness", which led to the ethnification of the republics in SFR Yugoslavia that struggled to find common ground in a peaceful manner. It was obvious that the state apparatuses were unable to mediate between a common state identity and the more specific national identities, but those identities were competitive and at variance with each other.[3] The consequence was inevitably disintegration of the country and ethnic clashes.

Specific Serbian Situation

In Serbia, Slobodan Milosevic came to power as the champion of the "anti-bureaucratic" revolution and the doctrine of "national revival" conceived by the Serbian intellectuals. When the nation replaced class as the basic ideological principle, opponents to the regime became enemies of the state.[4] The pathological milieu that was soon produced was marked by the strong authoritarian politics, national-chauvinism, warlike spirit, hate spread through the media, and xenophobia. One of the causes for the production of such a drastic social space could be seen in the strongest wave of ethno-nationalism recorded in recent European history, accompanied but the equally strong wave of populism that were incidentally conceived and conceptualised in the highest scientific and cultural institution, the Serbian Academy of Arts and Sciences, through its *Memorandum*

on Actual Social Questions.. On the other side the sanctions by UN and the complete isolation of the country, plus the breakdown of official communication with the rest of the world, caused the "economy of destruction",[5] economic collapse with the highest rate of inflation ever recorded.

Another aspect that runs along with the wave of ethno-nationalism was the wave of populism, favoured by the political oligarchy, which respectively came back to the sphere of culture and "contaminated" it. The effects were so strong that devastated the most important cultural institutions that started to reproduce this ideological matrix. The exhibitions that were organised and shown in the National Museum and the Museum of Contemporary Art in Belgrade had a task to glorify the history of Serbian people and to recycle the national myths from the past, mainly from the golden period of the medieval Serbian Empire. The "works of art", presented at those exhibitions could be therefore read as symptoms of the social pathology of the milieu in which they originated. The socio-political context in the country was strongly influencing the citizens and was forcing them to choose whether to conform and identify with this dominant wave; to oppose it; or to try to ignore it by withdrawing themselves from the social sphere. The brutality of the social reality was very traumatic for the artists, and therefore the immediate reaction to the social conditions was delayed till the mid-nineties, when some of the most prominent Serbian artists started to reflect on the problem of loss of identity and the confusion of citizens that couldn't find their response to this situation.

Withdrawal from the Public Sphere
Due to the socio-political circumstances, the condition in which Serbian artists worked could, without exaggeration, be called traumatic. The lack of information

and cultural contacts with international centres of art, as well as the psychological feeling of deprivation, confinement—and even repression—has certainly left its mark on them. For the artists who did not want to conform to the dominant ideological matrix and accept this "mainstream", the trauma they experienced had a different effect, and caused strong reaction. One aspect was the withdrawal from the social, public sphere into the closed, hermetic artistic circles, and the strategy defined as *active escapism*.[6] Another was the gathering of artists into groups and associations like Urbazona[7] or Led Art[8] with the aim to criticise, oppose, and "face" the social reality with the engaged artworks.

This problem regarding the relation of the artists towards the social sphere could be defined through the "ever-present" dilemma whether to emphasise aesthetic or ethical aspects of their work. For the beginning of the nineties, in the brutal situation of warfare raging all around, and the total collapse of the economy, it was noted that Serbian artists were primarily concerned with aesthetic issues in their art, and rarely reflected openly on social issues, either analytically, critically, ironically or committedly. The impression prevailed that the majority of Serbian artists did not work *in socius*, and react neither to social circumstances nor to their marginalised position, but had turned to formal problems immanent to the artistic medium and material.

Since the mid-nineties, first sporadically and then more overtly, the generation of artists formed in this decade turned their focus on the socio-political sphere. It also marks the turning point in the careers and even in the artistic strategy of some of the most prominent Serbian artist in the nineties (Apsolutno, Skart, Milica Tomic, Uros Djuric, Zoran Naskovski, Tanja Ostojic, Mihael Milunovic, *et al.*), who shifted their work form aesthetic to ethical issues, but also from the more conventional media like painting and sculpture to the more conceptual use of the various media, that is, new digital reproductive technology, video, or video-installations.[9]

Stepping Again into the Public Sphere

After the political changes of 5 October, 2000 a certain period of interregnum and a new break concerning "large-scale national projects" occurred, together with an attempt to homogenise the citizens and to create the new models of identification. New (proto-)democratic society in the public field initiated the idea that all progressive forces—including artists—should actively participate in carrying out the reform and contribute in producing a "better society".

However, there are still many problems in the public field and the way of its production and reconstruction. The enthusiasm that dwindled after the first years of change opened many possibilities for further critical reflection of social processes so, unlike a directly politically committed art which lost its *raison d'être* a new strategy slowly started to develop characterised by its consciousness of the need for a reflection of social processes, a consciousness of the need for work *in socius*. This new strategy started to occur in the public sphere, gradually, and the artists performing it are dealing with a subtle ironical or self-ironical approach regarding the situation in the social sphere. With their work and interventions those artists started to *appropriate* some spaces in the public realm and to leave traces of their *subtle presence*.

Finally, although in these years a paradigm of mythological fabula has been replaced with much more pragmatic models offered to the citizens for their identification, a constant state of uncertainty and expectation of a realisation of vague aims continues to make the individual passive, keeping him in lethargy and preventing him to join the public field more actively.

Dejan Kaludjerovic
Electric Girl 15, from the series
"The Future Belongs to Us II", 2003

After the political changes in Serbia, the cultural contacts with the former republics of SRF Yugoslavia are being intensively re-established and the art exchanges are taking place more often then in the nineties. In the meantime the FR Yugoslavia has changed the name of the country into "Serbia" and "Montenegro". After the disintegration of the "second Yugoslavia" and the unsuccessful effort to maintain its continuity with the "third Yugoslavia", the name of the country and the national identity of Yugoslavia officially ceased to exist in February 2003. The comparison between the new countries, their specific socio-political, economical and cultural conditions and the phases of transition should be the topic of more thorough research and investigation. Nevertheless, one common denominator could be analysed and followed as a thread on the artistic scenes of these countries: the art practice that could be generally described as a socio-specific work, or the work *in socius* that constantly reflects, analyses, questions, and deconstructs the most pertinent problems in the public sphere. Therefore, I would like just to outline some of the main topics and examples of this artistic strategy.

Artistic Strategies
From Collective to Personal Identity
One of the first paradigmatic art works that addressed the issue of collective (national) identity and identification in Serbia was the video installation by Milica Tomic – *xy ungelöst* in 1997. The work was highly politically motivated and the artists reconstructed of the crime that hap-

Miodrag Krkobabic
Portrait of an Unknown Man with a Beard, 2000-2004

pened on 28 April 1989, the very day of the declaration of the new Serbian Constitution, when thirty-three ethnic Albanians, citizens of Kosovo, were murdered. Her later work *I am Milica Tomic* from 1999 was more "programmatically" dealing with the issue of national identity: through a statement expressed in different languages she affirmed her belonging to numerous nations. It may be said that this work dealing with the problem of identity and identification (national in this case) opened up the discourse on the Serbian art scene, and that several younger artists, (Miodrag Krkobabic, Vladimir Nikolic, Zolt Kovac, Nikoleta Markovic, Vera Vecanski, Jelena Radic, etc.), took upon this problem in all of its ramifications. This

generation of artists entered the scene by the end of the nineties, had very strong conceptual background from the beginning of their work, and started using various strategies, always in the most appropriate media, to address different aspects of the process of identification and acquiring of social, gender, religious, and above all, professional artistic identity.

Miodrag Krkobabic is dealing principally with the problem of "our inability to pin down a personal identity" that is always changing and relational. In one of the latest projects *Portrait of an unknown man with a beard*, Krkobabic is using the form of police photography, *en face* and two profiles, but mixing the eye-line of friends and colleagues with his own face and marking the photos with the personal ID number of the one whose identity he is "borrowing". His own process of identification was interwoven with the same process of the members of his family, friends and his colleagues from the art-world. These encounters in daily life and in the sphere of work are influencing and shaping the personal identity of the artists, always adding something to it, and setting a track for an identity formation process that is eventually never going to be fully concluded or determined. This statement could be supported by the thesis of Ernesto Laclau that identity cannot be understood as something fixed, and should therefore always be a process, never an artefact. Laclau develops this argument further with the stress on the necessary incompleteness of identity formation. As he puts it, *the field of social identities is not one of full identities but of their ultimate failure to be constituted*.[10] He argues that any articulation of identity is just temporarily complete, it is always in part constituted by the forces that oppose it (the constitutive outside), and always contingent upon surviving the contradictions that it subsumes (forces of dislocation).[11]

In the case of Krkobabic this line of argument could be expressed with his statement from his first video *6=36* where he was using a narrative mode and documentary approach to tell the story about the relationship between his five friends from childhood and himself: "story of 6 men becomes a story of 36 identities".[12]

One of the representatives of the youngest generation of internationally present Serbian artists, Jelena Radic, started dealing with the gender identity issues, and commenting on different aspects of feminine representation derived from various sources in the public sphere. She was always using different, "inappropriate" media, such as paint, to show the image of the instructions for using tampons, or embroidery to show scenes from the pornographic magazine. This strategy of mixing and combining media and content in the peculiar, sometimes even bizarre way, culminated in the work *Family album*, where she manipulated photographs from her family album to create hybrid faces, like Siamese twins, thus revising personal "family history" into a horror story or a textbook of genetic mutations.

Social Utopias

The manifesto of Autonomism declared by Uros Djuric and Stevan Markus in 1994 was one of the most conceptually defined attitudes regarding the socio-political milieu of Serbia of the nineties. Later on, Djuric shifted from paintings to web-projects that reflected issues like populism. His argument was that populism could be understood as the new ideology that replaced all other social utopias. The Populist Project consists of three segments: *God Loves the Dreams of Serbian Artists, Celebrities*, and *Hometown Boys*. The last part is the simulated virtual Serbian magazine (or the First Serbian Porn, Art & Society magazine as he calls it) *Hometown Boys*, just showing the front page with content of the issue that covers actual topics,

whether related to his artistic career and the "world of art", or presenting his comment on the political sphere. Taking the form of the magazine or the manifesto as in the practice of historical avant-garde, Djuric is reflecting at the same time personal dreams and phantasms as well as the creation and production of new social utopias. This was best exemplified in the series of performances with photographic documentation where Djuric is posing in the outfit of the football-player of different clubs, like Sturm from Graz and Dinamo from Tirana. The football stadium could be therefore seen both as a space for production of individual fantasies (of success) and as an arena for the public (populist) display of national aspirations and anxieties.

Similarly, in his series of performances and photo works, Mihael Milunovic is allocating himself another social role, namely the position of Mister President himself. Taking all attributes of an authoritarian leader, and showing his insignia and rituals, like the inevitable kissing of the especially designed flags, Milunovic is commenting both on the well-known personality cults in former Yugoslavia, as well as the new situation in Serbia and the presidential elections, where new rules from "Western democracies" are being grafted onto electoral media campaigns.

Labour and Trauma

The problem of the working class and labour had to be re-examined in the societies in transition. The free market economy, privatisation of public companies, and the tendency towards neo-liberal society were cruel for the working class of the former socialist countries. One of the effects of this situation in the public sphere was the new advertising and marketing strategy, and the flourishing of spaces for political and commercial ads in urban settings like billboards, displays, panels for advertisement, and even facades of large buildings.

Jelena Radic
Everything Shines Here, 2003, video

The Croatian artist Andreja Kuluncic is using this pretext for the socio-specific research she conduced in Zagreb with her project *NAMA 1908 employees – 15 department stores*, dated 2000. She was thematising the bankruptcy of the public company NAMA («Narodzi Magazin» or «People's Store»), a major chain of department stores in former socialist Yugoslavia. The company stopped all the activities and left 1,908 employees—mostly female—without job, who continued with protests and kept the department stores open.[13] Workers' strikes, and bitter economic conditions caused by the transition to a competitive free market economy, prompted the artist to deal with the problem exactly by placing posters and billboards with the images of women workers underlined with the text *NAMA 1908 employees – 15 department stores* in the public space. The "glamorous" way women from NAMA were represented was conveying exactly the opposite situation of confidence, calmness and trustworthiness—the usual messages addressed to the consumers in commercial advertisements on billboards and TV commercials. With the opening up of public debate over the problems of privatisation of state-run companies, Andreja Kuluncic was also pointing out the shift from collectivism to individualism, and to the personal histories of the publicly "invisible" workers. In her subsequent projects she started focusing on all marginalised categories in the society in transition, on all "unimportant voices that are rejected in

statistics"[14] which led to socio-specific research projects and the development of multidisciplinary working teams.

From different perspective of Sarajevo, the city that suffered the most during the war in Bosnia, Maja Bajevic is posing the question of female labour and rebuilding of the new complex transitional society. In her performance *Woman at Work*, in 1999 she was doing embroidery with five women refugees in Sarajevo on the net protecting the scaffolding of the building of the National Gallery of Bosnia-Herzegovina.

Maja Bajevic was examining the question of labour from the different angle, emphasising the role of women's labour. She was placing the Woman to work in the public space, and shifting the stereotypical position of the female labour that should be confined to the private sphere of the house, with the exclusively male public space. By doing so she was reverting the most pervasive (patriarchal as well as capitalist) representation of gendered space, that is, the paradigm of the "separate spheres", an oppositional and an hierarchical system consisting of a dominant public male realm of *production* (the city), and a subordinate private female one of *reproduction* (the home).[15] These gender relations were constructed socially, culturally and spatially but in the most drastic situation of war and the four-year siege of Sarajevo, most of the women were forced to confine themselves to the space of the home, and to "feminine" domestic labour. Finally, the performance *Dressed Up* where the artist is sewing the dress from the material on which the map of SFR Yugoslavia is printed could be seen as a re-enactment of the trauma of war, and the destruction and disintegration of the country.

1. Bozidar Slapsak, "Promene proslosti u drustvu koje se menja", Republika 64 (15–31 March 1993): 16.
2. Mladjan Dinkic, Ekonomija destrukcije (Belgrade 1996).
3. Vesna Pesic, "Rat za nacionalne drzave", in Srpska srana rata, Part 1, ed. by Nebojsa Popov (Belgrade: Samizdat B92, 2002).
4. Erik D. Gordi, Kultura vlasti u Srbiji, Nacionalizam i razaranje alternativa (Belgrade: Samizdat B92, 2001), p. 26
5. Mladjan Dinkic, Ekonomija destrukcije (Belgrade 1996).
6. Lidija Merenik, No Wave in Art in Yugoslavia 1992–1995 edition of Centre for Contemporary Arts, Fund for an Open Society (Belgrade 1996).
7. Urbazona was the movement that emphasised the need for restoring the "urban values" and popular culture that was in danger of fading away and disappearing under the wave of populist "turbo-folk" scene.
8. Led Art is a loose association of artists that gathered occasionally to make happenings, actions and performances. "Led art" means "Ice art" and it was a metaphor for the closed society in which the artists are forced to work.
9. The shift in work of some artists was probably the main reason for consequent international recognition of their art that resulted in the breakthrough on the European or even global art scene, mainly through their personal engagement and persistence.
10. As quoted in Michael Keith and Steve Pile (eds.), Place and the Politics of Identity (London-New York: Routledge 1996), p. 29.
11. Ibid., pp. 25–29.
12. Unpublished artists' statement.
13. Nada Beros, Volume-Up. Andreja Kuluncic Catalogue Selection (The Art Centre Silkeborg Bad, Denmark, 2003)
14. Ibid.
15. See Gender Space Architecture, ed. by Jane Rendell, Barbara Penner and Iain Borden (London-New York: Routledge 2000).

The Neo-Avant-Garde between East and West

Lorand Hegyi

Many years after the fall of the Iron Curtain, the myth of "Eastern Art" is still thriving, but a full historical analysis of the former so-called Eastern Bloc has not been conducted yet.

Artists who emigrated to the West in the sixties have for a long time been considered "Western artists"; artists, however, who remained in the East are still typecast as "relics" of a mythical resistance movement. The Iron Curtain, as a border between Western—free, pluralistic, and democratic—and Eastern—manipulated, monolithic, and suppressed—art, is still the object of "negative admiration", seen as an oddity rather than something that would merit a historical, scientific, and unbiased analysis.

However, the oeuvre of Christo or Opalka, of Abramovic or Jetelova clearly illustrates that the cultural infrastructure functioned differently than imagined by the West for a long time. The impact of these artists was not just based on a passive absorption of certain modes of thinking conveyed, as it were, by Eastern European artists living in the West; rather, it related to a "reactivation" of a critical avant-garde attitude which was present despite all the political, ideological, and economic pressures exerted on intellectual and artistic life in the East. This reactivation also meant a preoccupation with questions like identity, national artistic developments, traditions, avant-garde, resistance, freedom, autonomy, or "subservient art", and so forth. We should not forget that some of the most significant proponents of the legendary Eastern avant-garde continued to work at home after 1945 (more precisely after 1948). Their influence on cultural life, for all its limitations, should not be underestimated (Lajos Kassak in Hungary, Wladyslaw Strzeminski and Henryk Stazewski in Poland, Surrealist groups such as "7 in October" or "Group 42" in Czechoslovakia). Hence, the so-called "Neo-Avant-garde" of the sixties and seventies did not prosper in an intellectual no-man's-land. It built on the very rich legacy of the early avant-garde movement whose focus, up to the early thirties, was distinctly international. It is important to note that discussions, including quite heated ones, on New Art and the options and functions of art always took place in a climate that regarded avant-garde as a lively and worthwhile tradition, or even a topical form of intellectual creativity and

Page 94
Roman Opalka
Opalka1965/1- ∞,
Detail 5447779

Roman Opalka
Opalka 1965/1- ∞,
Detail 993460- 1017875

suggest that they strove to take an original, a unique approach—oscillating between Western art dominated by America and Eastern art governed by official cultural policy and the pervasive notion of realism. Post-painterly Abstraction, Hard Edge, Minimal Art, Conceptual Art, Post Pop Art, and Structural Abstraction are quickly, skilfully, and innovatively internalised by young artists—and sometimes even copied—but often just at a formal level. At the same time, they embark on a theoretic or idealistic search for their own origins, sometimes merely to justify themselves. They set off on an original journey, following indigenous traditions so that they can modify the substance of formal systems taken over from the West. What is typical of this period is the articulation of abstraction: artists are looking for themes and materials to fill purely abstract formal structures with substance, with a view to allaying any suspicions about promoting formalism, toying with form, or engaging in *l'art pour l'art* exercises. Therefore, in purely abstract formal structures, one identifies symbols and themes and interprets them as metaphors and "messages", entirely ignoring their original structural and phenomenological principles. The geometric and abstract picture becomes a literary metaphor, and it is claimed—often erroneously—that it fulfils an illustrative function. Contemporary artists voice moral concerns over pure abstraction, not for aesthetic but for ethical reasons: it is crucial that the picture "tell" something.

It would be fallacious to assume that this is due to the ideological repercussions of the aestheticism of Socialist Realism. In fact, the aesthetic developments occurring in Central and Eastern Europe differed markedly from those in the West. First-generation avant-garde artists shared a utopian and romantic vision—to subject art to the processes of social upheavals—allowing them to change mankind and to improve society radically. This Schillerian,

artistic utopia. Unlike in the West, Eastern European neo-avant-garde of the sixties and seventies interacted much more harmoniously with art of the first half of the twentieth century. While this may provoke critical remarks about its parochialism, it is nevertheless a historical reality. Continuity was much stronger than surmised in the West.

The oeuvre of artists working in the sixties in Central and Eastern Europe was marked by a dual aesthetic strategy, both naive and messianic in kind. On the one hand, progressive artists tried—radically or sometimes quite naively—to catch up with "Western art", a rather fuzzy concept, for all intents and purposes. On the other hand, there is plenty of evidence to

Karoly Kelemen
Duchamp Face to Face, 1978

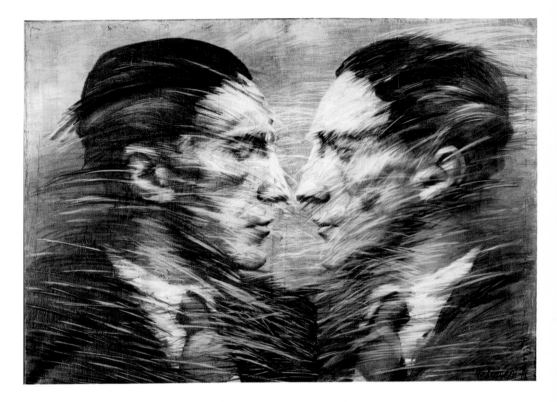

romantic, and revolutionary attitude has nothing in common with *l'art pour l'art* of the late nineteenth century. It turns the artist into an educator, an architect of the future, a revolutionary "soldier" who fights to make the world a better place.

Central and Eastern European artists of the sixties attempted to integrate western developments into their work, while also exploring their own identity. This manifested itself in an often anachronistic form of interpretation, and in an artistic movement that considered itself a continuation of the Eastern European avant-gardes of the first two decades of the twentieth century.

This ambivalent and contradictory situation spawned great artists who, in their oeuvre, overcame this historically necessary anomaly to create something universal, something that transcended the discourse of their era. Roman Opalka's oeuvre is a telling example of an artistic position that can no longer be interpreted within the confines of an East-West dialog but within the vast context of "eternal art". For all the loftiness of this statement, it is both realistic and historically correct. Roman Opalka was inspired by Kasimir Malevich's Suprematism, Strzeminski's Unism, but also by the new currents of Conceptual Art. His work is positioned half-way, as it were, between East and West, between mysticism and pragmatism, between transcendence and structuralism. But we are dealing with something else here: Roman Opalka led

Braco Dimitrijevic
Triptich Post Historicus: Picasso,
1988

art back to its "source" without declaring this vociferously and didactically. He took the claim very seriously that art is identical to, and yet essentially different from, life (the contradiction is merely apparent). In a stroke of artistic genius, he highlighted this simple and fundamental statement by placing it in the middle of his oeuvre and by finding the adequate means of expression. He did not want to do Conceptual Art, he did not want to reify a "dematerialisation process", he just wanted to demonstrate this factual and yet radical attempt at identification. That is how he succeeded in detaching himself for good from the "national avant-garde approach", and in articulating his feelings

as a fully independent artist. He no longer appeared as an importer of Western art into the East, but started making unique contributions.

As Roman Opalka became a "timeless" and "homeless" artist, he achieved general validity. Attaining this kind of artistic and moral sovereignty, overcoming East-West conflicts, rising above the disparities between one's own tradition and international artistic language (which always remained murky and ambiguous, for that matter)—that feat was only performed by those artists who regarded the naive and ahistorical opposition between "East" and "West" as uninteresting, anachronistic, and irrelevant. They focused solely on their art since they felt that this was the best way for them to advance the human cause. Their commitment ushered in a new era of art in the former Eastern Bloc, one that could no longer be captured by applying traditional criteria.

The oeuvre of Marina Abramovic, Magdalena Jetelova, or Braco Dimitrijevic is a case in point, as it imbues the internationalism of artistic language with a unique and authentic substance, severing the mythical ties to time and place with self-confidence utterly atypical of the East.

These artists do not just endeavour to be engulfed by Western art or to import Western art to the East; they also postulate their independence, they stress their education and culture, but these do not really differ from the West. To put it differently: This generation no longer intends to conceal its eastern origins. On the contrary—it turns this "disadvantage" into an "advantage" (politically, geopolitically, infrastructurally, and economically) and radicalises questions relating to the essence and function of art. That creates a linkage between East and West which fundamentally challenges categories like "Eastern art" and "Western art". Belgrade and Prague, Budapest and Warsaw, Bratislava and Sarajevo, are defined as

authentic art places, and it is from these vantage points that artists can scrutinise western infrastructures and marketing systems. Artists who transport this pointedly critical attitude from their home country to the West may call themselves "unaffiliated"—they are no longer Eastern artists and not yet Western artists. Because of their radicalness they have overcome this pseudo-polarisation in a fatalistic and romantic manner. And that is exactly how they are able to have a lasting impact on their national art scene. They loosen masochistic, self-tormenting inhibitions while neutralising the pseudo-romantic ideology of "uniquely" Eastern developments. Their position in a no-man's-land makes them appear as guardians of a universal attitude towards art.

This enlightened view, which dispenses with any naive or educational artistic ideology of the '68 generation, may be called the new and authentic position taken by artists from the former Eastern Bloc. It has significantly influenced the way in which art is perceived in central and Eastern Europe. It has given rise to the art of this "sandwich generation", placed between East and West, between idealistic revolutionary romanticism and resigned private mythology, between pseudo-romantic globalism and nostalgic parochialism. These are authentic and confident contributions to art that will not accept any simplified framework or ahistorical model.

Karoly Kelemen
Serrasmoke, 1999

Were We Looking Away?
The Reception in the West of Art from Central and East Central Europe at the Time of the Cold War

Henry Meyric Hughes

There have been a number of different visions of Europe, not all of which (from Napoleon's to Hitler's) we would nowadays regard as benign. The meeting at Yalta between Churchill, Roosevelt, and Stalin in February 1945[1] determined the shape of Europe and the pattern of relations for the next fifty years. But only the threat of "Greater German" hegemony had been sufficient to hold together the anti-Fascist alliance between the Soviet Union and the Western capitalist democracies. The Western nations were anxious to get on with the business of rebuilding their shattered economies, with American support, and preferred to meet the Soviet threat with a policy of containment, rather than one of confrontation. In Eastern Europe, the struggle against foreign domination went on and ideas of resistance and of civil disobedience took root. Already, in a famous speech at Fulton, Missouri, Winston Churchill had warned of the impending danger:

"From Stettin on the Baltic to Triest on the Adriatic, an iron curtain has descended across the continent. Behind that line lie all the capitals of the ancient states of central and Eastern Europe—Warsaw, Berlin, Vienna, Budapest, Bucharest, Prague, Vienna, Budapest, Bucharest, and Sofia... This is certainly not the liberated Europe which we fought to build up."[2]

There was a brief moment of uncertainty, from 1945 to 1948/49, when the Communists sought tactical alliances with the socialist parties in Eastern Europe, but after that, the ideas of a Danube confederation or of a wider "United States of Europe", of the kind envisaged by Churchill, to counter Soviet expansionism,[3] were replaced with a fragile equilibrium between two opposing power "blocs", represented by NATO and the Common Market, in the West and the Warsaw Pact and Comecon, in the East.

The next four decades form the core period covered by this exhibition, which was dominated by a Manichean, and sometimes apocalyptic, view of the ideological struggle between East and West. Images of an "Iron curtain" and of a homogenous East (or Communist) "bloc" all too often obscured from western observers the varied contours of Central and East Central Europe and its convoluted past, whilst the peoples inhabiting that region felt cut off from their natural historical and political affiliations to the West, abandoned to their own devices

101

and thrown back on their inner resources. Right up to the fall of the Berlin Wall in November 1989, Westerners seemed content with their version of a Little Europe, based on the Franco-German alliance and rooted in the assumption of growing material prosperity, under the protective umbrella of the United States. The overthrow of the Communist regimes in Eastern Europe changed everything, at a stroke, and the choice of Berlin as the eventual capital of a reunited Germany signalled a dramatic shift eastwards of Europe's centre of gravity.[4]

The Soviet domination of Eastern Europe, which began with Stalinisation in the late 1940s, was characterised by successive waves of liberalization and repression, reflecting the key political developments in Moscow, such as the (relative) "thaw" of the Khrushchev era, from 1956 to 1964, the stagnation of Brezhnev and his short surviving successors, from 1964 until 1985, and the "perestroika" of Gorbachev, which ended in the disbandment of the Soviet imperium, in 1991. It was punctuated by Stalin's rift with Tito in 1948, which led to Yugoslavia's positioning outside the main socialist camp and the "Finlandisation" of Austria in 1955, as well as the workers' uprising in East Berlin in 1953, the Hungarian "counter revolution" in 1956, the Prague Spring in 1968 and the rise of the Polish Solidarity movement in 1981–82, with all their attendant consequences.

Each of these events had major repercussions within the countries concerned and a powerful effect on their political, economic, and cultural development, but local circumstances varied so much, from one country to the next, that is impossible to speak of a uniform or synchronous development throughout the region, as a whole. This is particularly true of the cultural field and the gradual recovery of artistic life from the blanket imposition of Socialist Realism to the attempted nation-

alisation of the means of artistic production (i.e., the imposition of state control over the academies, studios, awards, commissions, sale of artists' materials, and practically everything else affecting the individual artist's means of livelihood). Initially, at least, artists not playing a full part in the official unions or academic groupings worked in a position of near-isolation, and their achievements were local and unreported. Such news of their activities as reached the West was due largely to the occasional relaxation of constraints on the movement of people, works of art and ideas, reflecting the barometric changes in the political climate, referred to above, rather than in response to pressure from artists, critics, dealers or curators in the "free world". Even within the east bloc itself, it was sometimes easier to gather up-to-date information about artistic life in the West (or the Soviet Union) than in neighbouring countries.

One point which is often emphasised by those who are anxious to defend the notion of an unbroken continuity in the cultural development of Europe as a whole, is the common intellectual heritage of all parts of Europe, which had been affected by the great religious and intellectual movements from the Middle Ages onwards, as well as the social revolutions, of which Marxism was one of the principal motors, and early Modernism, in which Vienna, Prague, Budapest and other capitals in the region had played a notable part. There is truth in this, as there is in the assertion that Marxism is itself an important part of the western heritage, but should not be allowed to forget that official ideology allowed no room for the study of individual psychology (Freud or

Nietzsche, Surrealism or Existentialist philosophy), that Adorno and the Frankfurt School were unknown, Benjamin unheard of, and that structuralist philosophy and its aftermath were regarded in official quarters ad characteristic products of late capitalist decline. Many of the principal sources of twentieth century modernism were banned, occluded or partially inaccessible to the majority of artists and intellectuals, throughout much of the period in question. In contrast, much of the most creative thinking of Marxist philosophers an theorists (Lukacs and his school, for example, or Brecht and his followers) had been completed by the 1950s and passed over into the western corpus of thought, where it reached the American campuses at the time of the Vietnam war and became absorbed into mainstream political discourse in western Europe, at the time of the protest movements of 1968. Official culture in the countries of central and eastern Europe languished in a heavily subsidised limbo, and access to popular western culture was blacked. It was left to individuals to pick up the threads of their own traditions and tie these together with their fragmentary perceptions of what was going on in the West.

Socialist realism was only pressed into service in the satellite states of Czechoslovakia, Hungary, and Poland, in the period from 1949 until the death of Stalin in 1953 or, at the latest 1955. It barely survived, as a style, though the link between socially committed art and some form of realism lasted a great deal longer. At the very last, Socialist Realism provided independently inclined artists with a negative model, against which they felt an urge, and even a moral compunction, to react, often by retreating into a private world of denial or by explicitly renouncing the possibility of social engagement.[6] It helped to sustain a widespread belief in the myth of the inviolability of the avant-garde, for some time after such illusions had been dispelled in the West and provided their work with an ethical determinant which was to be a frequent source of misunderstanding in the West.

Throughout most of the 1950s, it was virtually impossible for artists from eastern Europe to travel and exhibit in the West, unless they belonged to the privileged elite associated with the official unions and state-run institutions. Countries such as France and Italy still had large Communist parties and many Communist sympathisers among artists and intellectuals, but the position of Stalinists among these was fatally weakened by the brutal suppression of the Hungarian uprising in 1956. What was occasionally exhibited in state-sponsored exhibitions of East European art in the West merely served to reinforce a western prejudice against figurative painting, in general, and "art engagé", in particular. Westerners scarcely suspected the existence of an alternative art scene in certain of the countries in Eastern Europe and implicitly rejected the notion of "inner emigration".

Art in Yugoslavia was freed from most stylistic constraints by around 1950, after which official blessing was bestowed on a wide variety of personal forms of expression, ranging from naive or primitive art, to abstract art and magical realism. Tito is known to have spoken out forcibly against modernist artistic tendencies, in the semi-private of his own circle of supporters, but from the 1950s onwards, Titoist Yugoslavia did much to promote contemporary art, both at home and abroad, as a sign of political liberalism (though artists were well advised to avoid any direct allusion to political themes) and as a demonstration of cultural independence from the Soviet "bloc".

The situation in Austria in the early 1950s was comparable to that in Germany, insofar as the country was divided up into different zones of allied occupation (until 1955), and regional centres, such as Graz, Innsbruck, and Klagenfurt were almost as important to incipient cultural life as the capital, Vienna. However, in contrast to Western Germany, little or no attempt was made to come to terms with the recent past or to rehabilitate the modernist artists and intellectuals who had suffered persecution at the hands of the National Socialists. This explains, in large measure, the violence of the Actionists' revolt against bourgeois attitudes to sex and religion and the limited impact of contemporary Austrian art outside the country itself, until the early 1980s.[7]

As so often, in the history of East-West relations in this century, Germany has played a pivotal role. Indeed, there is a sense in which it might be said that the early ideological struggles of the Cold War were played out on the territory of divided Germany, with the superpowers (the United States and the Soviet Union) on the touch-line, spurring on their respective sides. In this respect, at least, the two Germanies continued to represent a certain idea of "Mitteleuropa", but one that was regarded initially with understandable mistrust.[8]

The German Democratic Republic developed into the most loyal satellite of

the Soviet Union, to whose fortunes it became more closely attached than was the case with any other central European state. (It was only in the GDR, perhaps, that an authentic and original "national" school of painting eventually grew up, on the unpromising soil of Soviet-inspired Socialist Realism).

The *Dritte Deutsche Kunstausstellung* (Third German Art Exhibition) in Dresden, in 1953, was the first effectively to exclude Modernist tendencies and West German participation. It attracted a total of 200,000 visitors,[9] and its success contributed, in part, to the West Germans' determination to establish a rival quadrennial international event of their own in Kassel, some 300 kilometres to the west, on their own side of the internal border.

Documenta 1, in 1955, had aimed to reinstate the centrality of modern art, as a reaction to the Nazis' "cleansing of the temple of art",[10] whilst *documenta 2*, in 1959 (134,000 visitors[11]) gave prominence to American Abstract Expressionism and the idea of "abstraction as a world of language".[12] Werner Haftmann, the principal architect of *documenta 2*, went out of his way to emphasise the independence of the artist from social and political concerns, and had recourse to German idealist aesthetics to justify the virtual exclusion of all forms of realist art.[13] Thus, *documenta 2* came to be seen as a direct riposte to the hard-line policies for a politically engaged, figurative art, laid down that year by Walter Ulbricht and the art functionaries of the GDR (the so-called "Bitterfeld Way").[14] It marked the high-point in the controversy over the respective merits of abstraction versus figuration (or "formalism versus humanism", in Communist terminology), which had dominated artistic debate throughout the decade, on both sides of the ideological divide.

The 1960s brought a gradual loosening up of political and artistic doctrines, and the easing of some of the restrictions on

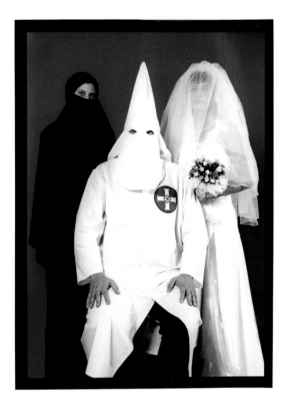

Gordana Andjelic-Galic
On Globalisation…, 2003

travel and communications contributed to the development of artistic dialogue between East and West. The influence of American art in Europe reached its peak in the period beginning with the consecration of Pop Art at the 1964 Venice Biennale, where Rauschenberg won the major painting prize, and ending around the time of the oil crisis, in 1973. As the sixties progressed, the US influence expanded to embrace Minimalist and Conceptual Art, Hyperrealism, Happenings, Performance Art, Body Art, Earth Art and the rest of what has now come to be regarded as second-wave Modernism. All these movements met with a sympathetic response in Central and East Europe, in so far as they provided an alternative to pre-

vailing orthodoxies, though ideas from abroad sometimes arrived late, were imperfectly understood or modified in relation to local circumstances, and were mostly developed in private. The avant-gardes in Yugoslavia (and later, in Poland and Hungary) were placed in an awkward position by the state's espousal of some of the safer brands of abstraction, and this, no doubt, encouraged younger, more radically inclined artists to demonstrate their independence, by experimenting with different ways of engaging once more with reality, from Hyperrealism to actions and performances. It may also account, in part, for the retrospective nature of much Central and East European art and the artist's involvement of elements of their own lives in their work—qualities that enjoy wide currency today.

Little is known in the West about the Hungarian or Czechoslovak variants of Pop Art, for instance, though some of the supposed protagonists had occasion to exhibit there out of context, on their own and a number of leading protagonists emigrated to the west (Gyula Konkoly in 1970, for example, and Laszlo Lakner in 1973). Indeed, it is hard to determine whether this use of a label makes any sense, when it is applied to work produced under entirely different social and political conditions, and in the virtual absence of a consumer market or of an advertising industry.[15] One Yugoslav critic asserted that no local brand of Hyperrealism had emerged in his country, because the economic conditions were not right for it,[16] whereas it would seem that Laszlo Lakner was treated as a "Hyperrealist" by German critics reviewing his first show in that country, in 1974, when, in reality, he was handling the pictorial imagery of communist propaganda in a perfectly conventional, painterly technique.[17] Much of the conceptual or performance art of this period was poorly documented and never accessible to the general public,[18] so even local audiences

have had to wait for from twenty to thirty years to see comprehensive and carefully researched exhibitions, such as *body and the East,* in Ljubljana (1998) or one of "Polish" Conceptual Art (only on apparent contradiction of terms, perhaps), in Warsaw (1999). Little such work was seen in the West, at the time of its production, and as the Slovene curator of *body and the East* points out in her catalogue introduction, "just as Western art has mainly presented itself to the relatively isolated East as reproduced in magazines and books, so the east has been presented in the West with a small quantity of poor quality documents, with white spots in retrospectives of European art, with the myths of official art and suffering dissidents. In that dialogue, the power always remained on the side of the West which has been constantly producing a new trend."[19]

The fact remains that it seems far more important in the Czech than in the international context, that George Maciunas should have nominated Milan Knijak the official representative of Fluxus-East, in 1965 and that the latter should even have succeeded in organising an international Fluxus festival in Prague, one year later. (Knizak's recent nomination to the prestigious directorship of the National Gallery in Prague provides a wry epilogue to this!). In general, it is hard to disagree with the verdict of the British performance artist, Adrian Henri, that it was often difficult in the atmosphere of "repressive tolerance" (Marcuse) in the West, fully to appreciate the radical nature of many new art which might be construed as a political action, in its country of origin.[20]

Work still remains to be done on the reception in the West of some of the more ephemeral and transportable forms of art which succeeded in crossing the frontiers both ways with relative ease, from Concrete Poetry to Mail Art and Multiples. (There was a particularly active scene in Hungary in the 1970s, bur even in the

repressive GDR, Robert Rehfeld managed to establish an active web of postal communications with artists from all over the world). Some reference would need to be made, in this context to the role played by small independent galleries, such as the Galeria Foksal, in Warsaw and Akumulatory 2, in Poznan, as well as the student centres and clubs in the principal cities in Yugoslavia, which managed to use public funding intended for individual visits and exchanges to invite artists from the West to present suitcase-sized exhibitions to a limited, invited public. Needless to say, encounters such as these did much to promote bilateral contacts, at a time when these were extremely difficult to sustain and undoubtedly helped to make the art of a number of eastern European avant-gardes better known in professional circle in the West.[21]

One area of fruitful exchange was in the field of geometric abstraction and related forms of kinetic and Op Art, in the 1960s. Artists from Poland had gravitated to Paris since the 1920s, and this link was maintained by the *Salon des Réalités Nouvelles,* founded in 1947 and the Galerie Denise René, which mounted an important exhibition of *Précurseurs de l'art abstrait en Pologne*, including work by Henryk Berlewi, Katarzyna Kobro and Wladyslaw Strzeminski (in addition to Malevich) in 1957. This exhibition and other like it,[22] were instrumental in highlighting the direct link between Strzeminski's "Unism" and the pioneering work of Malevich and his pupils in Soviet Russia. In turn, they are recorded as having exercised a direct influence on the evolution of the work of Max Bill, in Switzerland and the somewhat younger François Morellet, in France and Günther Uecker, in West Germany.[23]

Constructivism and various forms of geometric art had an equally long and virtually unbroken history in Hungary. Most of the pioneers, such as Vilmos Huszar and Laszlo Moholy Nagy, had emigrated to the West, between the wars, but among those who returned, Lajos Kassak and Sandor Bortnyik exerted a direct influence on younger artists, in the 1950s and '60s. Kassak himself had his first one-man exhibition abroad at the Galerie Denise René in 1960, at the age of seventy-three, and the younger Vistor Vasarely (a former pupil of Bortnyik, before emigrating to Paris in 1930), became a pioneer, first of Kinetic art in the late 1950s, then of Op Art, around 1965. The strength and continuing vitality of the Hungarian constructivist tradition were demonstrated in a number of exhibition in western Europe in the 1970s and in two parallel exhibitions at the Fodor Museum, in Amsterdam (1988), where eight contemporary artists from Budapest were shown alongside *The Hungarian Constructivist tradition until the 1980s*. In contexts such as this, Western viewers could trace the survival in Central Europe of a tradition of fine arts and design, closely linked to a faith in social and technological progress, which had become unfashionable in the West, by the 1970s.[24] By and large, the utopian component in the urge to intervene in all branches of human thought and activity ran parallel, rather than counter, to the prevailing socialist ideology and could be followed back to William Morris and the social reformers of the nineteenth century, via the Russian Constructivist movement, the neoplastic idealism of De Stijl and the practical utopianism of the Bauhaus.

Until the 1980s, the most frequent way in which contemporary art from Central and East European countries became known in the West was through group exhibitions selected by the sending country and funded under reciprocal arrangements, laid down under the terms of bilateral cultural exchange agreements with host countries in the West. The problem with the majority of such exhibitions was that they reflected, not so much the

Nedko Solakov
The Absent–Minded Man, 1996-1997

ideological as the aesthetic prejudices of the established bureaucracy and the selfish interests of the individuals controlling the artists unions, in addition to the usual considerations of national representation and (in the case of federated states, such as Yugoslavia and Czechoslovakia) geographical balance. Where possible, exhibitions toured a number of countries or individual cities, for reasons of economy, and little attention was paid either to the suitability of the host venue or to the potential relevance of the work on show to the interests and concerns of the audience, at the receiving end. A country's openness to the West could be measured by the volume of two-way traffic, but qualitative criteria, such as the nature of public and critical response took second place, in the general scheme of things. The typical package might be tagged with a label such as *23 ungarische Künstler* (Bielefeld, 1969) or *Modern paintings and Graphic Art from the CSSR* (Munich 1960).

The characteristic Western response, when it was not in like kind, seldom went beyond an affirmation of established values, such as academic abstraction or assertions of "humanist" faith, as in the case of a figurative artist such as Henry Moore.

The International Association of Art Critics (AICA) played an important role, in sustaining contacts between critics in East and West. Of particular relevance were the three congresses held in East Europe— in Poland, in 1960 and 1976, and in Czechoslovakia, in 1966—and the exhibitions organised locally, to coincide with them, since these not only gave western critics, such as Pierre Restany, the opportunity to meet colleagues and artists who were prevented from travelling abroad, but it enabled them to write up what they had seen, in some of the leading art journals, on their return. Restany acted as the Paris correspondent for two Czechoslovak reviews,[25] in the years of ferment between 1964 and 1968 and introduced his readers to "Nouveau Réalisme", of which he was the leading theoretical exponent. At the same time, he did much to help artists from the region to visit the West and exhibit their work there—most notably, perhaps, in the case of Alex Mlynarcik, who became actively involved in artistic circles in Paris in the late 1960s and became an influential figure behind the scenes in his native Slovakia, in the much-changed, repressive climate of the 1970s and '80s.

Private individuals in the West were generally more successful than the representatives of publicly funded institutions, in making the necessary contacts in unofficial circles and bringing back from eastern Europe, for exhibition. Just what was possible, given the necessary

108

commitment and determination, was demonstrated by the Scottish gallery owner, Richard Demarco, who succeeded in mounting successive exhibitions of Romanian, Polish, and Yugoslav art, at a very early date (from the late sixties and early seventies onwards), within the context of the Edinburgh International Festival. He also engineered the sensational first performances in Britain of Tadeusz Kantor's distinctly anachronistic Cricot 2 Theatr, in 1972—seventeen years after the company's first, clandestine appearances in their city of origin, Krakow. (Kantor became a popular figure with audiences in Britain—as in Germany and Italy—though his impact here had much to do with the spectator's own black-and-white preconceptions about conditions under Communism and was largely confined to the theatrical world, rather than across the whole spectrum of the arts, as in Poland.). The seeds sown by Demarco during this period bore fruit in a major Hungarian Arts Festival organised by the Third Eye Centre, in Glasgow, in 1985,[26] which introduced artists such as Miklos Erdély, Ilona Keseru and Sandor Pinczehelyi to Britain for the first time and Polish season there, in 1988,[27] which was notable for its inclusion of the sculptor, Miroslav Balka, the installation artist, Mariusz Kruk and painters, such as Tomasz Ciecierski and Leon Tarasewicz. However, it may be worth remarking on the political dimension to these events, which were intimately connected, not only to the increasing liberalisation in East Central Europe but to the self-esteem of a Labour-dominated City Council in Glasgow and Scottish aspirations to greater cultural independence, within the United Kingdom. As so often in East-West exchanges, the political, rather than the artistic agenda dictated the timing and the nature of relations. Indeed, all of the artists shown in Glasgow, only Miroslaw Balka has been given a subsequent opportunity of wider exposure in London.[28]

Throughout the 1960s and 1970s, West Germany was more receptive than other countries in the West to the first tentative signs of liberalisation among the Communist regimes, though art from central and eastern Europe continued to be ignored by the major institutions. Whether some of the initiatives mounted at the time reflected a genuine thirst for knowledge, a desire to escape from provincial constraints or a predilection for exotic is a moot point, though there was often a combination of all three. At a later date, Kunst, Europa (1991),[29] a plethora of simultaneous exhibitions of work Kunstvereine, was the first and, for some years, only attempt to show contemporary art from all part of Europe on a basis of open-mindedness and respect for individual achievement.

The Museum in Bochum organised a series of well-documented exhibitions of contemporary art from Poland (1964–65), Czechoslovakia (1965) and Yugoslavia (1966), on a scale which was not repeated until the museum in Esslingen, near Stuttgart, attempted something similar, in the changed climate of the late 1980s[30] the Museum Folkwang, in Essen, whose initial, politically controversial, contacts with Poland went back to 1961, went further still, in making a first, systematic attempt to collect, as well as to exhibit and re-evaluate the work of contemporary artists in central and eastern Europe. Essen's small collection was probably the most significant of its kind in a public institution in western Europe, before the 1980s.[31]

As Ryszard Stanislawski, the former Director of the Muzeum Sztuki in Lodz was to remark later, the geographical radius covered by museum collections of contemporary art in East and West coincided neatly with the lines of the old political divisions.[32] It was not until the 1980s that private (West German) collectors such as peter Ludwig and Henri Nannen, began to collect contemporary art from central and eastern Europe, and not until

the end of that decade that they began to take an independent line from the advisers and salesmen of the official art agencies, Artex in Budapest, Art Centrum in Prague and Desa in Warsaw.

Even so, it would seem that the best qualification for acceptance in the West was emigration, to judge from the fact that the only living artists to be included in the Ludwig Museum, Cologne's catalogue of work by almost 300 artists are the painter, Laszlo Lakner (b. 1936) and neo-constructivist, Attika Kovacs (b. 1938), from Hungary and the performance artist, Marina Abramovic, from former Yugoslavia, all of whom have lived in west Europe for many years.[33] Today, a visitor to the Tate Gallery in London, or to the Centre Georges Pompidou in Paris, would be unlikely to see on display more than a token example of work produced by any artist living in central or eastern Europe before 1990.

Personal contact between artists and critics is, of course, one of the most effective ways in which ideas travel and develop. It was particularly in this area that so many obstacles were artificially placed in the way of a normal dialogue between East and West. Hence, the importance of private initiatives and of the few established programmes in the West for artists' residencies, scholarships and exchanges. Until the late seventies or early eighties, it was, in fact, exceedingly difficult for artist from Eastern Europe to travel West on a two-way ticket, though the haemorrhage of talent through emigration and exile was constant and severe—particularly, after periods of political turmoil. (20,000 Hungarians, including many artists and intellectuals, sought asylum in neighbouring Austria, after the revolt of 1956, and Austria later provided asylum to a number of signatories to Charter 77). As an example of what could be achieved, Dieter Hornisch, when he was a curator at the Museum Folkwang from 1968–1975,

enabled a number of Hungarian artists, Imre Bak, Laszlo Lakner, Istvan Nadler and Gyorgy Jovanivics (all of them, born in the 1930s) to visit Essen on short-term awards and make contacts with other artists in the region.[34] He also gave Roman Opalka his first solo exhibition in the West, in 1973, before the latter's emigration to France (1977) and showed, in his writings, a keen understanding for the specific qualities of his work, in its historical context.

Berlin occupied a rather special position in all this, even in relation to the German Federal Republic. In the 1960s and 1970s it became a place of refuge or of transit, not only for artists escaping the pressures of Communist regimes (including painters from the GDR, such as Baselitz, Polke, and Richter), but for a number of leading Austrian writers and intellectuals, including several members of the Wiener Gruppe, who fled the oppressive atmosphere of Vienna in 1969 and joined two writers from the Wiener, in setting up an "Austrian government in exile". The Deutscher Akademischer Austauschdienst (DAAD Exchange Scheme), which had been launched by the American Ford Foundation, as a Cold War initiative and run by the Berlin Senate since 1967, gave residential scholarships to artists, writers and composers from all over the world, including artists from Poland (Wojciech Fangor, 1963–65 and Karol Broniatowski, 1967) Czechoslovakia (Jan Kotik, 1970–the present, Jiri Kolar, 1979, and Milan Knizak, 1980–82) and Hungary (Endre Tot, 1979, and Gyorgy Jovanovics, 1980–81).[35] They all contributed greatly to the cultural life of the city—in Fangor's case, at a formative moment in the evolution of Op Art.[36] One or two of them found connections to artists and dealers in the West, but Berlin was trapped between East and West and was regarded as somewhat provincial, until is emergence at centre stage, in the early 1980s.

The countries of Central and East Europe were generally keen to present their artists at international events such as the Venice Biennale, the Bienal de São Paulo (from 1953), *documenta* (from 1955) and the Biennale des Jeunes de Paris (from 1959). Yet they often found that the expenditure of hard currency and effort involved were considerable, in comparison to the meagre rewards, usually amounting to a sceptical press, public indifference and the occasional minor prize or commendation, either as a sop to the conscience of the jurors or as a consolation to the artist concerned. That their national entries were so uninspiring was probably due as much to the official nature of their culture as to ideological pressure of any kind, though it was often difficult to separate the two. What could be achieved, when professional curators were given a free hand was demonstrated by the engagement of Jerko Denegri, as Yugoslav commissioner for the 1971 Paris Biennale (see below) and Katalin Neray, as the Hungarian commissioner for the Venice Biennale, from 1986 to 1990.[37]

Art shown in the West under official auspices was generally regarded as too derivative, too out of touch or, at most, a bait for conservative collectors. Most non-western artists were passed over in silence by critics, who had no understanding the context in which their work had been produced or key to its correct interpretation. Even those few who succeeded in making their mark at an event such as one of the international biennials often found that their success was short-lived. Such was the fate of the Polish "informel" painter, Jan Lebenstein, who was selected for *documenta 2*, in 1959 and won a prize at the Paris Biennale, in the same year, but subsequently dropped out of sight. (According to Ryszard Stanisalwski, the French critics completely misunderstood his work, by attempting to relate it to Dubuffet's[38]). The Yugoslav sculptor, Dzamonja, did well

enough at the 1960 Venice Biennale to sell a number of works, but was dismissed out of hand by one of the avant-gardist critics, Lawrence Alloway, for his "ornaments with creepy larval references", betraying "a period style that had lost the crispness of its origins".[39] Perhaps the most fortunate were those artists, like the Polish sculptor Magdalena Abakanowics, whose work conformed sufficiently, both to a contemporary idiom and to the western expectations of "otherness", denoted by her "eastern European" sense of alienation, combined with a craft-oriented technique and use of organic materials appropriate to an agrarian economy.[40]

The Biennale de Paris (founded in 1959) was open to work by young artists outside (or not yet within) normal commercial circuits and to cross-cultural activities, including music, theatre, film, poetry and design. For most of its existence, it attracted contributions from Central to Eastern Europe, as was somehow appropriate for countries where there have never been the same rigid divisions between individual art forms, as in the west. The high-point of Central and East European participation came at the time of the 7th Biennale, in 1971, which afforded the French public their first opportunity of seeing a comprehensive selection of conceptual art from all over Europe and the USA, in which an especially strong Yugoslav selection, including Braco Dimitrijevic and half a dozen groups of conceptual or performance artists from Belgrade, Ljubljana, Novi Sad, and Zagreb. Yet it was not on this part of the world that the Parisian critics and curators had set their sights, and it had been evident to some people, all along, that the primary objective of the Paris Biennale was to win back from New York the title to world leadership in the field of contemporary art. As one of the French selectors for the 1980 Biennale put it, "Rien n'est plus naturel en France que de ce prendre pour l'Empire du

milieu: qu'autour d'elle se ressaisisse la vieille Europe pour envoyer outre atlantique, comme on l'y conjure, quelques Airbus promis au plus grand succès!"[41]

From an East European point of view, *documenta* has always resembled a half-closed door, through which no more than a maximum of half a dozen artists from the entire region (often, émigrés) have ever been admitted at any one time. As one of its later directors has recounted: "In the mid-1970s there was an encyclopaedia in East Germany, in which *documenta* was spoken of as if it were an advertisement for the capitalist world."[42] And so it has appeared to remain: even the last two editions of 1992 and 1997 have given greater prominence to the more "exotic" cultures of other continents than to the artistic production of central and eastern Europe.

It is interesting to observe how the second wave of (American-led) modernism was played out in the 1970s against a gradual softening up of the confrontational lines between East and West, in Europe, and how the western Europeans edged towards greater independence from American cultural dominance. One of the consequences of this was a gradual erosion of the monolithic aspect of the modernist movement and a move towards the eventual disappearance of the old opposition between abstract and figurative art, and "pure" and "impure" forms of expression. Arte Povera was one of the first European avant-garde movements consciously to stake out an independent position, in relation to the power and wealth of Americanised art market; ten years later, the "Transavantgarde" took the process a stage further, by undertaking a reverse conquest of that market, on its own terms.

There now developed among the small, neighbouring states of central Europe a new conception of "Mitteleuropa" to rival (or supplant) the unpalatable Pan-German version, which had been at the origin of two world wars and the subsequent division of Europe. This new version was based, in part, on a nostalgically tinged recollection of the multi-ethnic, multi-cultural and multi-lingual Habsburg Empire, pre-1918,[43] and, in part, on Tomas Masaryk's democratic vision—on returning to Prague, in December of that year—of a "close friendship with our neighbours to the east and south-east" and an "amicable group of small nations, extending from the Baltic to the Adriatic."[44] As a formula for collaboration, it was based on a recognition of mutual interests and acceptance of different needs and traditions of the various peoples in the region. This notion appealed, not only to dissident writers and intellectuals in the east, such as the Czech, Milan Kundera and the Hungarian, György Konrad, but to Westerners of various political complexions, ranging from representatives of the international Peace Movement, in the wake of the Vietnam war, to conservative politicians, such as the Austrian Christian Democrat, Erhard Busek, who envisaged a new mediating role for his country. In cultural terms, the growth in regional consciousness was an extension of the Post-Modernist spirit of the late 1970s and the breakdown of confidence on the existing hierarchies if modern art, the "grand narratives" (Lyotard) and the catalysing role of the avant-garde.

Joseph Beuys represented an isolated, and rare, case of a Western artist attempting to heal the breach in European consciousness caused by war and political dissent. His divided cross symbolised the rift which between the churches of Rome and Byzantium, and a number of his actions, starting with EURASIA – 32. *Satz der Sybirischen Symphonie* (14/15 October 1966, in Copenhagen) and EURASIENSTAB 82 min organum fluxorum (2 July 1967, in Vienna) represented an attempt, metaphorically, to overcome the divisions of the past.[45] As he expressed it, "It is necessary to view West Europe,

Central Europe and East Europe as an organic, and indivisible, whole. Starting out from my personal conception of art, I endeavour to establish this on a theoretical basis and develop it further into a new aesthetics."[46] But Beuys' influence was slow to percolate through to Eastern Europe, and in the end, neither his, nor the politicians', vision of a third way prevailed.

So far, little has been said about the artistic situation in Austria or Yugoslavia, partly because they were already, in theory, integrated into the Western art world and enjoyed a degree of institutional stability (though no appreciable domestic market for contemporary art), and partly because the isolation they endured, in reality was geographical and economic, rather than political. However, the biennial arts festival, "Trigon", in Graz, assumed a growing significance, as a forum for cultural exchange in the 1970s, first with the neighbouring countries of Italy and Yugoslavia, parts of which had formerly belonged to the old heartland of Austria—then with Hungary, and other countries in the region. Successive exhibitions and workshops had helped Austrian artists, not only to reconnect with their own past, which had been characterised by the repeated attacks on modernity and cosmopolitanism since the 1930s, but to connect up with international Post-Modernist tendencies.[47] In 1987, the exhibition, *Expressiv* in Vienna and Washington,[48] was an important first attempt to survey contemporary artistic developments in the region embracing the five adjacent countries, Austria, Czechoslovakia, Hungary, Poland, and Yugoslavia. Although it placed a perhaps unduly strong emphasis on the expressive painting which had found its way onto the international market, it provided a proper context for this work, alongside that of older and more established artists with figurative concerns, such as Arnulf Rainer and Maria Lassnig. It also included senior figures from East Central Europe, such as

Adriena Simotova and Karel Malich, who had been cut off from the West and, sometimes forbidden to exhibit, for many years. (This was only made possible by the organisers' decision to purchase all of the work by the Czechoslovak artists, in advance of the exhibition opening). *Expressiv* was followed up in 1992 by another exhibition in Vienna, on "Reductivism" in the same countries,[49] which placed an emphasis on the strong rationalist and constructivist tradition of much art in the region. Finally, *Identität: Differenz* (art from Central and East Europe, 1940–1990),[50] in Graz that year, brought out the renewed relevance of art from the region, with all its historical and stylistic discontinuities, at a time when national borders were being called into question and the (West-) Eurocentric accounts of the evolutionary development of modern art were under attack.

It was not until 1994 that a systematic attempt was made to chart the history of avant-garde movement in the whole of East Europe, from the beginning of the century onwards. The impressively ambitious exhibition, *Europa-Europa. Das Jahrhundert der Avantgarde in Mittel- und Osteuropa*,[51] was mounted, significantly enough, in the capital of reunited Germany, Bonn, with the substantial government support. In part, it was conceived in atonement for the sins of omission from the major survey of *Westkunst*, in Cologne (1981),[52] which had appeared to continue the post-war tradition of equating "good" art with political freedom,[53] and its four-volume catalogue provides an indispensable reference source for the art of the period. However, it failed to do more than fill a gap in information, perhaps, because its line of enquiry was set in a traditional perspective, which ill accorded with recent research techniques and the global reorientation of artistic practice. A fully revisionist view of Central and East European art would involve a thorough reassessment of the West European tradition,

as well, and might usefully start with Joseph Kosuth's suggestion: "If certain artists from the past are revived, it is because certain aspects of their work becomes usable for living artists."[54]

The spirit immediately following the collapse of the Berlin Wall, the disintegration of the Yugoslav and Czechoslovak federation and the resultant turmoil was captured by the director of the 45th Venice Biennale, Achille Bonito Oliva, in basing his concept of "The Cardinal Points of Art" on the "three closely related principles of cultural and political transnationality, multiculturalism, and nomadism."[55] However, Oliva was less than successful in his attempt to globalize the creaking structure of the Biennale, by asking the foreign commissioners in charge of national pavilions of their own to share these with artists from countries of the post-colonial world, which had not been present on the territorial carve-up of the exhibition ground (the Giardini), earlier in the century. A central feature of this Biennale was the exhibition *La coesistenza dell'arte. Un modello espositivo*,[56] curated by Lorand Hegyi, which built on the achievements of Trigon and the previous exhibition in Vienna, by assembling recent art from the Central and East-central European region (including the newly independent states of Croatia and Slovenia), with which Vienna was historically affiliated. This marked one of the first attempts to demonstrate some of the contradictory tensions at work in the art of these years and highlighted some of the difficulties which a couple of dozen artists from at least two different generations were experiencing, in coming to terms with their fractured past. In this effort, there was more than a suggestion that both the problems and the opportunities of the new Europe were reflected in the work of young artists from the region.

In many ways, the 1990s have offered a wholly new range of possibilities, in which the old issues of national and regional allegiances—whether political or artistic—have taken second place to those of personal identity and groups endeavour, and the conditions of production, distribution and consumption of art have been changed almost beyond recognition. The ideological battles of the Cold War have lost their relevance, and a new generation of artists who have grown to maturity in the years since the fall of the Berlin Wall has moved onto the field vacated by their elders (friend and foe alike). The globalization of economies and of communications had done little to change the inequalities in the distribution of wealth and information, but artists in Central and East Europe are now confronted with the same problems of their colleagues in the world, and are liable to do so, in a language which owes little to the political and cultural determinants of the past. Indeed, the rapid spread of new(-ish) forms of expression, such as installations; of sophisticated new media, which are accessible to a widespread public and can be manipulated in a domestic environment; and of new, collaborative working methods, marks a break with tradition and its hierarchical values. Time and space have been elided into an apparent continuum of the here and now and there and then.

The network of Soros Centres for Contemporary Art, which was established throughout the region in the early 1990s, has confronted some of the structural weakness of arts institutions in East and Central Europe, the lack of government support and the continuing difficulty which artists have, in breaking into wider systems of information, sale and distribution. Yet artists in the region still have the greatest difficulty in promoting their work, in the absence of a genuine market for it, and the Soros network itself is at some risk of disintegration, as a result of a reduction of funding from its parent organisation in New York.

Antal Lakner
Bundesberg Berlin, 2003

BUNDESBERG Berlin 1000 m 2020
THE HIGHEST ARTFICIAL STRUCTURE IN THE WORLD

The 1990s have also witnessed the emergence of a new form of itinerant international Biennale, *Manifesta*, whose aim was to respond to the changed circumstances in Europe for the production and distribution of contemporary art and to provide a platform for young artists from all parts of the continent, who were already launched on their professional careers, but had not yet been given widespread commercial backing.[57] In keeping with the times, the chief emphasis in *Manifesta* is on collaboration, rather than competition, process, rather than product and an incremental use of new means of communication, such as the Internet.

To judge from the range and quality of the work exhibited at *Manifesta* and at the current exhibition, *After the Wall – Art and Culture in Post-Communist Europe*, in Stockholm,[58] it would appear to be something of an anomaly, still to consider the work of these artists in a geographical context or to show work together on a regional basis. However, we must always

be prepared, to paraphrase Marshall McLuhan, to drive into the future, with one eye on the real mirror. The current preoccupation of artists everywhere with questions of personal identity and with elements of autobiographical and fictional narrative is a reaction to the collapse of the old hierarchies and the ideologies of the past. Each one of us is left with the fragments of memory, with which to construct a defence against the totalising powers of global capitalism and the media. It may just be that artists coming from a background of repeated migrations, exile, persecution, ethnic and religious, strife will have something of particular strength to say to the rest of us about the integration of cultural difference into our rapidly changing society. What is certain is the need to re-evaluate the entire legacy of our recent past, and we could do no better than start with the forgotten, neglected, suppressed, distorted and disrupted cultures of central and eastern Europe.

1. In reality, "Yalta" is the commonly used shorthand for the decisions taken by the leaders of the "Big Three" nations of the anti-Fascist alliance, at Teheran (December 1943), Yalta (February 1945) and (after the end of the War), Potsdam (June 1945). See Norman Davies, *Europe. A History*, Oxford University Press, 1966. Second, paperback edition, with corrections, London: Random House, 1997, p. 1036.

2. 5 March 1996. Op. cit., p. 1065

3. Ibid.

4. Deimantas Narkevicius' 35-mm film, *His-tory, 1998* (1997), located the new geographical centre of Europe at "54º 54' - 25º 99 in the middle of the countryside". *Manifesta 2. European Biennial of Contemporary Art*, exhib. cat., Luxembourg: 1998, pp. 100–101.

5. See Milan Kundera, "Afterword" to the US edition of *The Book of Laughter and Forgetting*, quoted in Milena Kalinovska, "Exhibition Dialogue: Ther Other Europe" in *Carnegie International*, ex. cat., Pittsburgh: 1988, p. 30. This text was published in *Aspects / Positions - 50 Years of Art in Central Europe 1949-1999*, Wien: Museum Moderner Kunst Stiftung Ludwig, 1999, pp. 47-58.

6. It has even been suggested that an apparent predisposition towards conceptual art in eastern Europe formed a part of the legacy of Socialist Realism, with its emphasis on content and narrative forms. See Laroslava Boubovna, "Conceptualism between Despotism an Liberalism", in *Crossroads in Central Europe / Carrefour en Europe Centrale* (Budapest: Association of Hungarian Creative Artists, 1996), pp. 54–59.

7. The Actionists themselves have continued to evoke strong reactions abroad, as when a planned showing of the major touring exhibition, Von der Aktionsmalerei zum Aktionismus Wien 1960–1965/From Action Painting to Actionism Vienna 1960–1965, at the National Gallery of Modern Art in Edinburgh (exhib. cat., Klagenfurt: Ritter Verlag, 1988) was cancelled at the last moment. For French reactions to contemporary Austrian art, in general, see Bernard Ceysson, "Gedanken zu einer Untersuchung uber die Rezeption der osterreichischen Kunst in Frankreich" in exhib. cat., *Aufbruche. Osteterreich Malerei und Plastik der 50er Jahre* (Vienna: Österreichische Galerie, Belvedere, 1994), pp. 38–43.

8. Timothy Garton Ashn in his book, *In Europe's Name. Germany and the Divided Continent* (London: Jonathen Cape, 1993) points to the popularisation of the term "Mitteleuropa" by the nationalist German historian, Friedrich Naumann, in his 1915 book on the subject, and to Naumann's opinion that Bismarck "thought Europe from Prussia" (Garton Ash, pp. 316 and 67). According to Garton Ash, it was only later that the idea of "Mitteleuropa" was revived, in a very different spirit, first by Czech,, Hungarian, and Polish intellectuals and then by Social Democrats in West Germany, such as Peter Bender, whom he quotes as saying, at a symposium in 1987: "The renaissance of 'Mitteleuropa' is first a protest against the division oof the continent, against the division of the continent, against the hegemony of americans and Russians, against the totalitarianism of ideologies." (Garton Ash, p. 316).

9. Kunstdokumentation SBZ/DDR 1945–1990. Aufsatze Berichte Materialien, ed. Günter Feist, Eckhart Gillen, and Beatrice Vierneisel. Berlin: Museumspadagogischer Dienst, in collab. with Stiftung Kulturfonds, Cologne: DuMont Buchverlag, 1996, p. 70. (There were to be as many as 650,000 visitors to the seventh national exhibition in the series. See Kunstdokumentation SBZ/DDR 1945–1999, p. 81).

10. The title of the Nazi ideologue Wolfgang Willrich's book, *Die Säuberung des Kunsttempels*, Berlin and Munich: 1937.

11. *Documenta. Idee und Institution. Tendenzen. Konzepte. Materialien*, ed. Manfred Schneckenburg München: Bruckmann, 1983, p. 46.

12. Werner Haftmann, "Einführung", in *II documenta '59. Kunst nach 1948*, exhib. cat. (Cologne: DuMont Schauberg, 1959), p. 15

13. See Kurt Winkler, "II. Documenta '59", in *Stationen der Moderne*, exhib. cat. (Berlin: Berlinische Galerie, 1989), pp. 427–35.

14. See Martin Damus, *Malerei in der DDR. Funktionen der bildenden Kunst im Realen Sozialismus* (Hamburg: Rowohlts Enzyklopädie, 1991), p. 165ff.

15. A number of leading participants in the two IPARTERV exhibitions in Budapest, in 1968 and 1969, the second of which was referred to as the "Pop Art" exhibition, had seen American Pop Art and hard-edge abstraction in Stuttgart, Kassel and Venice, between 1964 and 1967; Lazlo Lakner saw Rauschenberg's work at the 1964 Venice Biennale, and Gyula Konkoly and Gyorgy Javanovics saw the big Pop Art exhibition at the Museum Modern Kunst, in Vienna, immediately afterwards. See Katalin Keserü, *Variations on Pop Art*, ex. cat., Budapest: Ernst Museum, 19 December–16 January 1994, which represented a first attempt to survey the phenomenon of "Hungarian Pop Art"; see also Julia Fabenyi, "Vorwort", in *A magyar neoavantgard elsö geràcioja 1965-1972 / Die erste Generation der ungarischen Neoavantgarde 1965–72* (Szombathely: Kunsthalle, 1998), pp. 6–7.

16. Jerko Denegri, "Yugoslavia", in *Septième Biennale de Paris*, exhib. cat. (Paris: 1971), p. 259.

17. Wolfgang Becker, "Vorwort", in *Kunst Heute in Ungarn*, exhib. cat. (Aachen: Neue Galerie-Sammlung Ludwig, 1989), unpaginated.

18. Udo Kultermann was one of the few western critics to keep abreast in this field and makes passing reference to the happenings staged in the 1960s by Milan Knizak, in Prague, Gabor Altorjay in Budapest, and Edward Krasinski in Warsaw, in his book, *Art – Events and Happenings* (London: Mathews Miller Dunbar Ltd., 1971), p. 43.

19. Zdenka Badovinac, "Body and the East", in *Body and the East. From the 1960s to the Present*, Moderna Galerija Ljubljana – Museum of Modern Art, exhib. cat. (Ljubljana: 1998), p. 11.

20. Adrian Henri, *Environments and Happening* (London: Thames and Hudson, 1974), p. 128.

21. Jaroslaw Koslowski's artist-run space, "Akumulatory 2" in Poznan provided the inspiration for Robin Klassnik's comparable "Matt's Gallery" in London, which has just celebrated 20 years of activity.

22. E.g. Pologne, 50 ans de peinture, at the Musée d'Art et d'Histoire, in Geneva, and Konstruktivismus in Polen (1973) at the Kroller-Muller Museum, in Otterlo (plus US tour)

23. See Ryszard Stanislawski, "Le Musée – un instrument critique", in Lodz/Lyon. Muzeum Sztuki w Lodz

1931 – 1992. Collection Documentation. Actualité. La collection du Musée de Lodz, exhib. cat., Lyon: 1992, p. 11; Dieter Honsch, "Zwischen Tradition und Avantgarde – Das Museum Stuki in Lodz" (1977), in Dieter Honisch, Texte, Ostfildern / Ruit, Stuttgart: Edition Cantz, , 1992, pp. 367–73; Présences polonaises, exhib. cat., Centre Georges Pompidou (Paris: 1983).

24. E.g. *Ungarische Konstruktivisten*, Rottweiler and Frechen, 1973; *Neue Konstruktivistische Kunst*, Bonn: Kunstmuseum, 1975; *Ungarische konstruktivistische Kunst 1920–1977*, München: Kunstverein, 1979.

25. Vytvarne prace (Visual Work) and Vytvarne umoni (Visual Art).

26. *Contemporary Art in Hungary. Eighteen Artists*, exhib. cat., Third Eye Center and King Stephen Museum (Glasgow: 1985).

27. *Polish realities. New Art in Poland*, exhib. cat., Glasgow, Third Eye Center, and Lodz, Muzeum Sztuki (Glasgow: 1988).

28. See *Rites of Passage*, exhib. cat., London: Tate Gallery, 1995.

29. *Kunst, Europa*, exhib. cat., Arbeitsgemeinschaft deutscher Kunstvereine, Köln / Karlsruhe: 1991.

30. Esslingen's series included exhibitions of contemporary art from Hungary (1987), Poland (1988), and Czechoslovakia (Czech painting, in 1989 and Slovak painting, in 1990–91).

31. See Dieter Honisch, "Neue Kunst aus Ungarn" (1977), in *Dieter Honsch, Texte* (Stuttgart, Ostfieldern / Ruit: Edition Cantz, 1992), pp. 351–56.

32. Ryszard Stanislawski, "Einleitung", in *Europe – Europa. Das Jahrhundert der Avantgarde in Mittel- und Osteuropa*, exhib. cat., ed. Ryszard Stanislawski and Chistoph Brockhaus, Bonn, Kunst- und Ausstellungshellen der Bundesrepublik Deutschland (Bonn: 1994), vol. 1, p. 21.

33. *Twentieth Century Art.* Cologne, Museum Ludwig (Cologne: Benedikt Taschen Verlag GmbH, 1996).

34. Dieter Honisch, "Roman Opalka", op. cit., pp. 494–500.

35. See Blickwechsel. *25 Jahre Berliner Künstlerprogramm*, ed. Stefanie Endlich and Rainer Hoynck (Berlin: 1988).

36. Eberhard Roters, "Begegnungen", in *Blickwechsel* (op. cit., note 35), p. 7.

37. Néray showed Imre Bak, Akos Birkas, Karoly Delemen, and Istvan Nadler in 1986, Imre Bukta, Sandor Pinczehelyi and Geza Samu in 1988, and Laszlo Feher on his own, in 1990.

38. Ryszard Stanislawski, "Le Musée – un instrument critique" (op. cit., note 22), p. 11.

39. Lawrence Alloway, *The Venice Biennale 1895-1968, from salon to goldfish bowl* (London: Faber and Faber, 1969), p. 142.

40. It is interesting to note, in this context, that the Hungarian critic Janos Sturcz suggests that Imre Bukta's arrangements of the low-tech products of socialist industry in a contemporary idiom (installation) have been misunderstood in the West as somehow folkloric, rather than as a source of shame or regret. J. Sturcz, *Tackling Techné*, exhib, cat., Venice Biennale, Hungarian Pavilion (1999), p. 21.

41. Jean-Louis Pradel, "Le puzzle mis en pièces", Xe Biennale de Paris, exhib. cat., Musée d'Art Moderne de la Ville de Paris (Paris: 1980), p. 26.

42. Jan Hoet, in *Heiner Müller and Jan Hoet, "Insight into the Process of Production . A Conversation"*, Documenta IX, exhib. cat. (Kassel-Stuttgart: Cantz, vol . 1), p. 98.

43. Lonnie R. Johnson, *Central Europe. Enemies, Neighbours, Friends* (New York: Oxford University Press, 1996), p. 197.

44. Ibid., p. 267.

45. Doris Leutsch, "Eurasien", in *Beuysnobiscum*, ed. Harald Szeemann (Dresden: Verlag der Kunst, 1997).

46. Trans. from Jaroslaw Jedlinski, "Joseph Beuys: Polentransport 1981", in *Der Riss im Raum*, exhib. cat. (Berlin: 1995), p. 52*

47. The fact that Achille Bonito Oliva included chapters on artists from Austria and Yugoslavia in his book *Transavantgarde International* (Milan: Giancarlo Politi Editore, 1982), but omitted Czechoslovakia, Hungary, and Poland from the sixteen countries surveyed, is an illustration of the habitual delay in the transmission of ideas between the two halves of Europe.

48. *Expressiv. Mitteleuropäische Kunst seit 1960 / Central European Art since 1960*, exhib. cat., Museum Moderner Kunst, Vlenna 1987/8, and Hirshhorn Museum and Sculpture Garden, Washington 1988, p. 38.

49. Lorand Hegyi, *Reduktivismus. Abstraktion in Polen, Tschechoslowakei, Ungarn. 1950-1980?* exhib. cat., Museum Moderner Kunst Stiftung Ludwig Wien, Vienna 1992.

50. *Identität: Differenz. Tribune Trigon, 1940-1990. Eine Topographie der Moderne*, exhib. cat., ed. Peter Weibel, Christa Steinle, steirischer herbst (Wien-Köln-Weimar: 1992).

51. Op. cit., note 32.

52. *Westkunst. Zeitgenossische Kunst seit 1939*, exhib. cat., ed. Laszlo Glozer (Cologne: DuMont Buchverlag, 1981).

53. This was caricatured at the time by Klaus Staeck, in a flyer entitled 'Bonanza – zur Lage der WEST-Kunst', in *Kunst International* Nr. 44/45, 1981, bearing the inscription, "Osten = unfrei = keine Kunst" ("East = unfree = not art").

54. From J. Kosuth, "Art and Philosophy", quoted by Catherine Millet, in "The Part of Risk", in *Braco Dimitrijevic*, exhib. cat., Museum Moderner Kunst Stiftung Ludwig Wien (Vienna: 1994), p. 58.

55. Achille Bonito Oliva, *Cardinal Points of Art. Theoretical Essays*, XLV International Art Exhibition, (Venice: 1994), pp. 9–27.

56. Lorand Hegyi, *La coensistenza dell'arte. Un modello espositivo*, exhib. cat., La Biennale di Venezia 1993; Museum Moderner Kunst Stiftung Ludwig Wien (Vienna: 1993).

57. *Manifesta 1*, exhib. cat., Manifesta European Art Foundation, Rotterdam 1996 and *Manifesta 2*, exhib. cat., European Biennial of Contemporary Art, Luxembourg, 1998. (This event moved to Llubljana, in 2000).

58. *After the Wall. Art and Culture in post-Communist Europe*, exhib. cat., ed. Bojana Pejic and David Elliot, Moderna Museet, Stockholm (Stockholm: 1999).

Stories, Places, and the Torment of Memories: Comments on the Oeuvre of Ilya Kabakov

Lorand Hegyi

> *"The room defeated me, as soon as I entered, it literally knocked me out, and everything started again ... I think this room has since then penetrated me, it lives inside me and won't disappear ... I want to shoot this damned hole, I want to crush it and annihilate it .. I beg you to do it together with me! Beat it! Release me from my past!"*
> (Ilya Kabakov: *Der Text als Grundlage des Visuellen*)

The multifaceted and complex artistic persona of Ilya Kabakov, who has been working in close contact with his wife Emilia in the past few years, is a phenomenon which can only be elucidated by delving into literary, historical, philosophical, and political aspects. A simplified political or historical localization invariably results in trivialization—firstly, because these references are frequently erroneously, ahistorically, or ambiguously specified, and secondly, because his oeuvre sensitizes much deeper, richer, more essential, and more universally valid existential experiences and poeticized processes of self-cognition than would be the case if it were an allegory of a unique, restricted, particular political situation. Categories like the "Second Russian Avant-garde", the "Art of Glasnost", or "Perestroika Art" allude to the marginal and contradictory positions held by an alternative, innovative, and critical art movement during the final stages of a slowly collapsing former Soviet Union, amidst tentative reforms and haphazard attempts at democratization. These categories, which have never been satisfactorily defined from an art-historical, cultural, and sociological viewpoint, only cover certain aspects of Ilya

Kabakov's art and do not do proper justice to its cultural and historical context. While they thus allow for a more accurate historical and political interpretation, they tell us precious little about the anthropological complexity and, above all, the alluring poetic rendering of his vision of existence and of the suffering entailed by his own memories. The enigmatic power of his installations and the intriguingly painful fragility of his drawings—complemented by sublime poetic texts that also exude a melancholy realism—provide us with glimpses into a universe fraught with longing and smarting, recollections and hopes, but primarily with the burning desire to comprehend the *condition humaine* in its stripped-down, bare, concrete, banal, and unique physicality.

At first sight, Ilya Kabakov's art radiates something specifically "local" and concrete, something uniquely "Russian" which appears to be so close and yet so far away, so alien and yet so frighteningly well-known. A compellingly direct, inescapable, almost bodily confrontation with an experience differently perceived, imagined, and internalised by the viewer. This experience is condensed in a highly charged and compact image.

119

In his artistic world Ilya Kabakov strives to create an encompassing and compact metaphor of human existence in concrete situations, thus devising an elaborate system of signs. This phenomenon circumscribes his individual intellectual approach taken in a specific situation of his era, i.e. his nomad-like existence. (Even after leaving his home country, incidentally, his life has always been marked by his encounters with and perception of the literary and intellectual circles of the former Soviet Union.) Ilya Kabakov's art also reflects the profound changes of values used for creative mechanisms—the transition from a linear, formalistic, and phenomenological methodology to an anthropological and quasi-"ethnologic" practice.

Viewed from this angle, his oeuvre may be addressed not only by resorting to conventional interpretations—Russian reality, his experiences with life and politics of the former Soviet Union as a child and young man, or his survival strategies employed as an underground artist in Moscow in the sixties and seventies—but also by pursuing another quite topical theoretical discourse. The latter is driven in particular by the referential interpretative methodologies applied by the American "October Circle".

This localisation, as seen in new approaches to "reading" contemporary art, also explains why Ilya Kabakov's art has gained so much importance in the past two decades. Triggering memories, re-contextualising artworks historically, socially, culturally, and anthropologically, a new narrative vein which postulates that personal history and experiences are a universal paradigm—all these aspects have contributed to the highly prominent role played by the oeuvre of Ilya Kabakov in contemporary artistic discourse. Referentiality and narrativity, his cultural and anthropological approach to art, the specification of subjective and personal observations and individual experiences in real historical, social, and ideological settings, which contain both general anthropological models and typical psychological and mental constructs—all this reflects the changes that have occurred in the art world over the past twenty years. Its theoretic statements have supplanted early phenomenological, evolutionist methods and the medium-specific formalism of art perception. Interestingly, while Ilya Kabakov created his first emblematic installations in Moscow, the first fundamental and methodologically paradigmatic essays of the so-called "October Circle" were written in New York, highlighting the significance of referentiality. It may indeed by argued that the poetic and enigmatic aura shrouding Ilya Kabakov's work—captivating us as something both real and unreal, both "realistic" and "surrealistic"—emerges from the highly intense, compelling, almost physical and emotional power that radiates from the objectification of referentiality; it allows us to view the artist's pictures, texts, installations, and drawings that teem with associations, connotations, memories, and experiences as a compact, coherent, heavy, and powerful reality that we can perceive with our senses as we are confronted with it head-on.

In the late seventies Alan Sondheim wrote about the strategies employed by a new narrativity, deftly analysing the ethnological aspects of a new artistic practice. Hal Foster, in his critical commentary on Minimal Art, argues that the way it is practised has resulted in an isolation, as it were, of artistic activities from social, historical, anthropological, and ethnological references, eliciting a formalistic, medium-specific, ahistorical, reductionist interpretation. Therefore, those opting for a novel post-minimalist approach to art and referential theories tried to focus on anthropological experiences, placing artistic activities in complex historical, ethno-cultural, mental,

and ideological contexts. Artists were to act as "ethnographers", as observers and analysts of real, specific, and unique situations, and the sensitisation of historically, culturally, and mentally determined settings was to cancel any formalistic structures. A concrete reading of a concrete constellation—that is the challenge facing a new, historical, and anthropological artistic awareness.

In almost all big installations Ilya Kabakov works as an ethnographer. He collects materials which trigger specific social, mental, psychological, and emotional configurations in specific situations. He works with stored memories, associations, and experiences which, paradoxically, seem a lot more "real" and direct in his installations than in everyday life from which they are taken. He works like an ethnographer, archaeologist, or—metaphorically speaking—like a scientist: collecting, structuring, commenting on, and presenting his material which derives its meaning from the fact that it is a vehicle that elicits historical, cultural, ideological, and social references. He builds new contexts and fills them with objects, recollections, and fragments of texts. What is crucial is not their primary meaning but their connotations. These turn emotionally internalised and intellectually perceived moments, concealed memories, and personal imaginings into a sensorially perceptible, physically discernible, and yet mysterious phenomenon. This new and inescapable phenomenon has a very real and physical quality to it. It is an example of created "reality" which unfolds like a "piece" of special reality, taking the place of actual, statistical, and empirical reality. It acts as a catalyst of historical, political, ideological, psychological, and anthropological references whose perception is invariably linked to emotional involvement. Ilya Kabakov's works do not allow us to remain passive or idle; we are forced to contribute both emotionally and intellectually. Their emotional intensity springs from the narrativity of "reality" articulated by the artist.

In an essay written in 1999 Ilya Kabakov describes a very important aspect of his art. He calls his aesthetic strategy "concealment". His words, texts, and fragments do not reveal what they mean syntactically but point to something deeper. These allusions make the artwork a maze of references. "With the word 'concealment' I wish to describe a situation in which you say something you don't mean. Of course a situation like this occurs frequently in everyday life, and its underlying objectives are varied. But in visual arts such a communication tends to alienate and make people uneasy…". This is what Ilya Kabakov writes about "situations" (Ilya Kabakov, *Der Text als Grundlage des Visuellen*, Oktagon Verlag, 2000, p. 15). The concept of a "situation" presupposes certain connections between different elements, and it also involves something active, such as saying and meaning something. The discrepancy between the two activities generates a tension. Artists and viewers need to proceed more actively, intensely, and independently. The tension, in turn, evokes and weaves together experiences, perceptions, and memories so that the artistic scope of action is widened to include more and more aspects. Viewers will thus not read a work by Ilya Kabakov "unilaterally", they will not grasp it in just one dimension as a "political allegory", but they will perceive it as a multifaceted metaphor. The latter manifests basic human conditions—these vary considerably, depending on the specific historical, social, and political situation—in their unique concreteness. Ilya Kabakov talks about a concrete personal situation in its specific historically, ideologically, and socially determined unique form, while he also elaborates on a general experience deep-seated within us, reaching to the very roots of our exis-

tence. This experience is ubiquitous, it has always existed in the history of mankind, under permanently changing guises.

It is important to note that texts play a key role in Ilya Kabakov's oeuvre, but the way he approaches texts must be interpreted completely differently from, say, American Conceptual Art. In Conceptual Art a sensorially perceptible, material, and pictorial reality is replaced by text. In the case of Ilya Kabakov texts strengthen the pictorial part: "This narrativity does not cancel visuality. On the contrary, because of its parallel existence and its 'progress' it invests it with depth and clarity which usually lack … This is not just about an unequivocally uttered or even written text but about an active verbal statement which, when creating or per-

ceiving an artwork, is articulated in the form of a text but need not be clearly and unmistakably 'voiced'. This internal 'flow of words' accompanies every artistic 'act' …". (Ilya Kabakov, *Der Text als Grundlage des Visuellen*, Oktagon Verlag, p. 11).

When presenting the way Ilya Kabakov handles texts, two crucial elements must be borne in mind. On the one hand, he talks about the "parallel existence", the juxtaposition of text and picture, with the proviso that the text never replaces the picture because the deeper meaning of the work, i.e. its real powers, can only be comprehended through its "parallel existence". The text is no substitute for the picture; rather, it explains and enriches it, adding clarity and depth. This depth also entails an uncontrollable expansion of

Ilya Kabakov
Untitled, (Two Tables) #2, 1997

associations which viewers specify and project onto themselves. While the text may unnerve viewers, it also explains the pictorial elements. Pictorial and sensorial moments generalise the artist's individual experiences and convey them to the viewers who may thus share the same story. Texts are not just composed of information but they are part of everyday reality fraught with multifarious references.

On the other hand, Ilya Kabakov also talks about an "internal flow of words" which "accompanies" the entire artistic act, regardless of whether this occurs in the text or in the picture, in writing or pictorially. This "internal flow of words" is the actual message, the narrative which connects the artist's own experiences and his life embedded in his specific historically,

culturally, and mentally determined unique context with the equally individualistic context of the viewer. The "internal flow of words" shapes the text and the picture, the outward appearance and the inner structure of the work, it establishes a link between past and present, memories and current emotions, literary experiences, appropriated moments, and situations witnessed first-hand.

Strikingly, in 1979, as Ilya Kabakov set out to create his first emblematic works, Giulio Paulini wrote in an essay on his approach to text: "I am not a conceptual artist, I do not work with the text, I live the text. I am inside the text, and I work with text like with objects."

In his essay on "concealment" Ilya Kabakov states that text for him is an expla-

nation, "a kind of active verbal statement". Both artists stress their active method of dealing with text. For both artists, text is an integral part of reality, not just a description of it. Text and picture, or the sensorial and material presence of text, allude to the general analysis of reality in which artists work. Their works are manifestations of real situations—not just descriptions or reflections but expressions of their active involvement in real processes. But in Ilya Kabakov's art memories and his release from the throes of a past life form a unique context which emerges from his individual history.

This deeper narrativity, this "inner flow of words", determines his work and explains his relation to Russian literature and the overarching traditional themes which have dominated Russian culture—and not just the culture of the Soviet Union—for a long time and have often been reformulated. Against this backdrop, Ilya Kabakov's oeuvre may be interpreted as a paradigmatic phenomenon of a new narrativity which enjoys pride of place again in a post-modern situation, after the "demise of narrativity" described by Lyotard, and fills the void of that vanished narrativity with concrete experiences and personal stories.

The narrative features of Ilya Kabakov's oeuvre manifest themselves in powerful, unforgettable metaphors that form something like a "literary framework" for his stories. One of the most important recurring metaphors in Ilya Kabakov's art is that of the room—a closed, self-contained, restricted, frequently loathed, or much-feared place.

"You are lonely and alone, there is nobody around you, the lamp illuminates the surface of the table at which you sit. You are deeply in thought as you glue postcards, positioned in a specially devised arrangement, on wrapping paper cut with great precision into smaller sheets [...] when attaching the postcards something quite different is emerging, a strong joy

shining brightly, a joy that hardly exists in the life surrounding you. You disappear, you are washed away by this stream of joy that takes you to other rooms, another world that you have never seen before and probably will never see, a world where there is singing and dancing; blue mountains encircle a blue lake, on a Tartar horse somebody rides across the vast steppe. If you glance upwards you will see the wall of the room, faintly lit by the lamp, and you realise heavy-heartedly that there is no connection between the gleaming postcard pictures and the place where you spend all your time, day after day ... And there is no transition, no bridge between this big and wondrous remote world and your wretched little universe." That is what Ilya Kabakov wrote about his installation "The Collector". This painfully beautiful and almost intolerably sad description bears a striking resemblance to nineteenth-century Russian literature, such as Gogol or Dostoevsky. What Ilya Kabakov offers here with his text and picture, with written words and the installation made up of objects and spaces is a metaphor of insurmountable loneliness and confinement. A metaphor which is ubiquitous and pervasive, across all cultures and epochs. But Ilya Kabakov renders it more concrete, affixing it to his context, his experiences, and his time.

The room, a self-contained space, a place devoid of air and promise becomes a universal metaphor. This metaphor evokes the story of a rushed, romantic, and utopian attempt at escaping ("The Man Who Flew from His Room into the Universe" or "The Man Who Flew into His Picture"), the tale of the joy felt over the alleged self-liberation from the power of imagination ("The Collector"), as well as blind anger and frustration that accompany the memories of confinement ("The Targets").

"I lived in this room in Moscow since 23 February 1961. I hated this room just

Ilya Kabakov
The Collector, 1995
Installation

as much as I hated everything connected to it that happened during that year and the following year. I didn't own this room, I rented it in order to write a book I had planned to write for a long time [...] Everything was old, dusty, frayed, faded, abandoned ... And amidst all of this a few strange-looking sheets of paper were strewn across a strange-looking table, and my hand had written a few words on these sheets of paper—meaningless, arbitrary things! [...] Feeling awfully despondent and almost crying with pain I jumped up, paced the room and then stood, dazed, in front of a window that had not been cleaned for ages, with the sleeping flies between the panes. My stubbornness and my unfathomable expectation that tomorrow everything would be different forced me to endure this torture repeatedly, day after day. But it was all to no avail. The room defeated me." In this description of the installation "The Targets" the main metaphor used by Ilya Kabakov is, yet again, the vacuum of the closed-off room. The room stands for a prison, a confined place of suffering from which humans want to flee. Several texts by Ilya Kabakov revolve around his desire to break free from the room, to leave it as fast as possible. "Ever since I can remember, and even before that (as evidenced by my mother's stories about me as a three-year-old child) I have wanted to get away from where I happened to be. Running away for good, leaving without looking back and going so far that nobody could make me return." This quote is from Ilya Kabakov's text on the installation "The Man Who Flew from His Room into the Universe". Another quote describing his emotions, taken from his text on the installation "The Targets": "What I particularly loathe are 'places'—rooms, houses in which I used to live and in which something happened to me, as well as streets I walk along all the time. As soon as I am there,

they all become dreary, desolate, and filthy in my eyes, filled with gloom and boredom, and that is the way they stay forever in my memories."

Fleeing, going away, leaving the room or confined place, "carefully planning and performing an escape", as Ilya Kabakov put it, or breaking free from a given situation, a prison—all these are significant and recurring elements in his artistic world. But these very personal emotions and his general attitude to life do tie in with the tradition of Russian literature, Russian philosophy, and the big utopias of Russian thought. Ilya Kabakov alludes to this when he writes: "When you know the century-old history of the Russian dream to fly and live in space, you will not find it difficult to place this installation entitled 'The Room' in a string of similar projects from which I would just like to single out Fjodorov's or Ziolkowski's ideas. An important feature of these theories is that outer space is envisaged as an adequate environment for human existence." (Ilya Kabakov, *Der Text als Grundlage des Visuellen*, Oktagon Verlag, 2000, p. 137). Quite readily we also discern the close links between Ilya Kabakov's depictions and Russian literature. What features prominently in both are descriptions of confinement, restriction, and limited existence, as well as utopias, visions, romantic, passionate, and sometimes naive and amateurish desires to break loose, escape, and conquer freedom. The bitter irony and genuine tragedy are derived from this very antagonism: on the one hand, the wretched and unbearable limitations of real life in a banal setting, on the other hand, the nostalgic yearning for absolute freedom, the desire to experience unlimited cosmic dimensions, the longing for infinity. Viewed from this perspective, it is quite irrelevant whether the artist articulates this problem in a typical nineteenth-century situation—a cold and

windowless tiny room somewhere in Saint Petersburg—or in a shabby room furnished with the bare necessities in a dilapidated communal housing project in 1950s Leningrad. The basic parameters are the same, the torture is the same, and the pain inflicted by limitations and hopelessness is similar.

Ilya Kabakov's passionate plea—"I want to shoot this damned hole from which thick fog billows that obscures my presence, I want to crush it and annihilate it […] I want to stop this destructive stream […] I beg you to do it together with me! Beat it! Release me from my past!"—is addressed to the viewers whose involvement in the process of self-liberation and self-cognition is essential. These words are designed to exhort viewers to not just watch the events from outside but to experience them from within. "Participation" is not just a "technical question", as Ilya Kabakov himself claims in an interview with Bachstein, and it is not just a call for a happening. Rather, it is actually the central message of his art—to reach out to people, and to familiarise them with another reality by this emotional involvement so that they can experience it first-hand.

That is what in antique aestheticism was called *catharsis*: participation, involvement, sharing. Viewers step out of their private and particular existence and are given an opportunity to perceive another reality. Art, therefore, is not just pleasure, healing, and aesthetic liberation in a romantic sociological and political sense, but a complex activity that creates another new reality.

What does this reality contain? At first sight, something quite trivial. Rooms, full of small, banal and yet important objects referring to different human activities. Viewers are expected to discover and reconstruct events, situations, and connections which include something specific and, at the same time, something universal. The poetic universe that awaits us is boundless. The world opens up, and we are invited to follow the artist, share his experiences, and enter his universe. And once we are there we ask ourselves simple and yet essential questions: Where do we settle down? Where is the place that we could live in? What belongs to us? Where are we free? Where can we be happy? These seemingly simple questions are questions touching the core of our existence, no matter where, when, and how we live. And when Ilya Kabakov raises these questions in his universe by applying his own methods, he does the same as all other great artists—he talks about himself, about his own experiences and also about us, about every human being who is intrigued by the mystery of life. The ultimate, most fundamental, and simplest questions are always identical.

Above there is a hole, a huge gaping hole, and below there is a catapult, and the person who used to live in the room has disappeared. This man who has wondered for years what it would be like to fly from his room into the universe, who has asked himself thousands of times how he could get out of his hideaway is really gone. People have been looking for him, but he has not been found. He simply lives in space, the owner of the building says. Probably he succeeded in doing what we never thought he would. He is up there. Ilya Kabakov makes us ponder: What are our dreams of freedom and sovereignty, what are our strategies to combat limitations? His language is simple, but his message is complex and multifaceted. And his pictures, his pictorial situations remain unforgettable.

Moscou 2004
An Attempt at Mapping a Territory in Motion

Anne Landréat

What is happening in Moscow[1] in the contemporary art scene in 2004? What has happened since 1992 when the *Moscow Declaration*[2] established the existence of an "Eastern European" identity (which is not to be defined as something in *opposition* to Western culture, but indeed as an integral part of the European "frame",[3] but with its own historical specificities and artistic traditions) and the ensuing need to invent and set up "new artistic and cultural infrastructures" capable of supporting this position?

What elements do we have available to us today "this side of Europe" to get closer to this reality, to try for a vision that is not too sketchy, trivial, decontextualised or, conversely, focused on the supposed post-Soviet identity? For if, at first sight, the Moscow contemporary scene appears completely fragmented, traversed by as many currents as there are artists, chronically weakened by the almost non-existence of the infrastructures that accompany creation, perturbed by internal quarrels which are, for some, aimed at controlling the mechanisms of artistic production as well as the stance to be adopted vis-à-vis the "West", the fact remains that, on closer examination, one can distinguish common denominators, trajectories and strategies that intersect and meet, bringing to the fore the contours and lines of force of a rough map.

Backdrop or Collective Unconscious

If one tries to analyse roughly the composition of the historical and artistic terrain into which the current Russian scene is thrusting its subconscious roots, one finds, in various proportions, depending on where the survey is carried out, typically local components mixed (often closely) with elements of European and/or Western origin, but filtered, reinterpreted.

Falling into the first category, at random: Russian nineteenth-century painting, the founding mythology of historical avant-gardes, the sole voice of socialist realism, the gradual and parallel rise of an accompanying voice, or rather voices (of which Sots art is the most obvious expression) that finally prevailed at the turn of the nineties; the traditionally bureaucratic and centralised organisation of the art world (whether it be a question of the profession of "artist" or the institutional authorities surrounding that profession), the more or less dissident stance that ensues, the historical pre-eminence of literature over all

Page 128
Olga Kisseleva
Where Are You?, 2003, video

Anastasia Khoroshilova
7 Home for Women, Essen, Allemagne, april 2003

there is a Russian fantasy), one finds, as well as a detailed knowledge of its history (History and the history of art) and its most contemporary artistic production, a quite ambivalent relationship, a continuous oscillation between fascination and mistrust. And then, all jumbled up together, Alexandre Dumas and swashbuckler films, Jules Verne and the universe of science-fiction, the desire and fear of "rationality", Deleuze and pop culture, structuralism and the omnipresent advertising image, the explosion of the mass media and its impact on the imagination, the end of art then the rebirth of painting, the capitalist economy and the spectre of third-worldisation, globalisation, the global village, anti then alter-globalisation, and then, and then, and then…

Henceforth in harmony with the world, Moscow gets carried away. But twice, four times, ten times more quickly it would seem. Even if, from the inside, the feeling that seems to prevail on the artistic scene is some kind of "restless stagnation".

Topology or Context

"Moscow today may be considered as a completely clean space, a sort of vacuum."[5] A vacuum, not of creation or thought, but rather perhaps of spaces for the forming, confrontation and friction of thought, spaces for the exhibition, preservation, and distribution of art today, intermediary spaces working with Russian as well as foreign artists and who are actively present on the international scene. And, it would appear, it is from this vacuum that an idea was born that is currently perturbing Moscow art circles, that of a "Grand project"[6] of an art *biennale* in Moscow, of an event that could "represent a great step in the setting up (…) of an artistic infrastructure of the contemporary kind."[7] Like a sort of laboratory, a model of what the ideal artistic Moscow could be. And everyone starts to dream, not really believing. A dream of a Moscow-version

other forms of artistic expression that it tends to corrupt, the taking into account of the public addressed (the "masses") within the creative process itself; the major events that punctuate official History (pre-Revolution, the Revolution, the Great Terror, the "Great National War",[4] etc.), personal, family history written by each individual and inextricably interweaving with History, the omnipresence of humour and irony in all circumstances of life as a resistance strategy against the pressure of context, and so forth.

If one then considers the alluvial deposits left by the West, that is to say, to some extent, the Western fantasy (just as

of the Beaubourg, or a Guggenheim, some sort of experimental event that would be permanently renewed through the debate and confrontations it would provoke. A dream of putting art itself back at the centre of the project, or alternatively, individual artistic strategies, or Moscow, or again the individual responsibility of the artist. A dream of bringing the international scene to Moscow. Others, on the contrary, dream of showing the diversity of the Russian scene to Western professionals, and still others dream of making a clean sweep, of settling the score, not with art (which is already dead), but with Russian art as a whole…

The expression of a profound malaise, it is no coincidence that this debate, using the Grand Moscow project as a pretext but above all highlighting the structural, human, and ideological problems that undermine the Moscow art world as a whole, and particularly the artists, arises (or arises again) now, at a time when "a more structured realisation than the one that took place in the nineties"[8] is beginning to take effect. For, if the beginning of the nineties brought encouraging raw energy and hope, it was also a time of confrontation with pressure from the outside world, a confrontation that was not prepared for, with nothing to absorb the shock. The big hope was that—responding to the winds of freedom and outward-looking attitude that were blowing at the time—artists, critics, exhibition curators and gallery-owners (these last two figures had only just made their appearance) and, why not, public authorities would, from then on, walk hand in hand, with one accord, in order to make room for contemporary creation in all its vitality, at home as well as abroad. But, very quickly, the pressure of this outside world and its expectations together with that exerted by the "exemplary nature" of the success of the "Great Elders" (Kabakov, Bulatov, Komar and Melamid…) on the Western scene were felt. And, under the combined effect of this hope and pressure, a sort of confusion of roles set in between artists and art mediators, who were supposed to know how to decipher the expectations (presumed or real) of the west, and who, because of this, found themselves in the position of sponsors almost, but without the means. Today, seizing the opportunity of this debate, which has only just opened and, let us hope, will remain open, artists are beginning to make themselves heard: it is vital for the growth of the Russian scene that they find their place within the system.

Mapping: Artists' Territories

In an interview given to *Moscow Art Magazine*, Oleg Kulik, one of the major figures of the generation we will call "intermediary",[9] states that "[the project] must be steered towards artists' individual strategies. […] By taking part in the Grand project, many artists, including myself, dream of presenting, not a project, but a sort of system in itself."[10] Individual strategies. System. Which reality/realities do these terms cover applied to a scene that is completely fragmented and within which it seems almost impossible to distinguish or put a name to a particular trend or system so much so does each artist appear to be a current in himself?

But if, in the wake of Deleuze, one considers that "every system is an intensive field of individuation built on series of heterogeneous or disparate edges"[11] and if, in this light, one questions the individual practice of artists, a more coherent and interconnected landscape, than it would at first appear to be, begins to emerge.

What strikes us first, is that most Moscow artists who manage to distinguish themselves, or who can be distinguished, have established strategies for skirting round art circles (Russian in any case), enabling them, as far as possible, to become self-sufficient in this respect. Some deterritorialise their field of action physi-

cally, geographically and socially, as does Alexander Ponomarev with his actions out at sea carried out with the logistical and material support of the Russian Fleet, or again Nikolai Polissky with his strange constructions (laden with snowmen, a hay ziggurat, a bridge of snow thrown across a river, a wicker constructivist tower…) to the scale of the landscape, made on the territory of a village he has "adopted" and whose inhabitants are all involved (including economically) in the creative process itself. Others, like the Vladimir Dubosarsky and Alexander Vinogradov duo or the AES group,[12] knowingly and in a very constructed way use the techniques and methods of the mass media which allow them, there again, to exist and function outside of Moscow art circles. As for Yuri Leiderman, in 1990 he leaves the "Medical Hermeneutic Inspection" group[13] and the Moscow Conceptualism[14] movement in order to "find himself again, what [he] was before […] he had any knowledge of contemporary art".[15] Around the same period,

Alexander Konstantinov turns his back on sculpture and drawing in order to devote himself to quasi-monastic work, the study of visual rhythms that he pursues in all sorts of forms, lined paper, graph paper, targets, etc. traced entirely freehand. The Aristarkh Chernyshev and Vladislav Efimov duo is also formed in the early nineties and seizes an almost virgin territory (and it still is today) in Russia, that of new technologies, with interactive installations where they present themselves as slightly zany characters that can be found from one piece of work to another. They use the technical knowledge they acquire through their artistic par explorations to develop a parallel activity individually, allowing them to preserve their autonomy as artists. Oleg Kulik, after having developed an occupation as an exhibition curator at the Regina gallery in Moscow towards the end of the eighties and early nineties, makes a sudden and conspicuous return to the artistic scene by turning into a dog, a dog that will bite, literally, the hand that feeds it.

We can see that, while the repercussions of the historical and political earthquake of the early nineties on the development of these artists are obvious, they took place at a structural, energy or social level, and not at a political one. It is as if they were suddenly freed of a Soviet context that, while it admittedly held them back, in the end only slightly affected them, unlike their elders. On the other hand, where they do follow in their footsteps (often unconsciously) is in the swiftness with which they transpose and revive within this new context—what I will call the "double skin strategy". For artists who were developing "unofficial" work under the Soviet regime, this consisted of protecting their artistic identity (their first skin) under a recognised social identity (many, like Kabakov or Bulatov had a "cover" as illustrators of children's books) that enabled them to carry out their artistic research without being too affected by a hostile context. The generation that appears at the beginning of the nineties creates a second skin of a slightly different nature, through the definition and appropriation of self-sufficient artistic terrain, within which they will henceforth be able to move freely. But these territories do not only function as a protective envelope. They constitute a series of Trojan horses capable of bringing pressure to bear on the context when the time comes and of changing it. "The artist must create, not a work of art, but a situation, a context, develop an art zone in itself".[16]

To name and define these domains or "art zones" is to name and define what Kulik calls "systems".

The domain appropriated by Dubosarsky and Vinogradov and which they define very loosely as *"an alternative to everything that has already existed on the local scene"* is nothing less than... Paradise. Or rather a paradise, their paradise, which, moreover, they have named "Our Best World".[17] A paradise they represented on

Pages 132 et 133
Alexander Ponomarev
Recycling the Pack [o] / Leonard's Northern Track
Arctic Ocean, 1996

Earth, then under water, before taking it one day perhaps to the heavens. A paradise where the motto would be "We can do anything we want. [...] We have delimited a vast enough territory and now we can work in it, relying only on our own impressions, reactions, [...] according to the principle of I like that or I don't like that". The language spoken there, a curious, "over-positive" mixture of a dead socialist realism and techniques borrowed from the mass media (freeze frames, glossy magazine photos, advertisements, erotica) is immediately understood by everyone—on the surface, at least. And

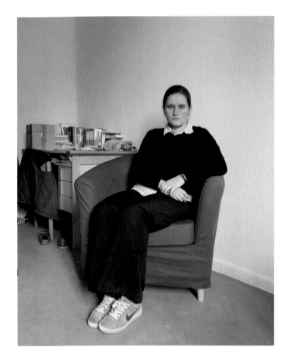

Anastasia Khoroshilova
Special Home for Scholars from Solling in Holzminden
Germany, december 2002

the fantasies of the masses dwell, conveyed by the media, fantasies they make come true, either really or virtually, and that are most strikingly illustrated by the nomadic project *AES Travel Agency to the Future* that brings shock images of their *Islamic Project* (the Statue of Liberty wearing a chador, Beaubourg transformed into caravanserai…) into the "normal" lives of "normal" people, as if suddenly the worst fantasies of the West were coming true, large as life.

Aristarkh Chernyshev and Vladislav Efimov take a doubly filtered look at today's world, avoiding its social reality which they find stifling, a look that could be qualified as "nostalgico-futuristic". The space where they present themselves (both sixties science-fiction buffs and guinea pigs of their own experiments) is at the intersection of the sciences, art and pop culture. During the course of their interactive installations using new technologies, the duo of black and white characters they have created replace arms and legs by prostheses on request (*The Shining Prostheses*), turn into a swarming crowd that the public may crush using one of Terminator's feet (*Terminator Monument*) or blow up like balloons until they float off (*Bubbles*). Proving that reality can sometimes exceed fiction, leaning on the success they met with in Austria with their *Terminator Monument* installation, they were within an inch of convincing the city of Graz (where Schwarzenegger was born) to commission a gigantic monument to Terminator… The debate continues today in the internet forum they opened for this purpose.

even if the viewer goes no further than the surface, this does not bother the artists in the slightest, as long as he enjoys looking at the work.

As for Lev Evzovitch, from the AES group, he works on the assumption that "a priori, it is not the art market that creates a demand, it is the artist himself who constructs one in accordance with his identity". Also using the mechanisms characteristic of the mass media, but to other ends and employing much more sophisticated techniques (for their latest project, *Action Half Life,* they went as far as setting up a real Hollywood production), AES commands perfectly the language of what they call the "sublime surface", a language which, "whilst existing within an artistic space, seriously disturbs it". The space they claim is that of "social paranoia", wherein

For Alexander Ponomarev, "every artist chooses a space that suits his attitude".[18] The system he has constructed unfurls inside vast territories that are "beyond" or " in-between" zones where only characters from *Stalker* by Andrei Tarkovsky can venture. Beyond reality and illusion with *Maya, the Lost Island,*

Erik Boulatov
I Live - I See II, 1998

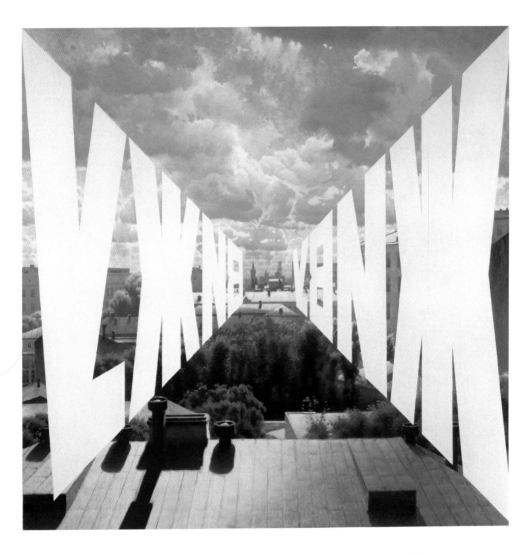

an action where he causes an island on the southern borders of Russia to disappear, beyond the forbidden and the state secret when he takes a submarine he has first transformed into a coloured artefact into the Arctic ocean (*Northern Trace of Leonardo*), beyond the laws of physics when he erects liquid columns inhabited by strange "submobiles" (*Breathing of the Ocean, Memories of Water*), or geography when he brings the ocean to the middle of the Himalayas (*Dalaï*). Working on boundaries, Ponomarev also creates a system that enables him to skirt around the art world and to it turn it round, pushing back its boundaries by introducing worlds that are, in principle, totally alien to it.

As for Nikolai Polissky he has found his territory through reversal, by changing the status of the countryside, the Russian landscape from subject or art cliché (Birch trees, churches with onion-shaped domes, rich earth, expanses of snow, beaming peasants, etc.) to that of actor in its own right of his art. A landscape painter, he has finally gone through to the other side of the painting and is playing a part in this very same landscape. That which surrounds a village 200 kilometres from Moscow, Nikola-Lenivets, where Polissky lives for part of the year and that has adopted him over the years. Using materials nature puts at his disposal, in tune with the seasons, he mobilises all the inhabitants of the village, getting them to build objects with him, both titanic and ephemeral. At the outset, there was a utopia: bring a dying village back to life through art. For that, he too will use the mass media he attracts into these isolated places by the gigantic proportions of his creations and the apparent zaniness of the experiment. Soon, the art world follows and, from exhibition to fair, Nikola-Lenivets and its inhabitants arrive in the West. "We're doing something together. They help me, and me, I try to help them [...]. We share life, we cohabit on this territory". A territory both utopian and absolutely concrete.

The place where Oleg Kulik works and that he calls "animality" is that of the ontological paradox that resides at the heart of a culture that, "calling itself humanist, shows itself to be absolutely without pity for anything that doesn't resemble it, and even, in the end, for everything that isn't art". Through animality, he distances culture, art, he goes over to the other side, turns himself into a dog, a bird, a bull or a cow in an attempt to establish "a dialogue with nature from the territory that threatens it with destruction". By bringing this paradox to a peak, he succeeds in bringing raw nature, in its

entirety, into the territory of art, which it can then, in turn, threaten.

Yuri Leiderman's quite extraordinary work is developed within the artistic field itself, but in a quite subversive way, relentlessly inventing "machine(s) to foil art's expectations".[19] Working on the assumption that "if something is important [for him], then, in one way or another, it may be interesting, amusing, important for others, [...] if one chooses the right angle", he uses all techniques and every medium available to him (just as a painter composes his palette), performances, installations, drawing, writing, books, "minimalist" video, that he mixes and muddles, confusing the issue into a play on meaning that constantly moves or slips away.

Alexander Konstantinov has chosen refuge in slowness, a sort of clockwork regularity that he keeps up against all odds from inside the frantic beat that equally characterises a city and a society undergoing massive changes as it does contemporary art circles. Everything continues, develops, transforms, without jolts or sudden movements, naturally. Always trying to "formulate" the impulses and motives that obsess him, he is primarily interested in confrontations of abstract geometrical forms which, little by little, call for a prepared base, a system of pre-established co-ordinates that, in the end, will be all that remains, "the prepared space proving more interesting, meaningful and powerful than what was represented in it" (On Well-prepared Paper series; project Within Descarte's Coordinates). These systems of co-ordinates, grids, a play of pure rhythms, slip, little by little, from the scale of the sheet of paper to that of the city, from the paper to the building site tarpaulins he puts up in natural or urban landscapes (View of the Town installation).

Russian artists of the "intermediary" generation, in the absence of an appointed

artistic infrastructure, have grown "out-of-frame", pushing back the boundaries and reinterpreting the codes of contemporary art, relying only on themselves to put together their artistic strategies and define the worlds and systems guaranteeing their autonomy. If most of them cannot be categorised, by confronting their individual approaches in their diversity, one can detect the shifting contours of a common territory, to which some of the keys could be facing up to individual responsibility, an invigorating energy and absolute freedom of movement.

1. The deliberate choice of confining this exploration to the Moscow scene is based on the geopolitical reality of the Russian territory, within which the desire for centralisation struggles endlessly against entropic leanings towards dispersion generated by the very vastness of this territory, making Moscow the receptacle and the point of convergence and confrontation of all energies. Saint Petersburg, Moscow's historical rival would require, for its part, a separate study, the Saint Petersburg scene being quite specific in its production and organisation.
2. A declaration signed in 1992 by Russian and Slovene artists and intellectuals (including Iosif Bakshtein, Viktor Misiano, Eda Cufer and the group of Slovene artists IRWIN who were developing their *NSK Embassy* project in direct correlation to this).
3. On the notion of "frame", cf. Piotr Piotrowski, "Framing Central Europe" in *Moscow Art Magazine*, n° 22.
4. The name given to the Second World War in Russia.
5. Lev Evzovitch of the group of Moscow artists AES in an interview given with O. Kulik to *Moscow Art Magazine*, n° 53, "A Biennale in Moscow: Mission, Structure and Public", p. 33.
6. On the subject of the Grand Moscow project, cf. *Moscow Art Magazine*, n° 53 which is almost entirely dedicated to it and to which notably A. Osmolovskyi, L. Evzovitch, O. Kulik, B. Groys, N. Bourriaud, I. Bakshtein, V. Misiano contributed.
7. Boris Groys, "The 'Grand project' as a personal

responsibility", in *Moscow Art Magazine* op. cit., p. 41.
8. Lev Ezvovitch, op.cit. p. 36
9. The artists following the generation of the "Great Elders", whose artistic activity boomed in the nineties and who today may be considered as "mid-career artists".
10. O. Kulik, op.cit., pp. 33, 34
11. Gilles Deleuze, "L'île déserte et autres textes; Textes et entretiens 1953-1974", *La méthode de dramatisation*, Paris: Éditions de Minuit, 2002, pp.135, 136
12. Created in 1986 by Tatiana Arzamasova, Lev Evzotich and Evgen Sviatsky, joined for certain projects by the photographer Vladimir Fridkes (AES+F group).
13. That he had founded in 1987 with Pavel Pepperstein and Serguei Anufriev
14. Created in Kabakov's wake and the leader of which is Andrei Monastyrski
15. Y. Leiderman, an interview with Vladimir Levashov, *Five Hours of Contemporary Art*, DVD, National centre for contemporary art, Moscow, 2004. Infra, artists' quotations that are not the object of a footnote refer to this.
16. V. Dubosarsky, op. cit.
17. *Our Best World*, exhibition at Deitch Projects, New York, 2003
18. *"Alexandre Ponomarev"*, an interview with Dominique Abensour, in cat. *de Moscou*. Quimper: Le Quartier, 2002, p. 43
19. Dominique Abensour, *Youri Leiderman*. Quimper: Le Quartier, 2004.

Braco Dimitrijevic: an Artist of the Post-Historic Era

Lorand Hegyi

Much like his personality, the oeuvre of Braco Dimitrijevic is a concise and clear expression of an artistic attitude which incarnates, from a radically subjective point of view, all the problematic issues of the twentieth century coming to its close. "Radically subjective" refers not only to the artist's personal life, his peregrinations which have led him from Sarajevo to London, and later to New York and finally to Paris, or the multi-culturalism of his family and friends, but also to the artistic stance that enabled him to overcome the antagonism maintained and mystified by history and politics, between art of the West and art of the East, between freedom and oppression, between progressive avant-garde and regressive official state art. Although he gained an international reputation as a conceptual artist in the seventies, his paradigmatic individual position became clear several years later and he directly influenced numerous artists of the next decade. There are a few eighties artists who expressed the conscious scepticism about history, as Braco Dimitrijevic had already done in the seventies, formulating, with unprecedented force and radicalism, his ideas in the book *Tractatus*

Post Historicus, which appeared as early as 1976.

However paradoxical it may sound, Braco Dimitrijevic's work establishes a radical confrontation between different cultural and sociological levels and processes of aesthetic perception, applying an aesthetic arbitrariness that is sometimes almost as brutal and unconstrained as those of the occidental avant-gardes like Dadaism, Futurism and the Fluxus movement—tying these together with an almost transcendental and traditionalist idea of fruition of imagery, which has its roots in the orthodox tradition of icons for worship. This aesthetic slant is what distinguishes Braco Dimitrijevic's oeuvre from that of his contemporaries, who are more directly oriented either towards the Duchampian intellectual tradition or towards the Futurist, Dadaist and Activist tradition of the avant-garde world reformers.

In an interview with Frank Perrin and Olivier Zahm ("Beyond Dualism", 1991) Braco Dimitrijevic said: "The whole of history is not so rich as one second of the Post Historical time" referring to the unlimited opportunities available to the artist of the Post Historic era, in which there is no longer either a linear historic

development, nor the necessary logical structures—fatalist and mechanical—to determine the "direction" and "goal" of history; history itself is radically put to the test, by which the juxtaposition of various semantic systems and levels of references become perfectly legitimate. Braco Dimitrijevic's *ars poetica* not only heralded the acceptance of pluralism and co-existence of contradictory concepts and aesthetic strategies, but requires that the artist himself/herself becomes an active and integral part of the Post-Historic era. Braco Dimitrijevic's radical interventions into history do not mean acceptance of the earlier stylistic formulas, nor the harmonisation between past and present, and even less changing the aesthetic roles—which would allow some poetic licence for emphatic strategies—but quite the opposite, calling history per se into question. The direct confrontation in art of various levels of experience becomes a metaphor for the experiences of the multicultural media society of the eighties and nineties, in which unequivocal, closed, homogenous information structures no longer exist.

Characteristically, Braco Dimitrijevic transfers certain meanings from the area of culture to fields that lie outside, and conversely makes an aesthetic apology and even over-evaluation of different non-cultural phenomena, which are thus "elevated" into the realm of culture. This deliberate confounding of different levels of references and the mixing of art signs and symbols with non-artistic languages produces an evident eclecticism that does not refer as much to art as to the experience of the crisis of history and historical consciousness.

When Braco Dimitrijevic presents a painting by Kasimir Malevich together with a black bicycle and a yellow melon, he at a primary level mixes the processes of aesthetic perception, and at a second creates a completely new, radically eclectic structure, which does not preclude a poetic reconstruction of a historically possible situation. The first level allows a formal and phenomenological reading: at the same time Kasimir Malevich's black and red squares and the circular shape of the bicycle wheel blend into one geometrical formal structure, while the yellow cat's-eye reflector on the rear wheel and yellow melon seem like complementary forms. Thus the non-objective world of Suprematism loses its transcendence and becomes a part of the world of objects. On the other hand, ordinary objects from everyday life (the bicycle and the melon) are taken out of their functional, practical and utilitarian context, and slotted into a universal, non-objective formal structure. However, the essence of this aesthetic restructuring is not fully grasped until we start to explore the second level of meaning: the black bicycle carries Kasimir Malevich's painting as if it was a parcel, like a postman delivering the mail. The autonomous aesthetic universe of Kasimir Malevich's non-objective Suprematism becomes a portable object, a concrete physical thing which contains a hidden message, just as a sealed envelop contains a letter. It recalls in our memory certain images from cultural history, for instance the "agit-prop" trains of the October Revolution in Russia or the geometric and abstract forms painted on wooden panels for mass demonstrations; this simple combination of objects becomes a means towards a greater awareness of history or a stimulus to overcome history as a concept that is no longer applicable to the development of the mankind. On the black bicycle the Post-Historic artist enters straight into history, mixing the temporal contexts of historical existence and blending different systems of references of visual art experience. They no longer function as authentic and exclusive structures, because we no longer believe in monolithic systems of logical causality.

For both West and East, the art historical significance of Braco Dimitrijevic's oeuvre lies in its ability to make us aware of our relationship to history, that is, to the multiple opportunities available to artists and intellectuals. He is the first artist from former Eastern Europe—and a radical representative of the new artistic consciousness—that refuses to accept the role of the avant-garde artist as a prophet bringing current western trends to the East. Nor does he accept the role of the emigrant to the West, who serves as an ambassador for little-known Eastern European avant-gardes. To Braco Dimitrijevic, East and West are of as little relevance as old and new tradition and avant-garde, for the very reason that, to him, history is no longer an applicable formula. Furthermore, the confrontation of new strategies of aesthetic consciousness with the obsolete conventional strategies —as formulated by the activist avant-gardes—has lost its meaning.

Beyond the historical structures, whether logical and causal, beyond the banal and simplistic political clichés, such as East and West, free and oppressed, creative and conformist, Braco Dimitrijevic attempts to free cultural consciousness from the fatalist and mechanical concept of history, and essays instead to sensitise the spectator, that is to focus the observer's perception on the infinite multitude of sign structures and cultural systems that exist alongside each other. The radical sovereignty creates an extremely powerful poetic expression which seems to be sufficiently effective to unify over and over again the fragments of the Post-Historic era into new coherent structures.

Alexandre Ponomarev: Artwork as an Active Organism

Anne Landréat

To take on the work of Alexander Ponomarev is to enter into essentially shifting terrain, where that which one had ventured to take for granted or assumed as obvious, subsequently begins to move, evade, disappear. For the art of Ponomarev is above all *interstitial*, in the sense that he explores solutions of continuity, spaces of friction and dynamic encounter between the various fields of "reality." For him, the *frontier*—which he defines as the place where he situates himself, where and from where he operates—is not a line demarcating set territories that ought to be crossed, bypassed, moved, or destroyed, but rather a space-time in motion within and beginning from which this "reality" can be re-examined, "re-subjectified," re-activated. Recycled.

Frontiers

Maya, the Lost Island,[1] an action during which Ponomarev causes an island on the borders of Russia to disappear in a cloud of smoke, can be considered both the manifesto work of this praxis, as well as a rather disconcerting warning: "Everything [...] was Maya, it was a kind of childish behaviour, show, theatre, fancy, a nothingness covered with a many-coloured skin, a soap bubble, something one could laugh at with a certain rapture and simultaneously scorn, but never take seriously."[2] For him, Maya poses "the problem of presence in the world of the image. How can one contemplate that something that does not exist is, and where is the frontier between that which is and that which is not? How can one grasp this frontier? [...] The frontier between land and sea, life and death, seeing and not seeing."[3] One might add, between art and "non-art," the human and the non-human (the machine, technique), or even between East and West.

For, Ponomarev's art, though fully part of a dialogue with the history of art (Western art, that is) is no less profoundly shaped by "where it comes from," which is equally "where it speaks from," namely that interval called Russia, which he defined as the *frontier* between West and East. A frontier where he lives, a frontier as vast as a continent, a space that is mental as much as it is physical, and which creates a link, connects, and questions more than that it separates or divides. His past as a sailor, which innervates his work as a whole, has allowed him to take this frontier "on board" with him, to confront it with the world, with movement, and to experience its malleability and elusiveness.

Reality, Form, Action

"Form *alone gives access to reality*."[4] Ponomarev's quest is the quest for the *right* form, that is, that form which is in a position to play the part of an active interface between his perception and intuition about the world, and the very world with which he engages in a constant dialectical relationship, producing a "subjectivity that continuously enriches his relationship with the world."[5] A form incapable of being static, fixed, univocal, or enclosed in a medium or mode of expression. Ponomarev's art is not "technological," not simply an "excessive" or "spectacular" art; he constructs systems, systematic fields that make it possible to grasp reality, and it is the very process of constructing these systems that, for him, *is* the artistic form. Technology, scale, and impact are merely tools, materials that he integrates in a complex way in constructing these systems. "I am like a runner running on several tracks. [...] I simultaneously initiate several processes, and I don't want to know what the final outcome will be."[6] When asked about the nature of these "tracks," he listed at least four, which develop in parallel along the same time vector: the confrontation with space (where poetry resides), the confrontation with technique, the inclusion in the social sphere (where all tensions emerge and need to be resolved), and, finally, the processual or reflexive "track" (checkpoint and point of synthesis) where what is happening on the other tracks is put into perspective and relation.

"Conduire le réel jusqu'à l'action [...]."[7] So well do the poet's words reflect the essence of Ponomarev's approach that they could serve as an epigraph for his work as a whole. For that is what all his artistic and life strategies are about: fighting against the force of inertia of reality, putting pressure on himself in order to cause a re-action in himself, upheaval, to create a void, a depression that renders possible the injection of new forms and contents that act within the very fabric of life.

The Mobile Laboratory: *Recycling the Pack*

If we return to the origins of his sprawling project-programme *Recycler la meute* (*Recycling the Pack*), to stage [0] / *Trace septentrionale de Léonard* (*Leonard's Northern Track*), what strikes us first is the formidable pressure he had to exert on reality in all its dimensions in order to make the realisation of this action possible, a pressure whose resulting raw energy still continues to irrigate the multiple ramifications born of this original impulse. In 1996, in a Russia that was only just beginning to realise that it had entered the post-Cold War era, Ponomarev went to the city of Polarnyi in the extreme north of Russia, to those very areas obscured on maps. His aim: to convince the Northern Fleet to put a combat submarine at his disposal so that he might transform it into a coloured artefact on board which he would carry out a voyage on the Arctic Ocean. A programme that initially seemed as harebrained as impossible to carry out, for all the reasons one can easily imagine. And yet, this stage [0] of *Recycling the Pack* was in fact the laboratory in which he would elaborate and establish the major principles underlying his artistic strategy, his *modus operandi*, and thus—beyond the multiplicity of supports and modes of expression he uses—his signature, his "style." Here, the pressure exerted on reality through the means of what is referred to as individuation,[8] "radicalness,"[9] "adventurism,"[10] "poetisation,"[11] and "constructivity,"[12] is brought to its point of maximum tension.

Firstly, through the choice of the submarine, which would prove to be emblematic. Nothing is more closed, secret, more a carrier of fears and ghosts than the world of submarines. This is especially true in the former Soviet empire. And it is precisely this spearhead,

this covert showcase of a disintegrating power that Ponomarev proposes to "recycle." One could see this as a mere act of bravado, a successful gamble, a paradoxical pirouette in the form of a tour de force for this former sailor who had served on board these very submarines. This is not the case. In order to understand it, it is necessary to go back in time a bit, by one year, to the turning point that the development of Ponomarev's work took with his action *Resurrecting Ships.* This action, in the form of a personal catharsis—a sailor who was forced to abandon navigation for serious health reasons brings ships lost at sea, useless and discarded, back to life, but in another field, that of art—announces the expansion and emancipation of his artistic gesture. With *Recycling the Pack,* he transposes and transmutes an entire world using what has become one of the symbols of the Cold War: the submarine, "useless" for a while as well, having re-become *non-functional.* And when, beginning the following year, he involved engineers from the Moscow Institute of Oceanology[13] in his adventures, he was drawing on the same impulse, the same process of the artistic "recycling" of a world in perpetual transformation.

Subsequently, not satisfied with "de-camouflaging" a submarine, he ventured into international waters[14] on board, encompassing, *de facto*, the entire world in this action "for the fish."

Finally, when in 2002, just as he was reviving his project and launching new stages, he declared that he wanted to create "squadrons of objets d'art which will surface suddenly in the areas of artistic instability"[15] to defend the interests of the international art community, he was setting forth a campaign plan, but on terrain where it would be as risky to take him seriously as it would not to...

Since then, four stages of this campaign have been realised, respectively at the Atelier Calder,[16] on board a ship of the Romanian fleet in the Mediterranean,[17] in the Loire by Tours,[18] and at the Musée d'art moderne in Saint-Étienne. The project, essentially "expansionist" in nature, after having encompassed the world symbolically, began its diffusion here. However, whether in Europe or in the Arctic Ocean, on board a warship or in a museum, the operating method remains the same, crossing, without inhibitions, the practices of heterogeneous worlds (the world of art, of the navy, of industry, etc.), working at the margins, within and from these forbidden zones from which the initial impulse came – in that place where, a priori, nothing is possible but anything can happen.

What Ponomarev recycles with his work are the rags of reality that freeze the gaze, "icing" it over, gumming the movement of thought, that cause our perception to stop at that which we have named and, because we have named it or someone has named it to us, we think we know. When, in his "technological" installations *Mémoires de l'eau (Memories of Water)*[19] or *Souffle de l'océan (Ocean Breath)*[20] he makes strange "submobiles"[21] move about in columns of water, behind the words "water" and "ocean"—which we are convinced to have mastered—entities appear, worlds that knowledge absolutely cannot comprehend. When he draws on marine maps, blurring scales, planes, levels of perception, he lays down that the map, "open, [...] connectable in all its dimensions, able to be dismantled, reversible, susceptible to being constantly modified"[22] is the world, because it is on a moving scale, from one to infinity, and thus without scale. Whether it is a matter of making an island disappear from the map, making three tons of water undulate under the effect of his breath,[23] or spreading packs of coloured submarines across the world, Ponomarev builds what he calls "machines," which are nothing other than active organisms.

1. *Maya, the Lost Island*, 2000, action, Sedlovatyi Island, Barents Sea, Russia. (cf. cat. *de Moscou*, Quimper: Le Quartier, 2002)

2. Hermann Hesse, *Le jeu des perles de verre* [*The Glass Bead Game*], Paris: Calmann-Lévy, 1991, p. 668; this quote appears as an epigraph to the booklet that accompanied the presentation of the work at the Novaya Collektsiya Gallery (Moscow) in 2001, Alexander Ponomarev, *Maya, the Lost Island*, Novaya Collektsiya Gallery, Moscow 2001

3. "*Alexandre Ponomarev*," interview with Dominique Abensour, in cat. *de Moscou*, Quimper: Le Quartier, 2002

4. Interview with A. Ponomarev, Paris, October 2003

5. Félix Guattari, *Chaosmose*, Paris: Galilée, 1992, p. 38

6. Interview with Dominique Abensour, *op. cit.*

7. "Guiding reality through to action […]", René Char, "Feuillets d'Hypnos" in *Fureur et mystère*, Paris: Gallimard, 1967, p. 85]

8. Or subjectivation: "New modes of subjectivation are created in the same way as a visual artist creates new forms from the palette at his disposal," F. Guattari, *Chaosmose, op. cit.*, p. 19

9. "Radicalness" makes it possible to penetrate and connect all the components of reality, without considering the artistic sphere as being "apart."

10. Which Ponomarev distinguishes from the strategy of provocation, which consists in creating a disturbance within reality, society, and then taking refuge in the position of observer of the reactions produced. "Adventurism," on the other hand, is to "throw" oneself into the heart of things, to be fully implicated in the process, wherever it may lead: "Singulière fortune où le but se déplace, / Et, n'étant nulle part, peut être n'importe où" (Singular fortune in which the goal shifts, / And, being nowhere, could be anywhere), Baudelaire, *Le voyage.*

11. Which, for Ponomarev, is a constant updating, an acuity of the view taken, and at the same time a message that does not single out any "favoured" interlocutor.

12. Or constructive approach, at once the construction of new artistic forms and new forms of life, positive energy capable of producing works of art that are "active organisms." Not to be confused with constructivism.

13. This institute is directly connected to Soviet military research in maritime matters. Its activities range from basic research regarding knowledge of the marine and aquatic environment, to spying missions and Western nuclear tests at sea.

14. In Russian: the universal Ocean.

15. Letter of application for a residency at the Atelier Calder in Saché.

16. Atelier Calder, Saché, 2003, *Recycler la meute [I] / BASE*

17. Thessalonique, Cassis, Toulon, Marseille, Valencia, 2003, *Recycler la meute [II] / MOBILIS IN MOBILE* (within the context of the Apollonia association's project *Laboratoires artistiques flottants* [*Floating art laboratories*])

18. Tours, 2003, *Recycler la meute [III] / QUELLE PROFONDEUR ? QUELLE PROFONDEUR ! [HOW DEEP? HOW DEEP!]*

19. *Mémoires de l'eau*, installation, Perspex, metal, water, air, Cité des sciences de la Villette, Paris, 2002; Nikoil Centre, Moscow, 2003

20. *Souffle de l'océan*, installation, Perspex, metal, water, Russian Pavilion, Expo 98, Lisbon, 1998

21. Submobiles: non-functional objects residing in water

22. Deleuze/Guattari, *Mille plateaux*, Paris: Éditions de Minuit, 1980, p. 20

23. *Dalai*, installation, metal, water, motor, video projection, Moscow 2001, Paris 2002.

The W O R D in Pictorial Space

Erik Boulatov

Contemporary artists frequently call on text (which I will refer to as w o r d) in very different ways in their work. Most often, however, this w o r d serves as a commentary on or explanation of the image, without whose help the work would be devoid of meaning. It is a w o r d that does not participate actively in the image, that is excluded from the space of the painting, whose content it comments on from the margins.

But the w o r d that interests me is a w o r d that lives fully within the plastic space of the painting, actively participating in its construction, and going so far as to become the image itself, to carrying the same weight as the image.

But why should a painting need such a w o r d-image? Is it that the painting could not exist without it?

Let us say that I have always sought to construct a painting that can entirely forgo external commentary or explanation, a painting into which the observer can *enter*, which causes him to abandon the role of mere bystander, and become a fully-involved participant, directly implicated in what is being played out in the painting.

For this, the w o r d-image becomes indispensable. First of all, because the w o r d, that is, language, represents the most direct way to address our consciousness; it is the most immediate and most-used vector of communication. Secondly, because the w o r d-image, which cannot be completely absorbed by the image and which "floats" in an intermediate space between the painting and the viewer's awareness, reveals itself to be a natural *ferryman* between the viewer and the painting, helping the former to enter *into* the painting, literally carrying him into it.

The first paintings in which I used the w o r d date back to 1971. Since then, I have never stopped coming back to it. The cycle *The W O R D in space* constitutes, at a given point, a review of my work and my pictorial research as regards the w o r d over the course of three decades. It is composed of twelve canvases, almost all of which—with the exception of *Black night, white snow*, which draws on a poem by Alexander Blok—bring into play the verse of the contemporary Russian poet, Vsevolod Nekrasov.

At this stage, two questions naturally arise: why use poetic language in particular? And is there not the risk that the painting will end up being reduced to a mere illustration of the poetic text?

I came to dedicate myself to the poetic w o r d because the words I am interested in are unwritten words, not yet fixed on a surface, words that sound forth, that move freely in space, expressed or even just thought, in gestation.

The movement of the word, its direction, its behaviour within the painting, the relationship it establishes with the viewer—all this comprises the painting's meaning.

For the letters that make up the w o r d are in fact abstract objects out of which a

concrete spatial situation is built that is perceived as *real* by the viewer. And it is this relationship of reciprocal transformation that establishes itself between an abstraction and reality that runs through all the paintings of the cycle.

But within the relationships that establish themselves between abstraction and reality, another set of themes opens up that is no less fundamental to me.

It is generally thought that two major traditions coexist in Russian art without overlapping in the least: nineteenth-century realist painting (mainly the landscape school), and the avant-garde painting from the 1910s to 1920s.

I am nevertheless convinced that between these two, admittedly very distant artistic currents, there is a profound, resultant, inescapable link—namely, the link created by a common national culture, which, consciously or not, inevitably has an influence on the world view and thought patterns that guide all artistic creation.

Starting from this premise, I arrived at the conclusion that that which characterises Russian artwork is the constant need it poses for *contact* with the viewer, for the impossibility of having an autonomous existence, folded back in on itself, not to say hermetic. And this, whether we are discussing a realist landscape by Leviathan, a Suprematist canvas by Malevich, or one of Tatlin's constructions. We are always dealing with an open space, conceived immediately in accordance with the active participation of the viewer, who is placed in the position of co-artist.

The cycle *The W O R D in space* refers directly to its traditions. Constructivist in the case of the three black and white canvases; landscapist in the case of *Tam-tam via the roads, and there the house*; while the junction occurs in the last painting of the cycle, *Reaching day there... ultimately too late*, where it is as though the two currents have been superimposed.

Erik Boulatov. Opening the Painting: Surface - Space - Word - Horizon - Movement

Anne Landréat

"To Boulatov
opening
he opened
the window
and there it is the world"
V. Nekrasov[1]

Opening. The window. The world. The gaze. The painting.
Opening. For him. For us. That which is closed, enclosed, concealed, inaccessible. A fundamental concern in Erik Boulatov's work.

If we return to the origins, to the genesis of the constituent grammar of Boulatov's pictorial language, which attains complete control in the cycle *The W O R D in space*, over the course of four years and five canvases[1] we see the appearance of the fundamental elements he uses to draw us ever further along with him into the painting itself, to open the painting—for us. For him, this is a painting that is not the context for an imaginary world to express itself, not a subjective vision that we are invited to penetrate, but rather a concrete, objective reality governed by its own laws, which he makes his duty to study and bring up to date in all their combinatorial possibilities.

Self-Portrait (No Entry) asserts precisely this—the entry. It represents the possibility of (or need for) such an opening, an access to the pictorial space, which is a space of freedom, an entry that passes through the artist's very body—at the risk

of his life, one might say. A declaration of war rather than a manifesto, this self-portrait conveys a violence, a momentum, an inflexible will whose waves still reverberate in the work as a whole to this day. A white background, virgin canvas crossed horizontally in the middle by red letters spelling out the text "no entry", the repetition of which evokes a scrolling text, the hackneyed prohibition churned out ad infinitum. In front of this text-band, which serves the same function as the red ribbon that crosses the view in *Horizon*, the sombre image of the artist—brows knitted, face inscrutable, gaze fixed—rises up between the painting and us. In the middle of his face—the "third eye" at the painting's exact centre—a black tear, as though the surface of the canvas had been scraped to open the painting's space and to allow us to make out, in the distance, far away, a horizon gleaming in the night. Everything is said—or rather, announced, for everything remains to be done once the obstacle of the prohibition has been surmounted.

Bookending this self-portrait, we find *Entry* (1972) and *Entry—No Entry* (1974–75). While in the former we still sense the artist's trial-and-error attempts to

find an entry, which increases behind a red grid that only the gaze can cross, but which disappears and loses itself in the white of the canvas, whereas *Entry—no entry* is a confirmation—purified of all lyricism this time—of what asserted itself in the self-portrait. For the first time in Boulatov's work, text alone occupies the space of the painting. In the foreground, in red letters, the affirmation "no entry" is taken up again, but as though bloated, unique, peremptory. Yet what predominates and opens the space is the word "entry" repeated twice, whose enormous blue letters run off towards the centre of the canvas, creating an appeal, an aspiration, a momentum that makes it possible to overcome the prohibition and to penetrate the painting, beyond the physical limit of the canvas's surface and the mental barrier imposed on us, allowing us via a strange physical-sensorial experience to *truly* and simultaneously be an observer of, and participant, in the painting. And this through nothing more than the combination of two essential elements of the Boulatovian grammar: the tension, intensified to the extreme, between the *surface* of the canvas and the *space* of the painting, and the use of the *word* both as an element of spatialisation or de-spatialisation, and as a semantic vector.

For it was precisely during these years that the word began its movement in Boulatov's work, a movement he had merely intuited at that point and which he would pursue, work after work, in an almost obsessive manner. Still, little by little, the words he used would change in nature, as though by exploring various semantic registers he were looking for "carrier" words. The ubiquitous "no entry", "entry", and "beware" signs of Soviet urban signage which he used in the early 1970s soon made room for words that one might define as generic or universal: "sea", "land", "New York", "Mozart", and so forth. But, from 1975, with his painting *I'm*

going, he announced the beginning of an internal assimilation of poetic language, an effort whose formal result would only come to light 25 years later with the cycle *The W O R D in space*.

"Nekrasov's poetry, his language, forced me to see the word in space."[2]

> " (…)
> *why are the clouds*
> *wandering there*
> *and moving about that way*
> *as if*
> *as if*
> *they were*
> *the home of mankind*
> *and not Moscow*
> *over there thus*
> *as if*
> *over there*
> *were here.*"[3]

I Live, I See.[4] Entry into the cycle. A credo. Nekrasov's.[5] Boulatov's. That of Russian art: not to tell lies, not to invent. The real, not realist, but reality, a reality grasped by the intensity of life and of the gaze. In the painting's composition we find the same principle used in *Entry—No Entry*, except that here there is no longer anything obstructing the horizon, we have left the obstacle behind us and our subsequently emancipated gaze can *see* the reality captured by the artist and rendered in an intentionally neutral, not to say banal, manner, as though Boulatov were saying to us: "This reality surrounding us, I am giving it back to you as is, unembellished, without any additions from my imagination; but through the spatial game of poetic language, I am reviving *your* gaze upon this reality." Like in the painting from the 1970s, *Beware*, where the word "beware" repeated twice moves about in a landscape that seems oppressed by platitude and banality on the one hand and by a menacing horizon on the other, like a line of sight, the impression given by the

painting, the interpretation of the real that it generates, is powerfully conditioned by the text alone, which both in the semantic field and in the spatial field acts like a framing of this seemingly banal reality.

"The word is an object. It thus has a form, a form that exists in space. But the word is not an object just like others, which are always outside of us, which come from the outside toward our awareness so that we can name them. The object and the word that refers to it move closer together ad infinitum, without ever really meeting. The word I use exists in this rift. It is between the viewer and the painting, creating the link. And this space which it inhabits, is inhabited by it alone."[6] The words "I live, I see" will torment Boulatov to the point of obsession. To see. To see the individual life of these words. To see their intrinsic energy and the unique movement that it brings about in time and space. *To see* these words in order to be able, afterwards, to see all the others, to learn to see all the others. To see the words of the poet as they take shape, as they take shape without ever being set down, moving to where speech begins, to where the latter hasn't had time to look at itself in the mirror yet, a thought in the process of being expressed, whose formalisation, whose outcome (never definitive), is ours. The painting *There It Is*,[7] which is at once the centre or pivot of the cycle and the dominant element of the subset composed of the three constructivist-inspired black and white canvases, is absolutely radical in this regard. The Russian word for "there it is," "VOT," is virtually onomatopoetic, a term that punctuates speech, internal even more than external; it makes it possible to insert breaths into it, the rhythm, in a repetitive and unconscious way. Isolated, moving on the canvas alone, this word becomes all other words, it contains them at the core of its 'O' which reframes the horizon, making it reversible, invertible, upsetting

all perspectives and all certitudes to the point of vertigo: it is the very soul of poetry.

These three canvases are also remarkable in that they contain and distil the totality of Boulatov's thoughts about the notion of horizon, which is another fundamental element of his grammar. While in *Horizon* the red ribbon concealing both the landscape's and the painting's horizon (it is as omnipresent for us as it is for the figures in the painting, whose view of the ocean it obstructs) leads us to suppose that the horizon (and thus the space) of the painting and of the viewer differ, as though given depth by an element that belongs at once to our reality and to the painting's, in the three black and white canvases, these two horizons coincide, but in such a formal way, in a dramatic tension intensified to such a degree, that behind this "reconciled" horizon yet another space, hitherto unsuspected, opens up. A virtuoso in his treatment of space (or rather, spaces), Boulatov, by multiplying the horizons and the representations he causes to coincide or diverge as he wishes, manages never to close the painting, always to suggest the existence of a "beyond" to the painting, and of a "beyond" beyond this "beyond", and so on, encouraging us to see, to pass through the layers of the real one after another: to enter into the painting, but in order to go beyond it.

The last canvas of the cycle, which concludes it without closing it, *Reaching Day There… Ultimately Too Late*,[8] can be considered the most accomplished synthesis and one of the most complex lines underlying Boulatov's work. Claiming to represent both the nineteenth-century Russian landscape tradition and the avant-gardes of the early twentieth century (these two traditions, so radically different in form, come together again in their desire to establish a direct relationship with the viewer, without the filter of culture or academic knowledge), this painting reaffirms

the great Russian utopian idea according to which art is a means and not an end in itself, a means for having an effect on the world's awareness. More than any other, through the incessant oscillation between inside and out, momentum and collapse, around a single visual and textual pivot, through the infinite nuances and at the same time the brutality of contrasts that it implements, *Reaching Day There… Ultimately Too Late* once again raises the question of that utopian notion of an art capable of encompassing life as a whole, of a life that would be completely transformed by art. But to make sure of this, we need to go there to see for ourselves. We need to follow the artist's lead, and enter the painting.

1. Vsevolod Nekrasov, *I live, I see*, "To Boulatov," Moscow, 2002. V. Nekrasov is the leader of Russian conceptual poetry. He is also an art critic. Boulatov's cycle *The W O R D in space* is (almost) entirely based on his verse.
2. Interview with E. Boulatov, March 2003.
3. Vsevolod Nekrasov, *I live, I see*, "To Boulatov" (2), Moscow, 2002. Trans. A. Landréat.

4. 1999, oil on canvas, 200 x 200 (private collection)
5. "And though I do not want / and do not try / I live and I see" (V. Nekrasov)
6. Interview with E. Boulatov, December 2002
7. 2001, oil on canvas, 200 x 200 (artist's collection)
8. 2002, oil, crayon and pastel on canvas, 200 x 200 (artist's collection)

Lecture at the Opening of the Exhibition
So Far, So Close... by Olga Kisseleva

Ekaterina Degot

In the past, artworks were more likely to travel. Artists rarely moved; when they travelled like Leonardo da Vinci did, it was considered an event. Otherwise, it was the patron, the collector, who came to the artist's studio to choose the piece, buy it, and sometimes send it off to a distant estate.

Since the 1990s, artists have been the ones to travel, and they are invited to create *in situ* installations. Art has made room for a generation of itinerant artists. The artist travels and creates works. These works, rooted in their environment, incorporate themselves into the place in and for which they have been created, into its plastic, geographic, political, and social context. The advantage of an *in situ* work is that we always know where it is.

But Olga Kisseleva, even as she is one of the representatives of this new generation of artists, rightly makes us question the place where we find ourselves with her exhibition "Si loin, si proche..." (*So far, so close...*). Are we in Saint Petersburg, Los Angeles, or still in France here? We, the viewers, have the feeling of being afloat, a feeling familiar to those who travel a great deal. Sometimes, when you travel a lot, when you wake up in the morning, you find yourself wondering where you are, in what city, in what country. And it can be difficult to know where you are, especially when the furniture is the same everywhere! This similarity between objects and places is the deceptive side of world civilisation, the result of globalisation.

Moreover, the corporation that has contributed most to the progress of the "globalization of daily life", contrary to what is sometimes said, is not the American company McDonalds, but the very European company IKEA. In Russia, Moscow has become a global capital ever since IKEA opened there. Now, in every Muscovite flat, you can see the same objects found everywhere else in the world. Thus, this globalization, whose consequences we dread, is not just an American context. We are beginning to realise that it is necessary to fight globalization to preserve our traditions, our culture. We all have the right to be different, to be a person and not a globality.

But beware: this notion of cultural preservation, this right to culture, can also become an obligation. And Russian artists are very familiar with this problem. The intention of protecting our culture can make us fall into the trap of exoticism, it can draw us into that same pressure toward exoticism that Chinese, Indian, or African artists also feel. The artist must represent her country, her traditions, even if she is not particularly interested in popular traditions, even if she has been living in New York for twenty years and prefers Italian food to the cuisine of her native country: she is under the obligation to bear witness to her identity.

But Russia is a country of European civilisation. It is a Scandinavian country that took shape in the North of Europe,

and whose inhabitants have gradually occupied the territories to the East – the Urals, Siberia, all the way to the Far East. But these territories were more like colonies, like the overseas French territories or the British Isles. The Russian, subsequently Soviet, Empire was unusual in that it was surrounded by its own colonies, it was a "compact" colonial empire. Moreover, the discovery of this reality often causes great disappointment in foreign visitors who expect to find "the Russia of Anna Karenina"… They consider Russia an exotic rather than a western country, despite the fact that Sophie Marceau played the role of Anna Karenina.

Faced with this "obligation to exoticism", the new generation of Russian artists often avoids defining itself as Russian, and does not play the "tradition" card. Olga Kisseleva's "Si loin, si proche…" also contains this gesture of "avoidance". This is a very important gesture in the global context. This artist's path is unusual: she is one of the first among the Russian artists on the international scene who does not allow herself to talk directly about Russia. Her work raises universal questions. It is not just a matter of intellectual integrity. We are also dealing with the legacy of Soviet globalisation.

Olga Kisseleva's work is rooted above all in this Soviet tradition. We need to remember the context, for it is not easy to grasp all the nuances between Russian and Soviet culture. For over seventy years, during the Soviet era, the Russians did not have their own traditions: in schools, for example, Russian literature was replaced by Soviet literature—consequently their only legacy of Russian culture was their mother-tongue. Soviet tradition also made itself felt in the artistic milieu. Artists' unions formed on various levels. And when the Union of Soviet Artists put on an exhibition, an interesting clash was expected, at odds with another exhibition organised by the Union of Russian Artists,

or by one of the unions of Armenian, Ukrainian, or Tadjik artists, which were considered kitsch, uninteresting. The Soviet tradition came out of a global tradition, which is now the source of an identity problem for intellectuals and artists—for the question of identity is a question of origin. Where do I come from? I come from the Soviet, global, tradition, which banned all national origins beginning in 1917!

The Soviet Union itself was constructed in such a way as to exclude any notion of nationality, geography. Not even the country's name contained any geographic or national reference! It was the Union of Soviet Republics; thus there was a Soviet Republic of Russia, a Soviet Republic of Ukraine, a Soviet Republic of Uzbekistan… And why not someday a Soviet Republic of France, England or India? It was open to all! It was a globalist idea.

Furthermore, the culture considered itself an heir to global culture, even as it was completely rootless. The inhabitants of the country could not travel abroad, yet they were very familiar with world culture, even if they had no idea what it might correspond to in real life. For example, the literature of Kafka and Proust were very well known in Russia, but we had no practical references for it. This literature was as pure as Malevich's triangles and squares, floating in a space. It was a pure idea. All the same, the fact of being isolated can be stimulating because it allows for freedom of intellect.

Nowadays, the Russian artist is postglobalist. He gives himself permission not to be exotic, not to bear witness to the place he is from, which is the case for Olga Kisseleva, because "where she is from" already *is* globalisation.

To close, I would like to recount a little anecdote concerning a Russian film that has marked generations. It is a comedy from the 1970s that conveys the banality of life. On New Year's Eve, after a night of

drinking, a man takes a plane in the place of one of his friends. Arrived in Saint Petersburg, he is not aware of what has just happened. He wakes up at the airport thinking that he is in Moscow, takes a taxi, gives the driver his address, and finds himself in an apartment similar to his own, where everything corresponds—the keys, the furniture, the walls. He falls asleep, wakes up, and, of course, finds the love of his life there. For the Soviets, this film bore witness to their sad life, where everything was the same, where there wasn't much of a choice. But if I were a Hollywood director, I would shoot a "remake" of this film now, because it also perfectly expresses the cliché of the profound banality of the Western globalized world.

This story proves to be significant for Olga Kisseleva's exhibition. In the world that the artist reproduces here, a simple click of the remote control is all it takes to move this indisputably material dwelling from one place to another across continents, and her label game "travel kit for immobile journey" allows us to get our bearings in space, to know the provenance and contextual use of the object. But this wonderful ease of travelling also indicates a problem: one's spirit doesn't always follow when one moves from one city to another, across a standardised world...

Julije Knifer's Meanders

Zvonko Makovic

Julije Knifer's entire oeuvre is connected with a single motif, the meander, which appears for the first time, clearly defined, in his canvases of the 1960s. The artist himself has said that he was motivated by the idea of creating an anti-picture and that in order to do so he sought to reduce the formal means at his disposal.

This reduction manifested itself in the rejection of all allusions to the objective world as well as that of the illusionistic elements of sculptural language.

Thus he reduced the choice of colours to two, black and white. In this way he sought to express extreme contrasts. Similarly, the system of meanders is made up of extremes as well, horizontals and verticals that create a regular and monotonous rhythm within the picture field.

Because of Knifer's regular participation in the New Tendencies exhibitions—be it in Zagreb, in Germany, or in Italy—many have tended to regard his reductionism, with its extremist structural logic of painting, as one of the derivatives of neo-constructivist aesthetics. However, the connection with neo-constructivism and even minimal art was not of great importance for this artist. The foundations of his art were and continue to be deeper and more stratified. They involve the most various spheres of influence, from existentialist philosophy to the absurd by way of Malevich and Cézanne.

In addition, there is a peculiar segment of Knifer's work that perhaps more than any other illuminates the nature of his art and his own nature. It is a series of self-portraits that he created between 1949 and 1950, at the moment when he decided to devote himself to art and just shortly before he enrolled in the Academy of Fine Arts in Zagreb. At this time he stood diligently in front of the mirror every day and drew himself. In the course of repeating a single, almost ritual procedure, Knifer became aware that his drawings were not in fact simple self-portraits, but engaged an infinite order of rhythmic invocations, similar or nearly similar.

This precocious discovery was extremely important for the painter, because he understood then that he did not want to create an individual picture, a self-sufficient work.

Like every picture, the individual drawing derived its meaning from the order of the whole that emanated from all the other works. This method, which is characterised by rhythm, crystallised in an essential substance, time.

This is why, if one compares the later works with the first paintings of the 1960s in which the meander motif appears, it is possible to observe that the idea of the meander occurs more and more frequently in Knifer's art.

From the moment that he purified and illuminated the formula of the meander and applied it to his first canvases, the artist went on to discover, with a truly obsessive determination, the multiple and interminable variations of meandering signs.

The tiny, subtle differences also stand out more clearly and concisely when they are considered in succession.

In fact, the great value of Knifer's art resides precisely in these minimal but pictorially significant differences provoked by the use of a single, identical formula.

Even if it is only the elements of filling in that put in their appearance—black and white, horizontals and verticals—each of them retains its own specific mass, that is, its own specific meaning.

Nevertheless, through the tiny variations of the nearly identical elements, a new context comes into being each time, despite the fact that the meaning of each isolated work is based on the ensemble in its entirety.

In 1977, when Knifer began a series of pencil and paper drawings that feature the meander as their constant motif, he wished to achieve what would at first glance appear to be the greatest possible density of black. He applied the blackness little by little, slowly, using gestures that he had studied and premeditated for a long time. It is precisely this notion of time as something passing, something used, that is essential in this art.

With this series of works, Julije Knifer introduced—and he did so magnificently—the presence of absence.

The same presence of absence that is also mentioned by Kasimir Malevich when, according to reports, he desperately tried to free art from the weight of the object and created the *Black Square on a White Background,* this square "that was not an empty square, but the very feeling of the object's absence."

Jiri Kolar
Objects of Passion, 1981

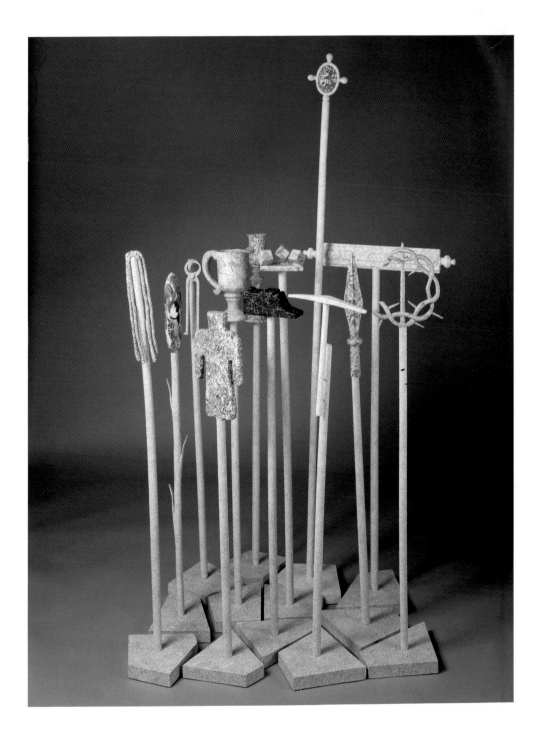

Colour Separation
Eurofotolit, Cernusco sul Naviglio, Milan

Printed in June 2004 by
Arti Grafiche Bianca & Volta,
Truccazzano, Milan, en June 2004.

Printed in Italy